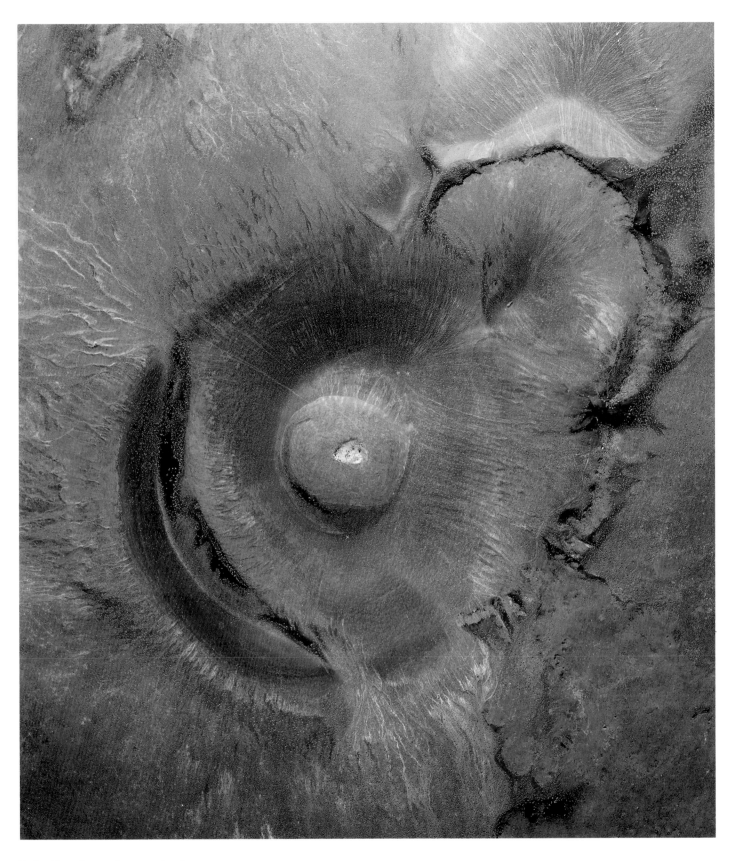

Roden Crater (survey frame 5752), 1982

Occluded Front
James Turrell

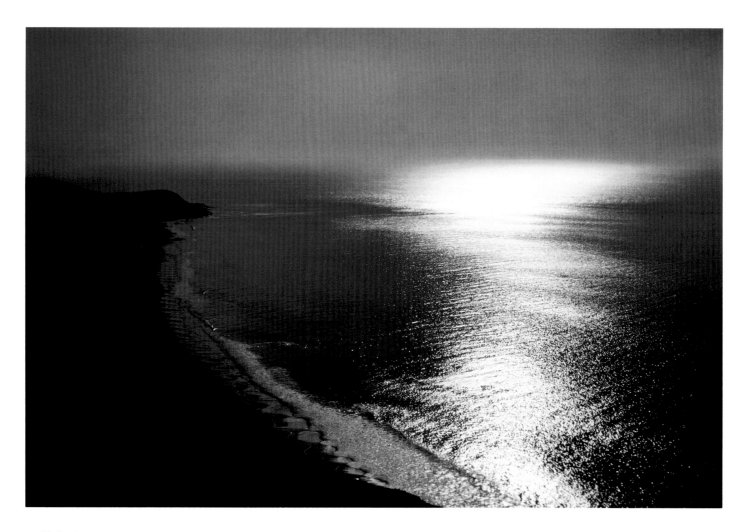

1 Under the overcast, Channel Island, 1975

Occluded Front
James Turrell

Edited by Julia Brown

Contributors:
Craig Adcock
Julia Brown
John Coplans
Edy de Wilde
Craig Hodgetts
Lucebert
Count Giuseppe Panza di Biumo
Jim Simmerman
James Turrell
Theodore F. Wolff

Fellows of Contemporary Art, Los Angeles
The Lapis Press
The Museum of Contemporary Art, Los Angeles

This book has been published in conjunction with the James Turrell exhibition at The Museum of Contemporary Art, Los Angeles, 13 November 1985 to 9 February 1986.

The Lapis Press
P.O. Box 5408
Larkspur Landing, Calif. 94939
(415) 461-5275

ISBN: 0-932499-11-2 paper
 0-932499-10-4 cloth
Library of Congress Number: 85-081089

Cover: *T–12 Aerial Photo Mosaic*
Photo: *James Turrell & Dick Wiser*

Contents

Acknowledgements
The Museum of Contemporary Art

It is a special pleasure to present the work of James Turrell at The Museum of Contemporary Art and to publish a book on his work. This exhibition and publication continue the Museum's commitment to present the work of individual artists designed for the spaces of the Temporary Contemporary, and monographs produced in collaboration with the artist.

I first thank James Turrell for his generous involvement in every part of this exhibition and publication and for his work that is its subject. Michael Yost and Roy Thurston have provided administrative, logistical, and technical support which has been essential to the production of work for this exhibition. We are most grateful to all the lenders, whose generosity helped to make the exhibition possible.

Julia Brown, Senior Curator, was responsible for the organization of the book and the exhibition. Howard Singerman, Publications Coordinator, offered particular assistance in the editing of Craig Adcock's essay. Assistant Curator Jacqueline Crist and Curatorial Secretaries Diana Schwab, Connie Butler, and Leslie Fellows provided assistance in all aspects of the project. Sherri Geldin, Associate Director, and Kerry Buckley, Director of Development, provided necessary support to realize this exhibition. Roy Thurston and Richard T. W. Roe, working with John Bowsher, Chief Preparator, realized the complex installation for this exhibition, along with Brick Chapman, Operations and Facilities Manager. Craig Baumhofer assisted James Turrell with the installation.

I particularly thank Sam Francis, Publisher, and Jan Butterfield, Executive Director and Editor of The Lapis Press, for entering into a partnership with the Museum and the Fellows of Contemporary Art to realize an ambitious publication on the work of James Turrell. Mathew Stephenson, of The Lapis Press, has been the invaluable editor who guided this text to completion. I thank designer Tina Beebe for her help with the book in its early stages and Jack Werner Stauffacher for his sensitive design, developed and carried out with James Turrell.

The artist would like to thank Ajax Daniels for her help with drawings and graphics, assisted by Susan Nardulli, Raun Thorp, Marina Lenney, Lauren Lieberman, Jo Schneider, Michael Gruber, Ramon Klein, Barry Chusid, Ruth Fukuji, and David Hanawalt. For help on the Roden Crater model, the artist would also like to thank Robert Mangurian and Mary Ann Ray. The artist also thanks Ivan Curtis and Dick Wiser for their particular assistance on aerial photography; Dr. Richard Walker for calculations and astronomical assistance; Dr. Ed Krupp for the use of the Griffith Observatory; and Greg Gentsch for engineering assistance. Special thanks to Malinda Wyatt and Karl Bornstein for their overall assistance and support and to Evelyn Billberg, Deborah Baker, and Sharen Gould for their help gathering materials for this publication.

I thank Count Giuseppe Panza di Biumo, Craig Adcock, Theodore F. Wolff, Edy de Wilde, Craig Hodgetts, John Coplans, Lucebert, and Jim Simmerman for their contributions to the book.

This exhibition and its book have been partially funded by Fellows of Contemporary Art, and we are greatly appreciative of the support and involvement of Dr. Arthur Chester and the Fellows since the beginning of this project.

We express our gratitude to the full Board of Trustees and its Program Committee for ongoing support of the Museum's exhibition programs and for their affirmation of the Museum's commitment to exhibit and document the work of individual artists.

Richard Koshalek
Director

6

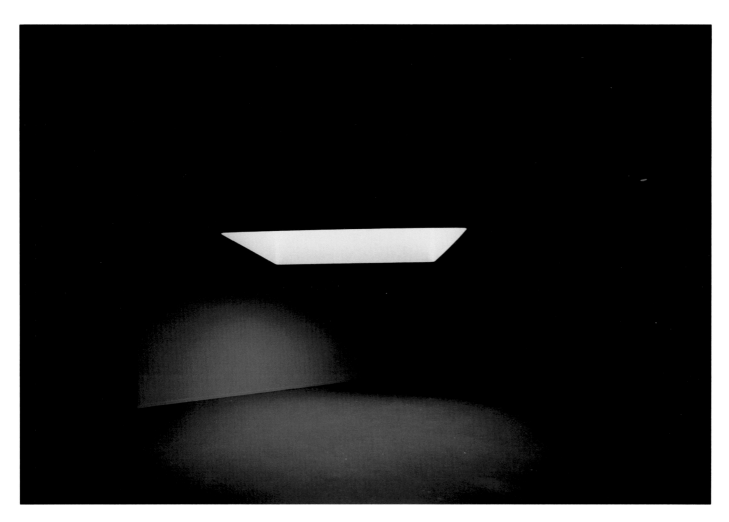

2 *Hover*, 1983

Acknowledgements
Fellows of Contemporary Art

Fellows of Contemporary Art appreciates the opportunity to participate in this exhibition of James Turrell's work. The exhibition enlarges our perception and expands our horizons through its scope and depth.

Since the Fellows was organized ten years ago, we have initiated and sponsored exhibitions in cooperation with museums from La Jolla to San Francisco. Each of these events was documented by a catalog bearing our name as a permanent record and tribute to the artists. We take great pride in the quality of these catalogs. Fellows uses all funds raised from membership dues for exhibition programs and has received several supporting grants from the National Endowment for the Arts.

The Turrell exhibition presents our first opportunity to cooperate with The Museum of Contemporary Art. It is a special pleasure because the focus of MOCA is the same as ours. MOCA's physical facilities lend a unique latitude of space, making this Turrell exhibition possible.

We are indebted to Dr. Arthur Chester who, as our liaison with the staff at MOCA, participated in the many necessary steps to bring this exhibition to fruition. Mrs. Richard Newquist, then Chairman of Long Range Exhibition Planning, assessed and negotiated the possibility of our participation in this exhibition. Gordon Hampton, Fellows' Chairman during the previous two years, has given us much encouragement and valuable counsel. Carla Witt, our Executive Secretary, is always a valuable factor in all our communications.

We wish to thank Richard Koshalek, the Director of MOCA; Julia Brown, the Senior Curator and curator of the Turrell exhibition; Sherri Geldin, Associate Director; Jacqueline Crist, Assistant Curator; John Bowsher, Chief Preparator; Diana Schwab, Curatorial Secretary; and the entire MOCA staff.

Peggy Phelps
Chairman
Fellows of Contemporary Art

Introduction

James Turrell's open-ended approach to art places particular emphasis on alerting viewers to perceptual ambiguities in order to induce heightened levels of awareness. His work can be interpreted in various ways: as aesthetically motivated; as a carefully calculated demonstration of certain laws as they apply to human perception and cognition; as a demystifying process leading to a clearer understanding of man's working relationship with his environment; as an instigator of subtly transcendental or metaphysical states of mind. In fact, it is a combination of all the above.

Whatever our interpretation, however, one thing is certain: Turrell's art is tantalizing and complex, and capable of producing reactions ranging from mild appreciation to something approaching awe.

But how? And what are the implications of this extraordinary effect? To what can we attribute his ability to provoke what some describe as moments of exhilarating expansiveness, others as illuminating insights into the distinctions between looking and seeing, and others still as quiet reflections on the mystery and wholeness of life?

Even more important, how does he manage to cut right to the heart of a viewer's perceptual proclivities and capabilities and activate his deepest and most fertile conceptual and creative resources? And how is he able to do this with an art form almost exclusively defined and shaped by light?

Technically, he accomplishes this through an application of scientific and aesthetic principles intended to lead the viewer into a state of total openness and expectancy, stripped clean of convention, artifact, dogma, and any other form of conditioned or habitual response to the raw, stark stimuli of experience. It is a state in which the viewer is permitted to confront and respond afresh to new and heightened perceptions of reality according to his or her nature, talents, aspirations, and ideals.

No wonder the reactions to Turrell's art are so personal and varied, for no two human beings will receive precisely the same "message" from his work. He brings us dramatically closer to our original primal state of uncertainty and wonderment, and then leaves us to our own devices. What we do then, whether we interpret the experience within an aesthetic, philosophical, or metaphysical context, is up to us – although the nature and quality of his art, its radiance,

harmony, and grace, suggest very clearly the direction he hopes each of us will take.

He has moved in a direction that is peculiarly American in its orientation, vision, and scope. His work embodies, and resonates with, much of the same dynamic spirit that animated the lyrically expansive nineteenth century landscapes of Thomas Cole, Albert Bierstadt, and Frederick Edwin Church – although in a form appropriate to a technological and increasingly urbanized society.

Turrell differs from them and his emotionally expansive American contemporaries in his methods. He consciously determines the precise perceptual framework within which his work is seen. He sets the stage, as it were, and eliminates all psychological and material distractions that could block or divert the viewer's wholehearted attention, and he successfully brings together forces, qualities, and ideas that our culture tends to separate.

Not much has ever been made of the fact that art can induce creativity and activate cognitive and developmental processes – or even that it can heal, in the simplest and best sense of the word. In Turrell's work these effects take center stage and are implicit from its very inception.

Almost inevitably, the ultimate result of such work is enrichment and growth. Rather than shocking or seducing his viewers into compliance in order to impose his ideas, Turrell presents them with a new means of gaining insight into *their* attitudes and perceptions and even, in some cases, helps them awaken intuitions pertaining to the quality and meaning of their lives.

James Turrell's work is extraordinary not only because he knows exactly what he is doing, but because his methods are remarkably integrative and life enhancing. There is plenty of art that is primarily pleasurable, formal, idiosyncratic, or assertive; but very little that celebrates and provokes clearer and more holistic perceptions of ourselves, reality, and truth – especially in a format that is startlingly beautiful in and of itself.

Theodore F. Wolff

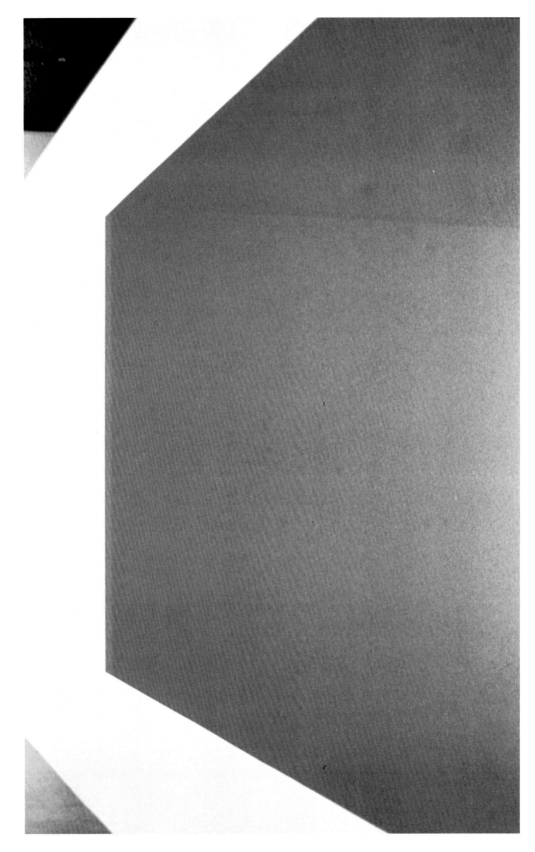

3 *Cumo*, 1976

4 James Turrell and Julia Brown, 1985

Interview with James Turrell

I have an interest in the invisible light, the light perceptible only
in the mind. . . I want to address the light that we see in dreams . . .

JULIA BROWN: Jim, your work is known for the relations it poses among light, space, and the viewer. Could you explain how much of your work is derived from a particular space, and how much is it independent of a particular place?

JIM TURRELL: I work in both ways. I like to find a site that has unique opportunities for light or the perception of space. If the site is neutral and doesn't have any unique qualities or many possibilities, then I construct an independent piece that could be transferred elsewhere, a more hypothetical piece than one which comes from responding to a specific site. Spaces in general are not neutral to begin with, and some have more complexities than others. The more they have, the less possible it is to make a neutral beginning. In that case, I respond to the site and make a piece that is unique to it. Generally, I would say that the spaces in museums are not particularly neutral, and they are more adaptable, basically, to painting. Some are reasonably adaptable for sculpture, but that's less common. And it is even less common that they are adaptable to environmental works. By and large, architects have created museums that support a limited view of art. However, when you take a warehouse that has been used for many functions and empty it of its intended use, you find a space that has more possibilities. For an art that's not restricted to objects that go up an elevator into an eastside apartment, spaces like this are definitely more interesting. I have more ambition for art than to have it limited to these things.

JB: When you say a site has a unique character, you're nevertheless making your own structure within it or within that architecture. You don't seem to actually work with the particular characteristics or details of the existing architecture.

JT: For the most part, I work within a given architecture that is generally rectilinear. In making a piece, I like the form and construct to have a neutral quality. This requires a rectilinear format. If a painter makes a canvas that is elliptical, it is in fact a shaped canvas and not neutral. So if what I want to make pays attention to the specifics of the given architectural form, the form of the construction may become more important than the space within. But if I want to get away from the particulars of the architecture, with its detail and attention to form, so

as to make an architecture of space, then I have to rid the space of those details and features that call attention to form.

JB: What do you mean by an architecture of space?

JT: I'm interested in the weights, pressures, and feeling of the light inhabiting space itself and in seeing this atmosphere rather than the walls.

JB: Are you talking about volume?

JT: Atmosphere is volume, but it is within volume. Seeing volume as a whole is one thing, but there are densities and structuring within a space that have to do with a penetration of vision and a way of seeing into it.

JB: Seeing, as opposed to being, inside it?

JT: You can inhabit a space with consciousness without physically entering it, as in a dream. You can be in it physically and see it in that manner also. But whether you're in a space and looking at it or outside and looking into it, it still has qualities of atmosphere, density, and grain so that your vision will penetrate differently in some areas than others. Some areas will be more translucent or more opaque, and other areas will be very free to the penetration of vision.

JB: Is that because of the nature of what you have constructed, or is it because of the way in which you control the light?

JT: It can be either or both. How the light enters can be controlled, and your sense of the confines produced by the structure can be altered by the light. It is possible to see spaces within spaces, not delineated by form but by visual pene-tration. An example would be the kind of space that is generated by blushes of light near you, such as at a lectern or on a stage where you can't see the audience yet the audience can see you quite clearly. You inhabit a different space than the audience, though you are in the same structure. Your penetration of vision is markedly different than theirs. You literally cannot see them, although there is no form between you and them. The penetration of vision has been completely limited by the manner in which the light around you is different than that on the people who are looking at you. So, in making a piece, the first objective is not to look at the possibilities of architectural form and the possibilities of space, but to work with them so as to express a particular realm or atmosphere. That's usually done by working with the manner in which the space yields to vision, the way you can plumb the space with seeing.

JB: You want to create an atmosphere?

JT: Yes, one that can be consciously plumbed with seeing, like the wordless thought that comes from looking into fire.

JB: At times you work with natural light, using light from a window or a skylight; at other times you bring in electric light, or so-called artificial light. Can you talk about the difference, and how those decisions get made in individual works?

JT: Whether or not I want to work with the light that's given depends upon its possibilities of empowering a space. It must have some grace. If not, then I'll use any other light available to me. But it doesn't really matter, because either way the light is used to make a realm that's of the mind. I don't have a preference between existing or "artificial" light. There isn't any real difference. In either case, you're burning a material, and that material releases its characteristic light. Whether you burn hydrogen, a piece of wood, or tungsten wire, the light reveals what that material is; it is characteristic of that material at that temperature. So it doesn't really matter to me whether you have to light electric fires or use the one in the sun or a reflection of it off the moon. It is all "natural" light.

JB: What sort of importance do you give to the structure?

JT: The physical structure is used to accept and contain light, and to define a situation. But the light can determine the space, and it can be experienced more than the structure if the surface does not call attention to itself. Extreme attention must be paid to making perfect surfaces, so you don't notice them.

JB: But doesn't the structure create the way in which you have that experience?

JT: If you see some of the pieces when they're not lit, they're just empty. It isn't the structure that's making the presence. It creates and defines context.

JB: Then the structure determines how you approach the work and stand in relation to it?

JT: Yes, but the structure is not the predominant maker of the work. How the light enters the space, and how the structure is formed to allow that, creates the work. The work is about your seeing. It is responsive to the viewer. As you move within the space or as you decide to see it, one way or another, its reality can change. The approach to it is very important. It's possible for you to make the reality of your experience of the piece become the determinant of its existence.

5 Construction photograph, *Razor*, 1982

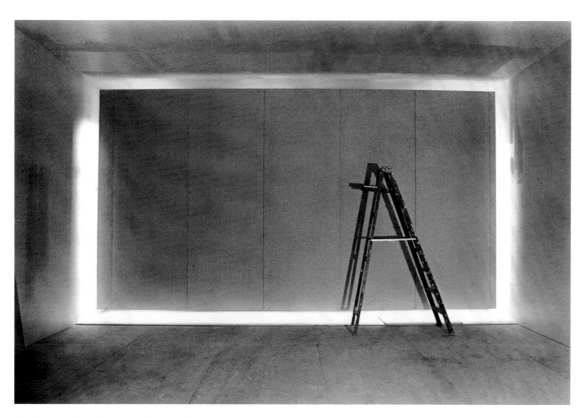

6 Construction photograph, *Razor*, 1982

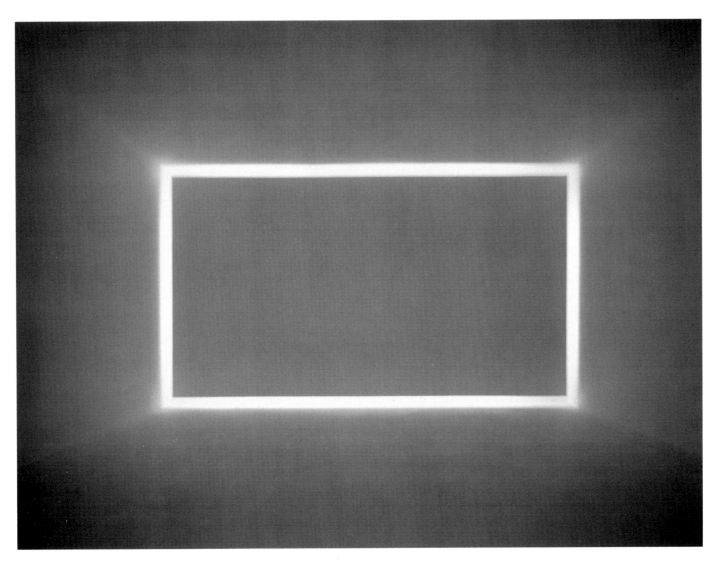

7 *Razor*, 1982

JB: When you say approach, do you mean the literal distance, or are you also describing the nature of an entrance?

JT: Both. One is how you first see it, and the other is how far away it is and how your approach to it can be a type of preloading. For instance, you can come from an area that's rather brightly lit into an area that's dim, or you can come from an area with a predominant color so that as you step into another space you're loaded with the afterimage of that first color. For a moment or so, you actually mix the afterimage of the previous space with the "real" color of the space you're in.

JB: That is a very complicated effect. Are you talking about memory or actual visual phenomena?

JT: The senses have a short-term memory. They don't clear immediately. We generally ignore the effects of afterimage, etc. However, it is possible to make situations where this is virtually impossible.

JB: Are there references for the use of a color or density of light or the particular experience you're creating? Is it something that you've seen elsewhere or experienced before?

JT: A lucid dream or a flight through deep, clear blue skies of winter in northern Arizona – experiences like these I use as source.

JB: You've been a pilot yourself for many years now. How much does your experience of flying come into your work?

JT: Very much. I use the plane to plumb those spaces within the sky. You're actually in those spaces. Some of them are created by cloud conditions or weather, others by virtue of the way light works in the sky.

JB: How do you see that? I mean, is it through a difference in color?

JT: Through the penetration of vision. Moving from twilight into night is a time when visual changes occur rapidly. Experiences of weather are amazing. If you're going through a fog, using Instrument Flight Rules (IFR) into the clear, you take off and enter the clouds, and just before you break out on top, there's a moment in which the clouds take on the color of the sky. Or coming down to land at night, for instance, doing an IFR approach, there are really interesting things that happen just as you are about to make out the ground below. The experience of flying in snow is another thing; it's a dangerous situation but still

very beautiful. Early on I was struck by Antoine de Saint-Exupéry's description of flight spaces in his books *Wind, Sand and Stars* and *Night Flight*. He described spaces in the skies, spaces within space, not necessarily delineated by cloud formations or storms or things like that, but by light qualities, by seeing, and by the nature of the air in certain areas. For me, flying really dealt with these spaces delineated by air conditions, by visual penetration, by sky conditions; some were visual, some were only felt. These are the kinds of spaces I wanted to work with – very large amounts of space, dealing with as few physical materials as I could.

My involvement with flying was very important when I began searching for a particular site for the piece that has become the Roden Crater project. In 1974 and 1975, I flew almost all the area from the western slopes of the Rockies to the Pacific, and from Lake Louise and the Canadian border down into Chihuahua looking for suitable sites. Aside from the time spent in the air, every possible site I saw generated thoughts of a whole series of potential works, first in response to the site itself and then to how the site might suit my original idea. This was an extremely rich period.

Things seen while flying are definitely sources I use for my work. Another example is seeing contrails shadowed on the earth, which make flat planes between the contrails themselves and their shadows 30,000 feet below. One experience in particular was very beautiful. I was on a very early solo just prior to receiving my license, above a scattered broken cloud deck and below a solid overcast. I was actually flying between two cloud decks which made a very narrow band at the horizon, with clouds above me and clouds below me. I could see through the clouds directly below me since it was not a complete overcast. But as I looked further away, I wasn't able to see through it. As I was looking at the horizon some distance away, a jet punched through the lower cloud deck and into the space where I was alone, and in less than thirty seconds punched through the upper overcast, leaving a beautiful contrail as a record of its action.

JB: Do your sources extend also to more everyday experiences such as seeing the light reflected off the side of a building or the way particular colors change during the day?

JT: Yes. Light bouncing off the water, or a shaft of light in the forest coming down through the trees, hitting the ground and splashing up, underlighting the trees – situations where you can literally feel the fluid quality of the light.

JB: The kinds of experiences you've been describing are almost open-ended – transitory and seemingly uncontainable – yet in your work they're formed and controlled.

8 Construction photograph, *Amba* and *Razor*, 1982

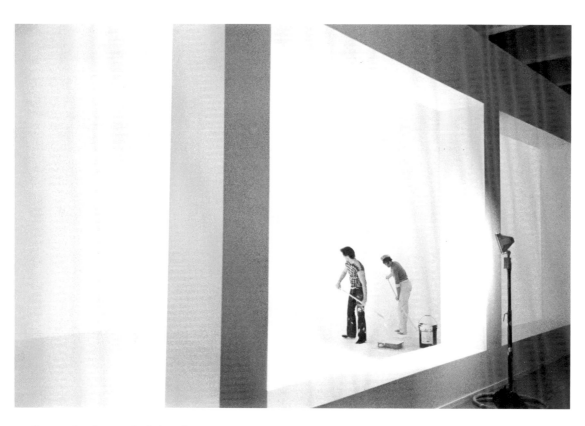

9 Construction photograph, *Amba*, 1982

20

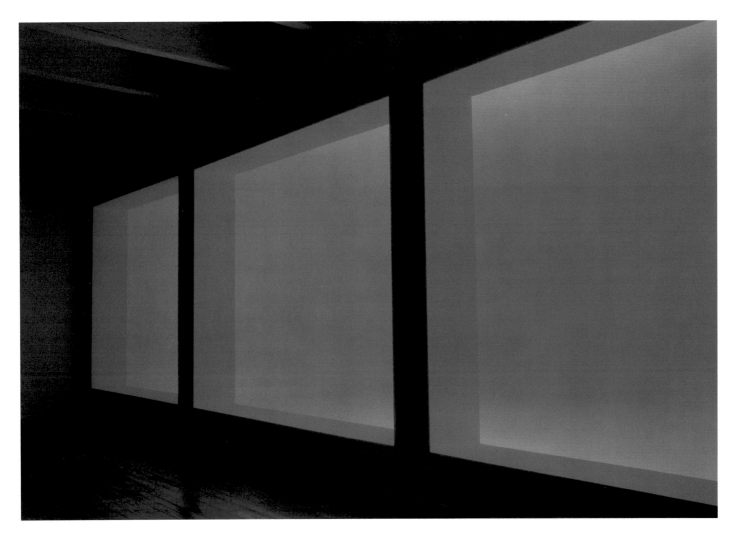

10 *Amba*, 1982

JT: Light is a powerful substance. We have a primal connection to it. But, for something so powerful, situations for its felt presence are fragile. I form it as much as the material allows. I like to work with it so that you feel it physically, so you feel the presence of light inhabiting a space. I like the quality of feeling that is felt not only with the eyes. It's always a little bit suspect to look at something really beautiful like an experience in nature and want to make it into art. My desire is to set up a situation to which I take you and let you see. It becomes your experience. I am doing that at Roden Crater. It's not taking from nature as much as placing you in contact with it.

JB: You sometimes use the word aperture to describe openings in your structures. Does the framing of experience in your work relate to the process of framing an image in photography?

JT: An experience is not framed so much as a situation is made in which experience can be created. I use the word aperture because it describes an opening that has a purposeful relationship of inside to outside. In other words, with some of those spaces I use an aperture so that the space achieves a sense of volume, with light holding volume. People have talked about illusion in my work, but I don't feel it is an illusion because what you see alludes to what in fact it really is – a space where the light is markedly different.

JB: Those are two very different words: allude, illusion

JT: Yes. Illusion is something that you think you see yet is not actually there. The work is static in the sense that the physical situation does not change, but the piece changes by virtue of how it's seen. It has to do with how we interpret reality. But none of the so-called illusions in the work are trompe l'oeil. In all cases, these situations allude to what they are. That is, if there is a space which seems to have surface and volume, that surface demarcates the difference between one volume and another and is in fact true.

What pieces from the Prado Series allude to, for example, is actually there. The light inside the space is sized for the color tone that enters it. This is what I call a *sensing space*. This is a situation where the space opens into another space from which it gets its light. That light passes through the opening and is diffused in volume. Because it takes all its light from another space, the sensing space is in some manner an expression of that space.

This situation is similar to that of a camera which looks out at a space through lenses for light energy. Something may be depicted in a photograph using a telephoto lens, a wide-angle lens, or a normal lens. The light can be put through a very small opening, or aperture, so all the rays of light pass through a fine point. Then everything in the photograph seems to be in focus, and there is a

22

very large depth of field. A narrow depth of field is achieved using a large aperture. The light energy passes through the aperture into the camera body and is focused on the plane where the film is. You choose what film to use. Film that represents tungsten light as white, or sunlight as white, or fluorescent light as white, can be used; the photograph can be made in black and white or color. But after you develop the photo, it is somehow proof of "reality," when – every step of the way – you have chosen how you wanted to see reality. In other words, rather than being an expression of reality, it is an expression of how you chose to form reality. It's the same thing with the sensing spaces in my work. The space I make looks out onto the space from which it gets light. I make the aperture, or opening, in relation to both. That opening dictates whether or not the light energy is diffused throughout the space or is imaged in a part of it. Then I form the space to accept the incoming light. I form it in relation to the color that enters it, as certain volumes will hold certain color tones. When the volume of space is correctly formed to receive the color that enters it, it fogs up. When it isn't, the space seems empty. The color holds the space; just as in painting, certain colors will hold a form and others will not. The color takes on a certain power or presence and appears as if it is inhabiting the space rather than just being on the walls. This space, then, is an expression of the space looked out onto, though the form of that expression, its "reality," is of my choosing.

JB: So, in what way exactly does your involvement with photography relate to issues in your work?

JT: My work with photography has been important first of all because it is a medium that is about light. One thing to remember about Western art is that it's an extremely rich tradition, which includes work that at times has a great deal to do with light. But the work I do is with light itself and perception. It is not about those issues; it deals with them directly in a nonvicarious manner so that it is about your seeing, about your perceiving. It is about light being present in a situation where you are, rather than a record of light or an experience of seeing from another situation. Because it is a record of light and a conscious forming of a particular reality that comes from a space, photography has allowed me to understand light. At the same time, it also helps me to understand sensing because it is a medium that has so much to do with light-sensitive materials and is a way of looking at a situation or space and consciously forming it.

JB: Which comes first in your work: the determination of color or the determination of space?

JT: I work both ends of it. There have been certain color phenomena that I've wanted to work with, and I have changed the space accordingly. It is also possi-

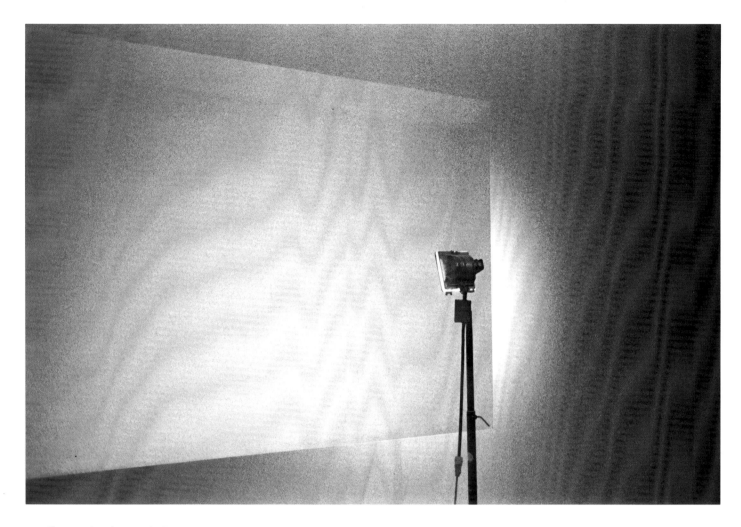

11 Construction photograph, *House of Wax*, 1982

ble to size the space closely enough so that final adjustments can be made with the color and the light.

JB: How do you decide the nature and extent of color in a work?

JT: That has to do with a particular space and what I intend to do with it. In *Jida*, from the Prado Series, installed at the University of Delaware, I created an atmosphere where I got the color to literally roll out of the bottom of the space like a mist. That was a work in which I used the existing building as much as possible and then worked with the lights in relationship to it. The results were accomplished by controlling the light outside of the space.

If the color is in the paint on the wall, then in making a structure and allowing light to enter it, the color will tend to ride on the walls. But if the color of the wall is white, which in one way is a noncolor, then the color is allowed to enter the space riding on the light, and that color has the possibility of inhabiting the space and holding that volume rather than being on the wall. This is true in pieces like *Laar* and *Avar* from the Prado Series. There are specific volumes for particular colors, which is no more unusual than painters finding that certain colors will hold certain shapes and not others. In this manner and in other ways in which the space is worked, what I rely on is really more like a painter's eye in three dimensions than a sculptor's.

My work records a vision rather than serving as a record of a vision of something else. Claude Monet, in the *Water Lily* series (particularly when viewed in a situation similar to that in which they were painted), works with your whole field of vision in a way that has to do with your seeing the painting rather than a visual record of something else. The work responds to your seeing of it. This is also true of the work of Georges Seurat. The paintings of Barnett Newman occupy a large portion of the visual field and flood it with intense color, to an extent beyond which you are actually seeing color – to the point that the paintings become environmental work. Careful sizing of these paintings for the space where they're seen is very important.

JB: Is it important to you to control the approach to your work, the way in which someone comes to experience it?

JT: My work is about space and the light that inhabits it. It is about how you confront that space and plumb it. It is about your seeing. How you come to it is important. The qualities of the space must be seen, and the architecture of the form must not be dominant. I am really interested in the qualities of one space sensing another. It is like looking at someone looking. Objectivity is gained by being once removed. As you plumb a space with vision, it is possible to "see yourself see." This seeing, this plumbing, imbues space with consciousness. By

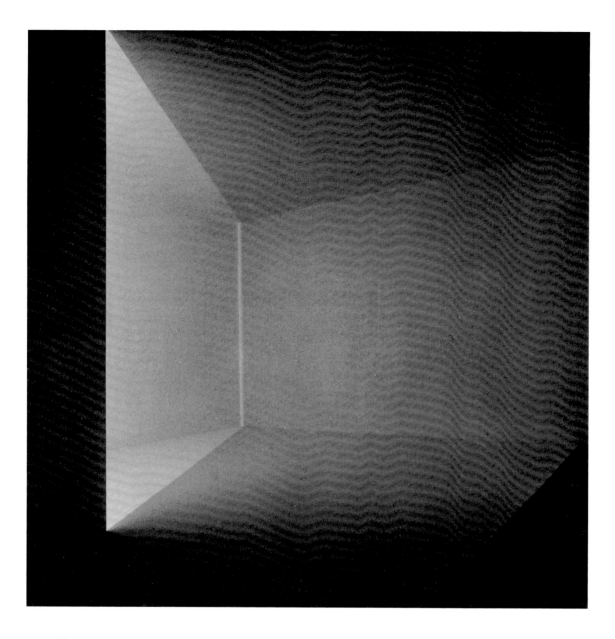

12 *Mikva*, 1982

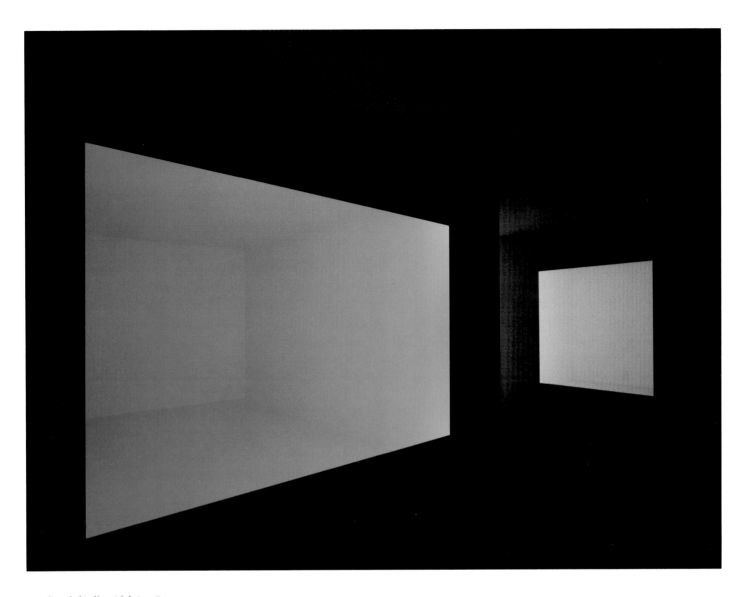

13 *Orca* (left), *Kono* (right), 1984

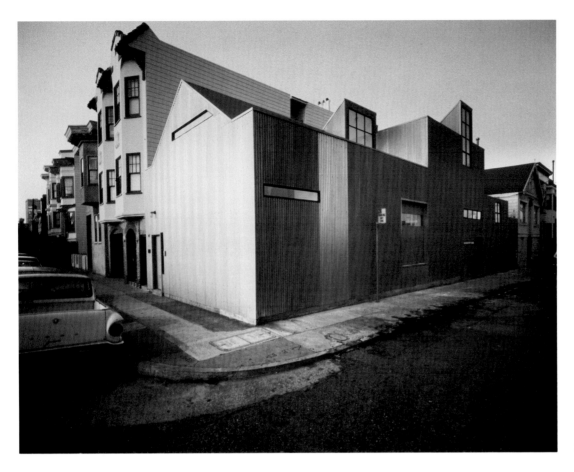

14 *Wolf* (day), 1984

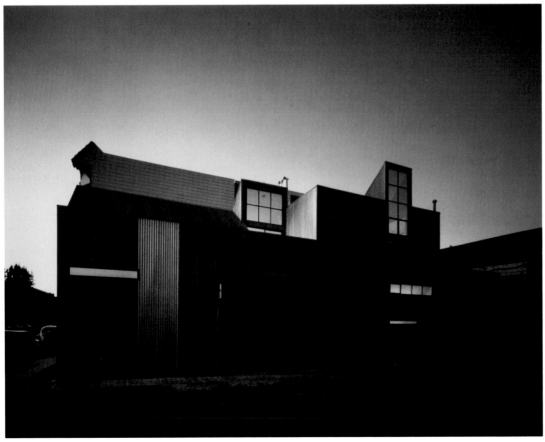

15 *Wolf* (dusk), 1984

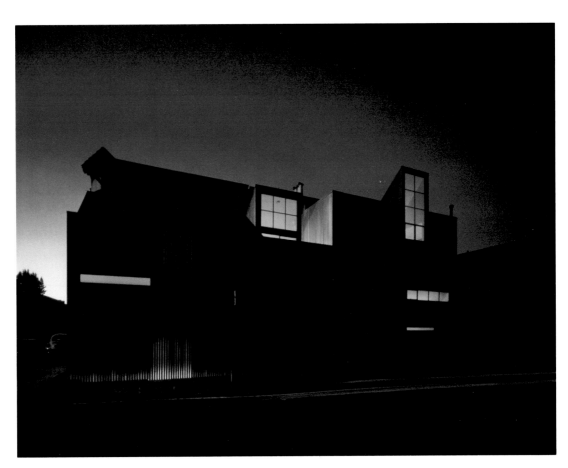

16 *Wolf* (twilight), 1984

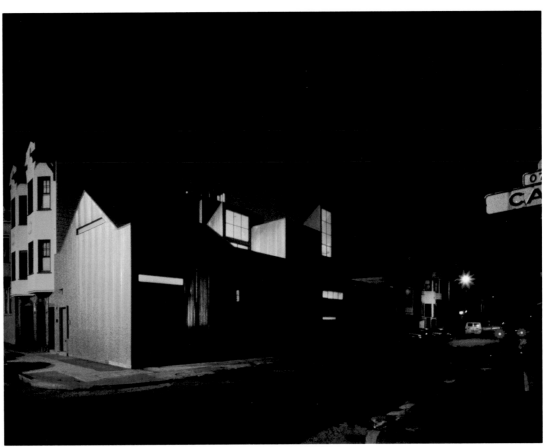

17 *Wolf* (night), 1984

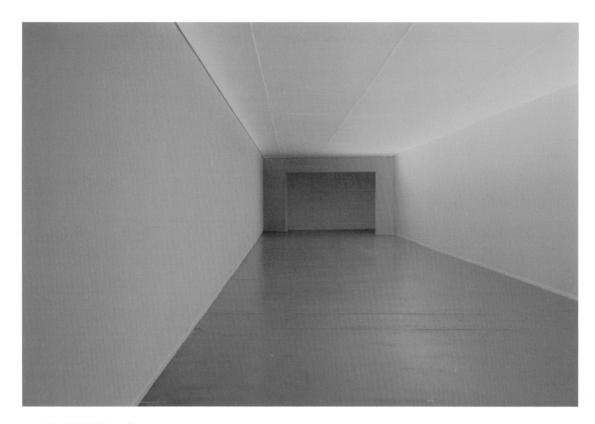

18 *Blue Walk* (night), 1983

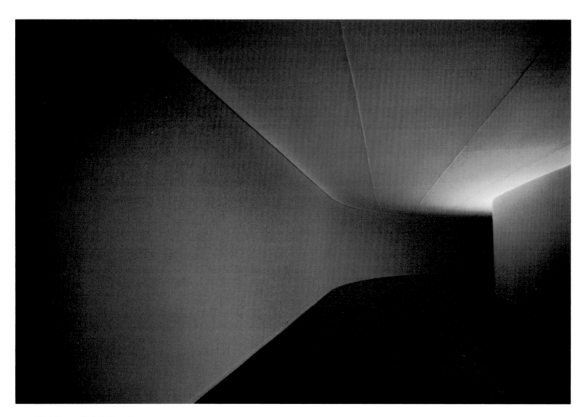

19 *Red Around* (night), 1983

how you decide to see it and where you are in relation to it, you create its reality. The piece can change as you move to it or within it. It can also change as the light source that enters it changes.

What will happen at Roden Crater is a good example of that. It is a volcanic crater located in an area of exposed geology, the Painted Desert, an area where you feel geologic time. You have a strong feeling of standing on the surface of the planet. Within that setting, I am making spaces that will engage celestial events. Several spaces will be sensitive to starlight and will be literally empowered by the light of stars millions of light years away. The gathered starlight will inhabit that space, and you will be able to feel the physical presence of that light.

JB: Your work creates a wide range of experience from the physical situation you make or use. Could you talk further about the different places and the different ways in which you work?

JT: Within existing architecture, I create spaces that you look into and spaces that you enter and in which you become enveloped. Other spaces I create are similar to the work in the collection of Count Panza in Italy or to what I am working on at P.S. 1 in New York, where I actually make alterations, cuts, or some sort of strong gesture to an architectural space, breaking through to the outside, perhaps removing the roof or the side of the building. Then there is my work at the Roden Crater, and there are commissions or proposals for public projects that are site-specific, not built within an existing architectural space but designed as independent structures.

At the crater, I am working in a situation that's outside the rectilinear format. In order to establish a neutral format within architecture, it has to be rectilinear; otherwise, it becomes form, not space. At the crater, I want to work with a more natural vision which is absolutely curvilinear. The work will have a horizon and will use the sky overhead. I am taking a natural form and making something that is still neutral because it doesn't in any way work counter to what is there. One of the reasons I chose the shape of the crater is that I wanted to affect the perception of large amounts of space and do it by moving as little material as possible. This, in the end, turns out to be a rather large amount of material, but for the amount of space affected, there is great economy.

JB: Yet, you are still working with the experience of interior.

JT: Yes. The works I will make there are still interiors even though they are mostly open. They create a sense of closure, so you feel as if you're in something, even though it's completely open. That actually allows me to work the skin or the end of the volume which is curved, not flat.

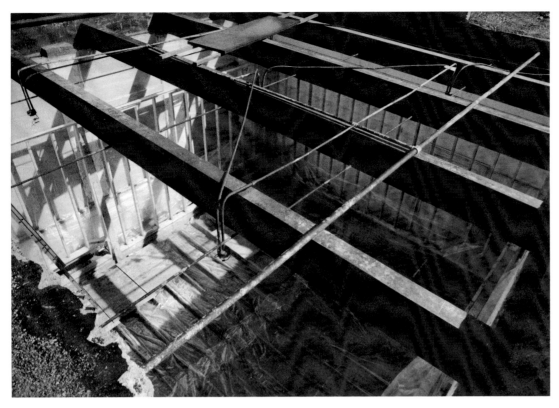

20 Construction photograph, *Meeting*, 1980

21 Construction photograph, *Meeting*, 1980

32

22 Construction photograph, *Meeting*, 1980

23 Construction photograph, *Meeting*, 1980

JB: I'm not sure I understand what you mean by the "end of the volume."

JT: There were several pieces in my exhibition at the Whitney Museum where you felt as though there was a tangible surface across an opening, or a demarcation of volume. But those skins or surfaces were generally seen as flat across the opening. In one work in Seattle, *House of Wax*, I achieved a bowing of the surface. At the crater, working from curvilinear shapes and volumes, I can make this bowing up and toward you, or I can make it go away from you. That's the skin, sense of surface, or "glassing up," that I want to work with. I wanted a curving shape that would work with the sky. I am really using the crater as the format. There will be spaces there but, in general, a lot of the spaces are just the natural forms – changed to make happen what I want to have happen. They will not look different from natural forms when they're done. But in projects like the design for the winery in California, there is more involvement with determining architectural spaces.

JB: This winery, the *Domaine Clos Pegase*, was different from most of your other work. Had you worked on the design of an independent structure before?

JT: I changed or made quite a few building designs in the work I did for Count Panza at his villa in Varese, the proposals I made for Rivoli Castle, for a proposed museum at Rollensel near Bonn, as well as a church I designed for him. The winery in northern California was a collaboration with architect Robert Mangurian done in 1984. Robert designed the actual structures, and I designed situations within them, such as an interior courtyard that would work with the sky. The winery design was a good integration of art and architecture. There were places where the structure that was the building was also the structure that was the work, and then there were situations where I designed a work to be within the building structure. It was really interesting because we planned some places of continuity and others, such as a flight of stairs that was actually a waterfall, where the passage was only visual. It was a good project.

JB: When did you begin your work with architectural projects?

JT: The first architectural work began in 1974 because of the need to have spaces that could achieve what I wanted. Generally, I worked within existing architecture and changed it to suit my needs. But there were times when doing this would not give me the opportunities I wanted, and I began to make projects which were themselves buildings, which had their own structure. The first of these projects began as an offshoot of the work for Count Panza – the Villa Scheibler in northern Milan. I designed an exterior space very much like the kind of work I am doing at Roden Crater, with a hemispherical bowl shape

COMPARISON OF OPEN AREAS

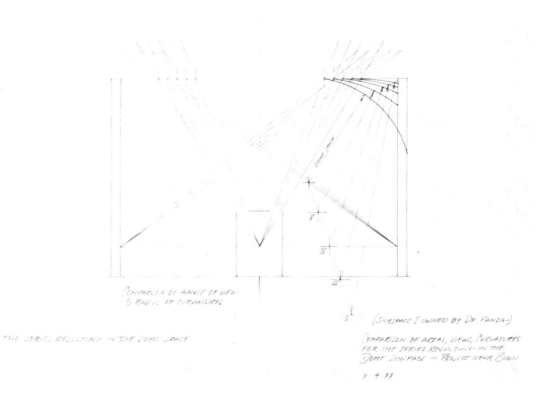

COMPARISON OF ANGLE OF VIEW
& RADIUS OF CURVATURES

THE SERIES RESULTING IN THE DOME SPACE

(SKYSPACE I OWNED BY DR. PANZA-)

COMPARISON OF AREAS, VIEWS, CURVATURES
FOR THE SERIES RESULTING IN THE
DOME SKYSPACE — PROJECT NEHR BONN

11-4-77

24 Drawing for Skyspace Series, 1977

which would actually shape the sky and which you enter from underneath. This was the beginning of the projects that actually made the structure, working the light into it from the beginning, rather than playing the light off existing structures. The next was at Cascina Taverna, and then I drew several proposals for the project in Bonn.

The first series of spaces in the Bonn proposal involved the volume of the sky coming down to the top of the area in which you were. These spaces are much like the Greek hypaethral spaces, although light in the interior of these spaces worked the color of the sky such that its color was changed by virtue of the coloration of the light on the interior. The density you perceived to be in the sky and its color are worked and changed. This leads up to a space, the outside of which is similar to the crater designed for Villa Scheibler. The space you finally enter then works with curvilinear formations of the sky. Most of the sky spaces are vertical and rectilinear. There is one final sky wall in this proposal, which has pyramidal steps leading up to it and reversed, fifteen degree edges, as in the work in the Prado Series. There is an open wall completely above the horizon. As you step into this space you see a pyramidal form of stairs leading up to total blue because the bottom of the opening is well above eye level. This then leads out to a space that works with the phenomenon of celestial vaulting and the shaping of the sky, by virtue of the way near space is formed to effect that sense of shaping. These are rather tight spaces, usually about sixty to seventy-five meters in diameter. The shaping for the earth form is from fifteen degrees above the horizon down to level ground. That is the part which affects the sky. The coloration is affected by the way white is used, particularly at the entries. Entries are always from below and, as you enter, offer no view of the opposite side of the crater form.

The largest of the pieces which work with the shaping of the sky was proposed for the University of California, San Diego, in La Jolla. This was designed to be an amphitheatre but made within a large hemispherical volume, of which only a portion would be used for the amphitheatre. The structure of the amphitheatre was conceived so that the form works the shape of the sky. The entries are tunnels much like those that come into a coliseum, except they come up from below so that as you enter them you see only sky, until you take the last two steps before stepping into the space itself. At the bottom, the stage area is grass, with a checkering of marble. The stage is actually a platform somewhat similar to the Mayan dance platforms, except that there is a wedge on the middle of each of the four sides of steps, and the steps end about six feet from the platform and continue visually in a very thin line of stainless diamond plate. The doors for access underneath the stage are behind the steps. The stage itself lowers in the center and is held up by four large hydraulic pistons, much like the pistons that raised cars in the old service stations. They have a beautiful polished quality. When the stage is up and you are underneath, there's an area

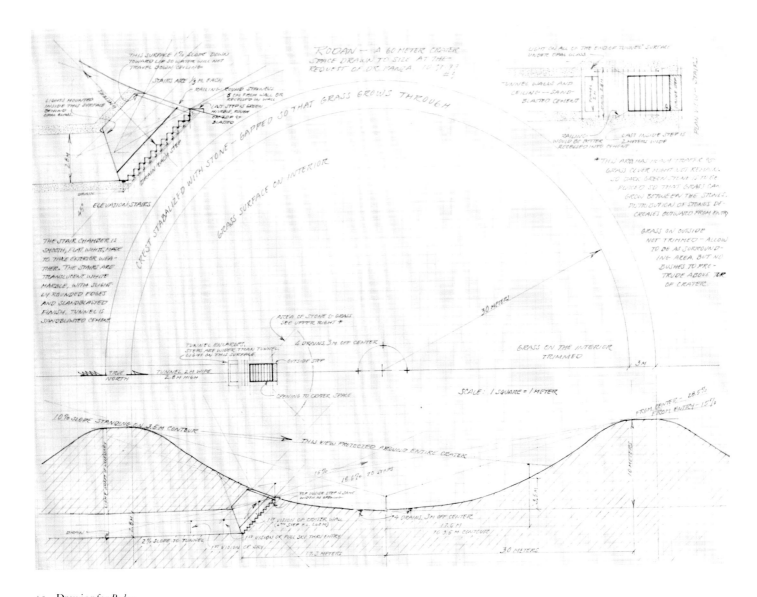

25 Drawing for *Rodan*

for dressing rooms and stage preparation. The whole stage drops and goes out of sight. From underneath, you can completely change a set and then raise the stage back up in its new form. When the performance is over, you can walk completely through this space which is also a sky space. When you are in it, the sensation of sky is absolutely flat; when you step outside, it is completely domed. This is accomplished by virtue of the manner in which the celestial vaulting is worked in the crater space formed by the seating of the amphitheatre.

I also designed a church for Count Panza which had four arms in a cruciform shape. Each of those is hollow and has a sky space where the sky is worked flat. The center is a traditional dome, except it continues in a sphere, with seating suspended out into it. The space works in a very large *Ganzfeld*, using northern light.

JB: What other kinds of spaces have you worked with?

JT: Among works that involve other functions and activities, I have planned pieces that are also swimming pools, which have unusual entries. There is a sky space above the pool to work the light of the sky, and the shaping of the sky space is exactly the same dimensions as the pool. Light is worked into the pool around the gutter or edge. The gutter edge is made so that the water takes the same level as the surrounding stone walk; it is very carefully leveled so the water flows over the edge into a very narrow slot. This edge is lit and the bottom of the pool is absolutely black at night. The light will have a very thin, sheer quality across the top. During the day, light fills the whole volume of the water in the pool. The entry into these spaces is made from the outside, from a smaller pool which can be in another structure. From this pool, you bend over and kick under water through a tunnel, usually about eight feet or so, and enter the larger pool and the sky space from underneath.

JB: Does function in design interest you as a problem?

JT: The sites I like to use are ones that, in general, have no function, spaces that are really only inhabited by consciousness. This inhabiting of space by consciousness is the entry of self into space through the penetration of vision, which is not limited to just that received by the eyes but also has to do with the entry of self into that which is "seen." A lot of spaces are interesting to me when they're generated not by the architecture of form but by the overlay of thought. I'm also interested in public places that are devoid of their function – Mayan and Egyptian ruins, for example, and places such as Mesa Verde. These civilizations adapted natural amphitheatres by building within them to create civic spaces. The fact that they are places of ceremony and ritual and are themselves

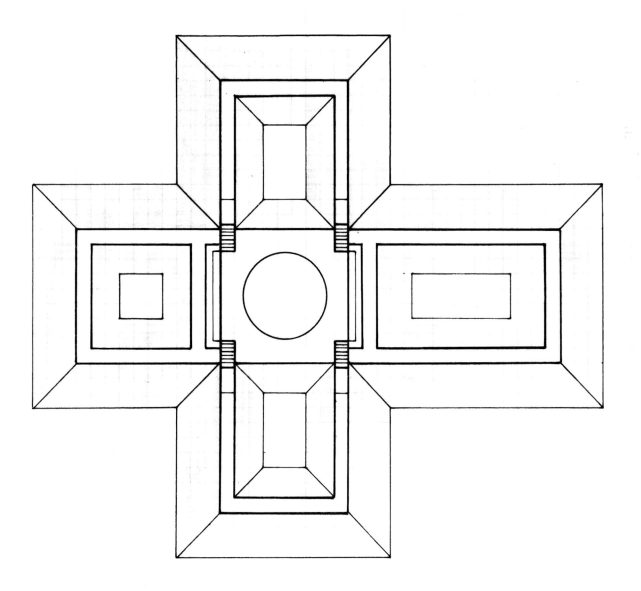

26 Planview drawing for Church, 1977 27 Elevation drawing, 1977

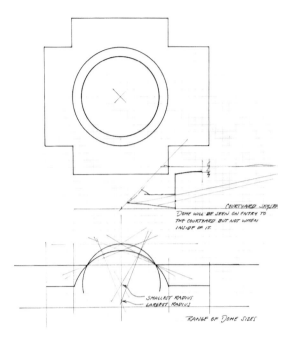

28 Detail drawing of dome, 1977

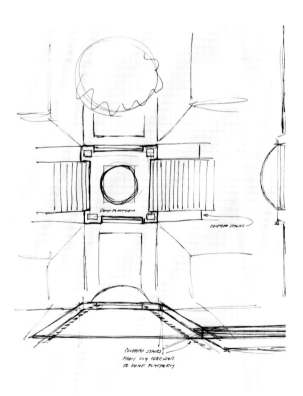

29 Drawing of courtyard space, 1977

physically powerful makes them meaningful. The impact of the space of the Gothic cathedral, for example, and the light within it is much more interesting to me than the rhetoric that is spoken there.

JB: Can you talk more about what you mean by spaces generated by thought?

JT: Daydream spaces, such as those generated by reading a good book, are often more commanding than physical space. While you read, you don't even notice people who walk through the room because you are actually in the space that's generated by the author. This is also true with sound, particularly since the advent of high fidelity and stereophonic sound – the spaces generated by music can be much larger than the one in which you are physically, whether you're in a small room or outside in an open space. This sort of overlay and creation of space that's generated by consciousness is very interesting to me. Another example is when you are driving down a freeway and you find that even though you have been driving reasonably well, you may have missed an exit or in some way feel you haven't really been driving. You've actually been somewhere else, whether it's in deep thought or in the sort of daydream that we often inhabit. This is, I think, the space that we inhabit most of the time, much more than this conscious awake space that is called reality. It's this daydream space overlaid on the conscious awake reality that I like to work with. I'm interested in doing works that seem to come from those places. When you confront a work, you can have knowledge of it already. That is, even though you haven't seen light looking like this or space that is inhabited with light in this manner, it seems to be familiar and comes from a place that you know about.

I'm interested in having a work confront you where you wouldn't ordinarily see it. When you have an experience like that in otherwise normal surroundings, it takes on the lucidity of a dream. The realm of the experience exists between the learned limits of our cultural perception and our physical limits. Because the work exists between those two limits, it has something to do with how we form reality. Though the work is a product of my seeing, it works directly with how you see, as well.

JB: Isn't it similar to an experience you might have in nature that is a perfect expression of what you're thinking or feeling, or where a space is understood in such a way that exactly fills and expresses an emotion?

JT: I would certainly like to think that.

JB: Your work has the quality of surrounding the viewer – both emotionally and physically . . .

JT: There are basically two kinds of spaces: one that you look into or enter only with consciousness, and the other that you enter physically. In the one that you enter physically, it's possible to have light come right up to your eyes, almost as if you were underwater. In the space you enter with consciousness, the plumbing of the space is done visually with only the penetration of vision. The vision and structuring of space is done without form so that the light and blushes of light around you limit the penetration of vision. In the pieces that use this particular principle or technique, there is often light at the side and in front of you. As you approach the work, the light begins to recede to the periphery, and your vision penetrates through an area or through an opening. This is much like what happens when you turn on the light on a porch. You can see things on the porch quite well at night with the light on, but if you turn the light off, you see further into the night. It's also no different from the situation of the light generated at night by cities which makes it impossible to see stars because of the illumination of the near atmosphere. The same thing can be done in a situation like the crater where you are completely out in the open. If you're standing on black sand in a moonless starry night, you will probably comprehend the deepest amount of visual space you can take in. But if you then walk to an area of white sand, starlight coming off the white sand will dramatically limit the amount of stars you see and thereby bring the space closer.

In the pieces you walk into, I like to have a feeling of the light inhabiting the whole volume, much like light does when you put it in water. If you're in the water, it will come right up to your eyes. The light has a quality of tangible presence.

JB: How did you first come to use light?

JT: My first attempts to use light as space were in 1965 and 1966, using gas to create flat flames. I used hydrazene and different mildly explosive gases in a large-diameter burner with a very small honeycomb interior. The flow of gas that was achieved was quite laminar, and the speeds were the same in the center as out toward the edges. The friction was similar across the entire flow of gas, so I was able to achieve very flat flames. These were the first pieces that I made with light, and actually they were quite beautiful. But I had trouble controlling them. There was much too great attention on the hardware, although the flames were tremendously beautiful and exciting. I had a number of explosions when first showing these pieces, and they were soon abandoned.

One of the difficulties of using light is that there isn't yet a tradition of using it in our culture. On the one hand, it is no more unusual to use it than to use stone, clay, steel, or paint. There are materials that you honor, and to that degree I was interested in using light as material – not light in glass, scrim, or Plexiglas, but light in the space itself and the qualities of space – making that light without

traditional physical form. There is a rich tradition in painting of work about light, but it is not light – it is the record of seeing. My material is light, and it is responsive to your seeing – it is nonvicarious. Light isn't something that you form with your hands like clay; you work with everything but what you are going to see. It's almost subtractive in its nature, although the use of color is additive. The more light and color you add, the whiter things get; as opposed to mixing colors of paint, which is reflected light or subtractive color.

By making something out of light with light filling space, I am concerned with issues of how we perceive. It's not only a reaction to things physical. For me, working with light in large spaces was more a desire to work in greater realms, a desire that art not be limited to the European structure of works on canvas. This is not too different, perhaps, than the need of composers to expand the possibilities for music, which led to the development of the symphony. Although the symphony required a great deal from society and rather large patronage, it is a form that we've allowed to grow and one that's very good. Before the rise of the symphony, music was limited to what could be made with small instruments. The haiku poem has as much power as a symphony. I think that art should not be limited but be allowed its full range and possibility in material, form, and scale.

In working with light, what is really important to me is to create an experience of wordless thought, to make the quality and sensation of light itself something really quite tactile. It has a quality seemingly intangible, yet it is physically felt. Often people reach out to try to touch it. My works are about light in the sense that light is present and there; the work is made of light. It's not about light or a record of it, but it is light. Light is not so much something that reveals, as it is itself the revelation.

JB: How has your use of light changed over the last twenty years?

JT: The early pieces had a much greater reliance on the source of light and a lot to do with the hardware of forming the light. They were much more involved, particularly in the projector series, with the hard, crisp forming of an image. Even some of the early works, such as the projector series, had shapes and forms that were unbuildable yet existed in three-dimensional space. You could not realize them by a form that existed in the real world. Later pieces had less to do with hardware, often just using simple sixty or seventy-five watt clear frosted light bulbs, and were more involved with the subtle knowing of where light went, particularly off of one or two surfaces. These pieces also had much more to do with ambient lighting and light inhabiting a full space.

The most recent works have dealt quite a bit with the difference between rod and cone vision. In these you enter a very dark space in which there is absolutely no vision. In a period of three to four minutes, you can recognize some

form. Upon staring at it, this form will seem to disappear because its size is very near to that of the area of color vision. Occasionally, colors will rain outside of this form, as this kind of seeing comes and goes. This particularly happens if you don't look straight at it. The first of these pieces, *Pleiades*, was made at the Mattress Factory in Pittsburgh. The longer you stay in these pieces, the more the difference between having your eyes open and having your eyes closed is diminished. You see similar things whether your eyes are open or shut. After a while, the seeing that takes place in the space affects the color sensation you have when you first close your eyes. These pieces have their source in the kind of color vision you have when you first close your eyes and see a kaleidoscope of colors for a moment or so. In a very pure space, it's hard to cleanse your eyes of these sensations.

JB: In the beginning, when you were making your first pieces, how did you come to make your art the space rather than something put inside a space or on a wall?

JT: Artists are often accused of spending more time working on their studios than on the art that leaves them. To some degree that was true of me in the sense that in the end I actually made the whole studio a piece, and the pieces became studio size. That's the work that finally did go out. It took a little while because I started with pieces that worked with more discrete portions of spaces before I worked with the entire space. I actually wanted to work with space plastically, and I approached this with a painter's eye in three dimensions.

Often you will find artists who are involved with what I call the "cargo cult," that is, they tend to collect tools and have great love for tools, often more love for the tool than for the job the tool does or the work that it makes. That's a bit true with me, too, in the sense that I'm finally working on something with the Roden Crater project which begins to use all the tools that I have collected. I feel that the tool should be honored as well, for what it does. I am as interested in honoring the airplane as an instrument of flight, for example, as I am the flight itself.

JB: Could you describe what you will be doing for the exhibition at The Museum of Contemporary Art?

JT: At MOCA's Temporary Contemporary building, the realm of the work will range from extremely bright sunlight, working with light outside, to something barely visible, working with the light inside the self. I want it to be like the light that illuminates the mind, as opposed to the light that illuminates the eye. The exhibition will include some of my earlier pieces, some never seen before, and work made specifically for this exhibition. Some of the spaces you will enter

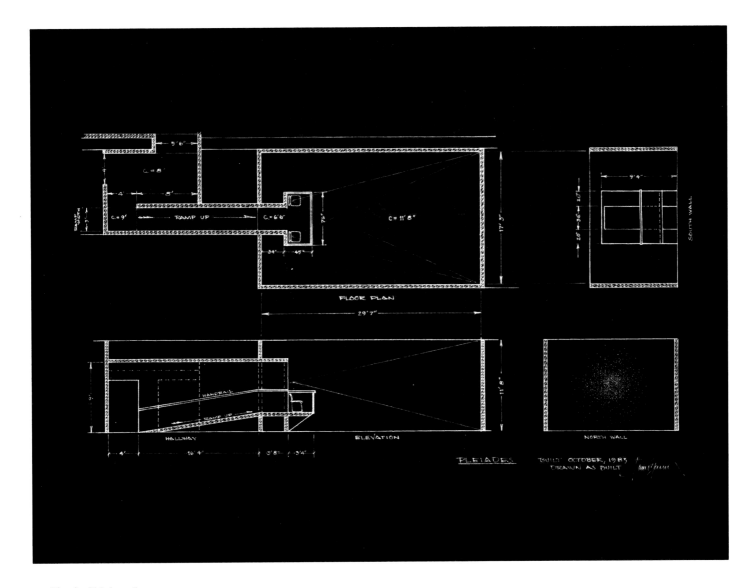

30 Plan for *Pleiades*, 1983

only with vision, and others you will enter completely. The early pieces will work with discrete, small portions of a space, and the later ones are full spaces that you enter. Some begin with opaque darkness and then yield to vision. One piece, as you look along it, is very translucent, and as you move it becomes transparent and begins to vanish.

There will be four projector pieces and five spaces. The projector pieces are from between 1967 and 1969. The spaces are from 1969 to the present. Only a few of these pieces have been shown before. There will also be a whole portion of the exhibition devoted to work on the crater – plans, models, photographs, and documentation.

JB: How closely do you rely on science or technical information from other disciplines in your work?

JT: The work I do does not have to do with science or demonstrations of scientific principles. My work has to do with perception – how we see and how we perceive. Though I use the information and need the help of people in the sciences to calculate positions of celestial events and to solve problems of refraction caused by changes in atmospheric pressure and temperature, for example, my work does not push the boundaries of science. I think artists have a lot more to do with investigating the limits of perception than science does at this time. The basic difference, though, is one of intent. I am more interested in posing questions than in answering them. I also think artists are more practical than scientists in that when they find something that works and is useful, they're quite willing to use it without necessarily knowing why or how it works.

I have an interest in the invisible light, the light perceptible only in the mind. A light which seems to be undimmed by the entering of the senses. I want to address the light that we see in dreams and make spaces that seem to come from those dreams and which are familiar to those who inhabit those places. Light has a regular power for me. What takes place in viewing a space is wordless thought. It's not as though it's unthinking and without intelligence; it's that it has a different return than words.

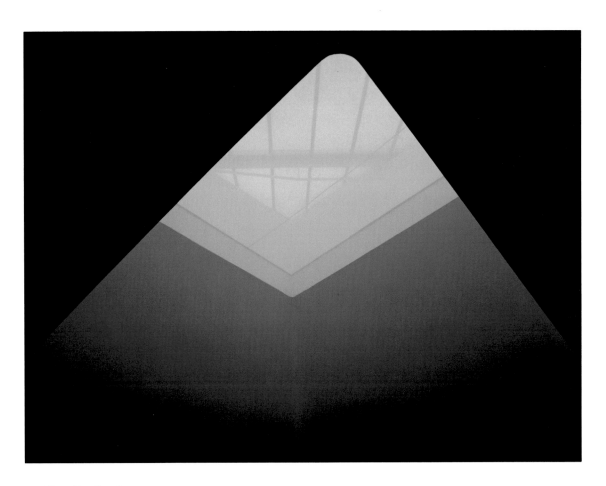

31 *Hover* (detail), 1983

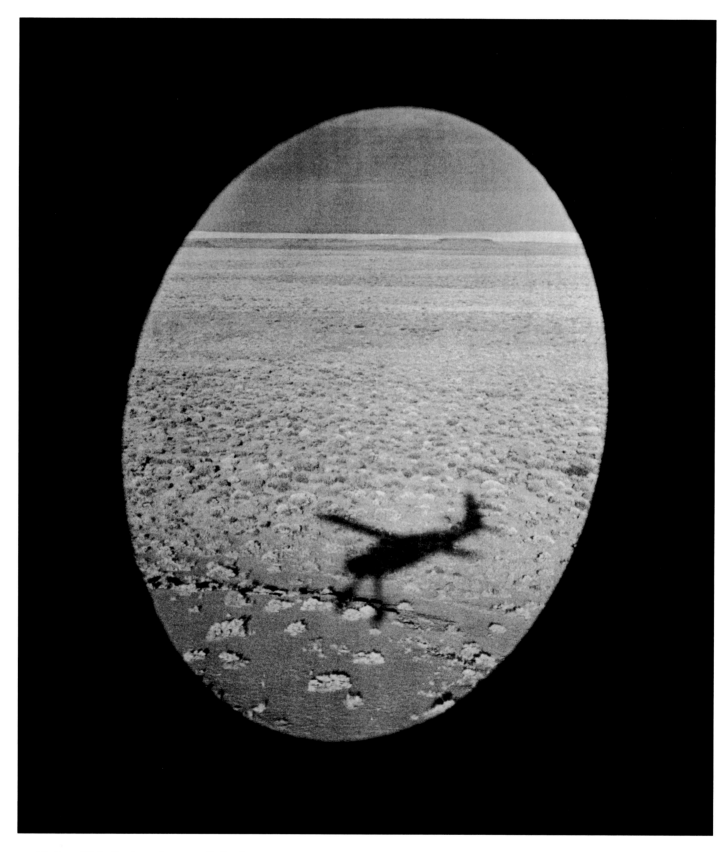

32 Shadow of Helio Courier on desert near Roden Crater, 1977

48

james turrell

Lucebert

the artist made seamless spaces
in the museum of amsterdam
spaces turned away from all shadows
and the commotion of all bodies
i knew that here a smith of the light was born
the servant of my eyes because i saw
as for the first time myself and i saw,
in the stillness of a waterfall in the distance,
myself made to carry the light
back to the sun as a river

this light-smith came from far away
and i never met him

still in my mind i was flying along
with my friends who were persuaded by jim
to accompany him in his small airplane
above the mortal wounds of an old country
over the irritated flesh and the greedy tumors
of new settlements there in the american west

and with them i saw the sun sink and all hope
of even more gold and blood vanished gloriously
i saw that the moon was growing again
and thought: she feels like it again
with that adult child down there
chosen to give a face to nebulae

then we dove into the mouth of jim's volcano
because that is his house
while the stars leapt up simultaneously in the cockpit
i dreamt for a moment that i was half nothing and half cat
that just like the universe
needs no more than to play with its own tail

Translation by Peter Nijmeijer

james turrell

de kunstenaar maakte naadloze ruimten
in het museum van amsterdam
ruimten afgewend van alle schaduw
en van het misbaar van alle lichaam
ik wist hier werd een smid van het licht
de dienaar van mijn ogen want ik zag
als voor het eerst mijzelf en ik zag
in de stilte van een waterval in de verte
mijzelf gemaakt om het licht als rivier
terug te dragen naar de zon

deze lichtsmid hij kwam van ver
en ik heb hem nooit ontmoet

toch ben ik in gedachte meegevlogen
met mijn vrienden die door jim
in zijn klein vliegtuig werden meegetroond
boven de doodwonden van een oud land
en over het nijdvlees en het zuchtgezwel
van nieuwe wingewesten daar in het amerikaanse westen

en ik zag met hen de zon zinken en alle hoop
op nog meer goud en bloed glorieus vervliegen
zag dat de maan weer groeide
en dacht: zij heeft er weer zin in
met daar beneden dat volwassen kind
uitverkoren om aan nevels een gelaat te geven

toen wij daalden in de krater van jim's vulkaan
want dat is zijn huis
terwijl de sterren allen tegelijk opsprongen in de cockpit
droomde ik even dat ik was half niets half poes
die net als het universum
genoeg heeft ann het spelen met de eigen staart

EDITOR'S NOTE: This poem first appeared in 1979
in *Voor Vridenden Dierne en Gedichten*.

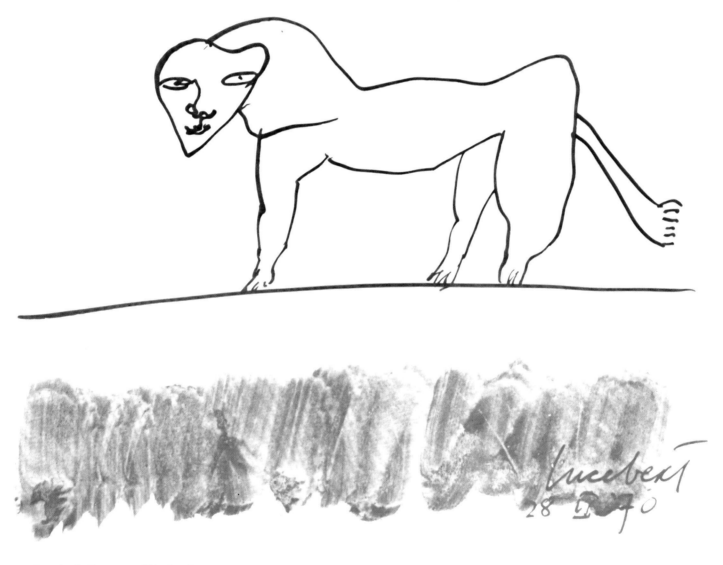

33 Drawing for "james turrell" by Lucebert, 1970

34 Low over water at dusk, 1976

Light Spaces

Edy de Wilde

In 1967 I visited Ed Kienholz in Los Angeles to discuss plans for his exhibition in the Stedelijk Museum (1969). It was my first time in California.

During my visits to artists' studios in Venice, where many artists from Los Angeles have settled, I was struck by the fact that light plays such an important part in the art of California. Some artists, like Irwin and Wheeler, made direct use of it; others were indirectly involved with light, such as Bell, Valentine, and Cooper. The idea arose to mount an exhibition of the artists most explicitly concerned with light. My studio visits became more selective, and so I ended up meeting Jim Turrell.

I can remember my first meeting with him very clearly. His studio was impeccably white: walls, ceiling, even the floor. The closed space was lit by a radiant matt-glass cube in one of the corners. Closer inspection revealed that the cube was in fact a projection of intense white light. It was a sort of minimal sculpture to the extent that the simple three-dimensional cube defined the space, but this was contradicted by the fact that the cube was an illusion, a two-dimensional projection. It created an equivocal situation.

Towards the end of my stay, I invited three artists for an exhibition in the Stedelijk Museum: Irwin, Wheeler, and Turrell. Turrell withdrew. The Irwin and Wheeler exhibition took place in 1969. A year later I went to see Turrell again. It was evening. Across the walls of his studio passed a progression of colourful abstract forms, frequently interrupted by startling images from reality: a passerby, a palm tree, a traffic light switching from red to yellow to green. The moving forms and images were a direct projection of what was happening in the street. The movement was due to the headlights of passing cars. We sat on the floor at least an hour, without speaking.

Since then I visited Turrell several times, but he did not show me new work. Later I understood that his thoughts were occupied by observations of a different kind, for which controlled representation had not yet materialized. In 1974 he visited me in Amsterdam. It was his first trip to Europe. He was ready for an exhibition, he said, and would like to have it in the Stedelijk Museum. (Until then he had shown only three works – projections in the Pasadena Art Museum. That was in 1967.) We agreed that he should come to Amsterdam in the spring of 1975, to study the light in Holland. This was necessary because he was by

then working with daylight. The exhibition was to be held in the spring of 1976.

California is a young country, full of life and vigour. Technology is a dominant feature of everyday life. Art has been absorbed into the culture patterns even less than in Europe, so it still has a pristine forcefulness. California artists are not burdened by an artistic tradition. Their élan is not dampened by relativizing comparisons with the art of previous centuries. Perhaps that explains their faith in their own discoveries and their preparedness to take the ultimate consequences. As a student Turrell saw very few real art works but plenty of slide projections on a big screen. Viewing Vermeer's *Lacemaker* projected on a scale of six by six feet has nothing to do with the experience of seeing the original painting. So Turrell's relationship with painting was largely platonic; that is, until he saw a painting by Rothko. The light seemed to rise out of the painting. The painting itself was a source of light. The light affects physically like a ray of sunlight streaming between the trees. It became clear to him that light and colour are one.

Turrell started working with light in his own personal way, not in the pictorial tradition of Rothko, but in the technological tradition of California. He concretized the illusion of light in Rothko's painting by working with artificial light.

Seven light-works have been realized in the exhibition. Four of them could be called sculptures, because of their geometric quality: the light projections, one of which is described above, and the spaces which permeate each other by means of geometric planes of light and shade. In one of these rooms, the light stands like a gleaming diagonal wall of white in space. In this case the entire space has become a light sculpture. In two other works, Turrell created a space-illusion – not by means of light forms this time but by means of light and colour exclusively. In front of one of the walls in another room, he built a smaller wall, framed on all sides by blue light shining from behind it. The radiant blue line makes the smaller wall fade into an immeasurably deep space. A similar project using warm-coloured light yields a totally different spatial illusion.

One of the things Turrell does to earn a living is air cartography. Flying has made him aware of the relativity of visual observations. It has taught him that the facts can only be registered by the aircraft instrument panel. He says: "The Cartesian space of three dimensions is (like all mathematical spatial concepts) a model which has evolved from the range of experimental reality as Descartes knew it. But if you are flying a plane, his concept holds true for very short distances only. If you fly from Los Angeles to Amsterdam, you will realize that the curved space of Riemann, in which the triangle can have more than 180 degrees, comes closer to reality. But even in this case you tend to think, wrongly, that the mathematical model covers reality. We superimpose the model on reality, and believe that the model actually is reality. The space we

35 *Wedgework III*, 1969

experience subjectively through our observation is more bizarre. It is a space that comes close to dreams." Turrell doesn't fly in the confined space of a passenger aircraft. He glides, observes, and relates to space. In 1975 I flew with him in his small plane from Arizona to Los Angeles. When we left, the sun was already sinking low on the horizon. Within the short time between sundown and darkness, all the changes in light (i.e., in colour space) take place, because light-colour-space is a triad. Dusk is the most ambiguous time of day. We flew into a sky of red-orange-yellow-rose-violet. In the undefined space beneath us, we saw mountains, forests, rivers, in every variegation of warm hues. Then Turrell swung round 180 degrees. Suddenly we were heading towards a white, gleaming full moon fixed in a deep blue sky. We were confronted with a totally different reality of the same mountains, forests, and rivers, covering the full range of cool shades this time. I was reminded of Cézanne: "The colours of things rise up from the roots of the earth." "If you go high enough," says Turrell, "you can see the light reflected in the moon change. The colour changes as the light glides by. You can know things without touching them, without handling them, without even being there. You can feel things with your eyes. Observation is much closer to thoughts than words." The memory of Cézanne persists. He too wanted to know and comprehend things through observation alone. The limits of Turrell's observation are closer to those of astronauts than to those of his pictorial predecessors. The object of his observations is the space of the sky. That implies a scale-expansion of the same order as that which took place in painting when the *plein air* painters took their easels out of the confines of the studio and planted them in the landscape.

For the Amsterdam exhibition, Turrell realized his space-observations in four rooms, which together make a single piece. There is no form to be seen in any of the four rooms. The light, daylight, is distributed in equal intensity over the three walls, the ceiling, and the floor. The spatial effect is created by light and colour alone. We find ourselves in a succession of blue-green, deep red, purple, and violet spaces. Every possibility of defining our position has been eliminated. We find ourselves in immeasurable space. Whenever a cloud passes before the sun, the space appears to shrink; and as soon as the sun is shining again, the space expands.

In this four-part piece, Turrell has analysed his observations of space in that time between sundown and darkness.

Turrell's observations have led steadily and quite logically to his sun and moon project. He wanted the shifting scale of light and colour, constantly changing throughout the day and night, to build its own space. So he started looking for a site to which the sun and moon would have direct access. Eventually he found a volcanic mountain in the Painted Desert in Arizona. He plans to build the space – in which he will determine the penetration of sun and moon – inside the crater. He has meanwhile left Los Angeles.

36 Flying east at dusk, 1976

EDITOR'S NOTE: This essay first appeared in 1976 as "Jim Turrell's Light Spaces," published in conjunction with an exhibition of the artist's work, *Light Projections and Light Spaces*, at the Stedelijk Museum, Amsterdam. It is reprinted here with the kind permission of Edy de Wilde.

37 *Ronin*, 1969

38 *Hallwedge*, 1976

39 Dr. and Mrs. Giuseppe Panza di Biumo with Helen Winkler, 1974

Artist of the Sky

Count Giuseppe Panza di Biumo

My interest in art made in Los Angeles started after 1966. In this year I bought several works by Dan Flavin made with fluorescent lamps, and I had information about similar work under way in Los Angeles. Light was the material for making art. I began to investigate this field and to look at other artists using the same medium. I saw a show at The Pace Gallery in New York which had a disc by Robert Irwin. At the Sonnabend Gallery in Paris, I saw glass cubes by Larry Bell. In 1968 I began to collect the works of these two artists. The same year, a room was devoted to Irwin at the Kassel Documenta. In 1970 I saw an exhibition by Irwin and Doug Wheeler at the Stedelijk Museum in Amsterdam which impressed me very much.

In the early years of the 1970s, I was buying minimal and conceptual art in New York. At the same time, I felt the need to have more information about what was happening in Los Angeles with artists using light, space, and perception. In New York it was impossible to see their works. For this reason my wife and I decided to go to Los Angeles, where we hadn't been since we started collecting art. There, Robert Irwin told me about the Art and Technology program organized by Maurice Tuchman for the Los Angeles County Museum of Art. I was always interested in the relationship between art, the sciences, and philosophy.

It is a basic fact that art can get closer to final knowledge; science and philosophy are necessary, but only as preliminary steps to reach this goal. Collecting conceptual art work, which was able for the first time to give a visual image to the most abstract concepts, was a very useful step in expanding my capacity to understand this new field. In studying the work of Marcel Duchamp, I realized how important thinking is and how powerful art becomes if the artist is able to fully master his intellectual capacity and his ability to learn.

My wife and I met Jim Turrell for the first time in Santa Monica in the fall of 1972. We went to his studio near the ocean in the late afternoon; the light was lowering because the sunset was near. The rooms of the studio were white, the walls and ceilings were even and clean, and there were very few things around, just what was necessary for living – no art or decoration, but the space did not look empty. So much effort was spent to make it clean and pure. The feeling from the rooms was comfortable and relaxing. We drank some herbal tea from

40 Main and Hill Street Studio, 1972

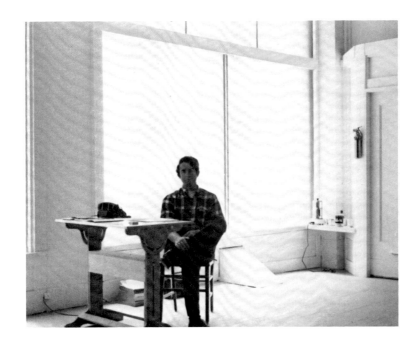

41 James Turrell, 1966

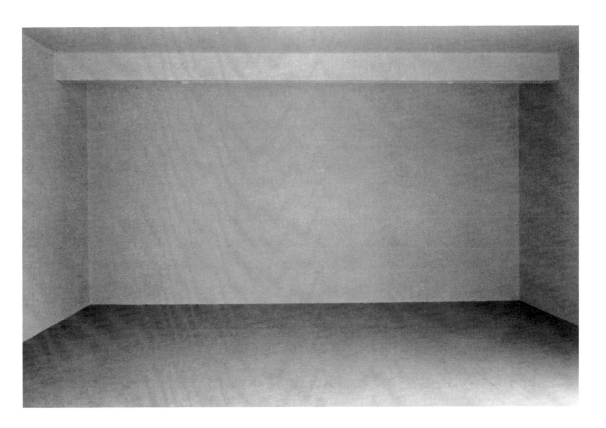

42 Studio interior, 1966

the Arizona desert where Turrell and his wife often lived. I do not remember what we spoke about, but I believe it was life in the desert and antigravity studies made by the previous owner of the studio, an eccentric scientist.

After the tea we went into another room, which was completely empty. Some light came from below, from a slot near the floor with hidden neon inside. He asked us to sit on the floor on small cushions leaning against the wall. There was daylight coming from the square opening above the front wall, which balanced the artificial light. The sky that we could see was like a surface which appeared as a solid blue material, but at the same time empty. The color was not one seen in paintings; it was material and immaterial at the same time. In the beginning the opening was blue – the sky of southern California in the fall.

Turrell asked us to stay, to look and not speak for about thirty minutes. After awhile the blue became darker and stronger, and the space inside the opening receded and gained depth. This feeling was not lasting; the sky became pale blue and lost its depth, appearing again like a surface painted with a light color, something solid and ready to come out of a frame. It was just the opposite of what we had seen before. We no longer had the feeling of being lost in an endless space; now something beautiful was nearby and real. Different colors began to appear in a slow but steady succession. The changes were fast enough to keep our attention on the opening. We went through the red, the orange, the bright gold, the dark gold, the dark red, the yellow mixed with the green, the violet, which lasted longer, and finally the black, which became permanent and without change. We realized that the night had arrived.

Something was seen; something happened for the first time. Were not the colors used by painters man-made? These colors in the sky were telling us something about the beginning of everything. The color is not in the sky, it is created by our seeing. Light is the materialization of energy: first there was energy, then light, and finally matter. Our bodies are made of protons and neutrons, which are the final condition of energy. Light makes photosynthesis possible, which makes vegetation, which is eaten by animals, and both become our food. We were not reading about the big bang theory – we were looking at it. I had always liked to look out of windows or sit down in front of the house in summer to see the sun go down and the night coming. This old phenomenon now appeared new and different and seemed to be the explanation of the theory about energy becoming matter. The blue sky at times looked like a painted surface, but void and endless and without any material quality.

Turrell told us that it would be possible to see more works later. After dinner we spoke about his first exhibition at the old Pasadena Museum in 1967, which used light projected onto walls with movie projectors.

How to make this art available to collectors was a question of interest to me because what we were looking at was almost uncollectable, and indeed almost

no one was buying this kind of installation. There was no object, nothing but a relationship to the sky. Speaking about this problem, I learned how Turrell was able to have an income without selling art. He was the pilot of his own plane and offered many services, such as fast delivery of replacement machinery for mines or highway builders located in remote areas, and aerial photography for archeological and mineral research. This job of flying between the earth and the sky was both a way of making a living and a coherent connection to his art.

After dinner we had a comfortable seat in another room that was much larger, without windows, and dark. This room and studio were near a crossing road. Again he asked us to wait and be silent, to adjust our eyes to the darkness. Turrell began by opening a small hole in the upper part of the end wall of the room. A soft, red light filled the opposite wall, strong in the middle, less so on the sides. The change in intensity was very gradual, almost impossible to do with paint; indeed, the color looked clearly not painted, so pure was its quality, so even the tone. Soon it became yellow and after a short time green, and then Turrell closed the hole and the room became dark. After awhile he opened another hole in a lower position. The incoming light was white and bright, running through the space like lightning. Staring at it, color would rain upward making opaque the vision past it. There were no lamps behind the wall; the light was clearly coming from the outside. For awhile the light was steady, sending a strong beam reflected by the wall, and then it disappeared. Another opening was used, and a quiet, bluish light came in, in a permanent way, similar to the one coming from the full moon at night.

This reminded me of my room at home where I go to read at night. When I want to think with more concentration, I shut off the lamp and spend time in the darkness, with some dim light coming from distant streets and windows. When we see only shadows of objects, things lose material qualities, reality seems to belong to the past, and memory dissolves physical presence. Because present time is in some way removed, it becomes easier to think about situations that have been common to everybody in every time.

The pale rectangle made by the reflection of the fluorescent lamp coming from the street into Turrell's room was so like the moon that it gave us the same state of mind as experiencing the moonlight and the opportunity to think about the same things. After about one hour, we moved outside and were able to see where the different lights came from – lights from the street and the cars passing through the intersection. Turrell was able to change in his art what is every night in front of us, but which we don't recognize because habit makes it difficult. If the goal of art is to make us aware that everyday life can be beautiful, this goal was fully reached.

We were planning a visit to the earthworks of Michael Heizer and Walter de Maria in Nevada and Arizona, country that Turrell traveled often by plane. He was free the following week and was willing to fly us to those places. Before we

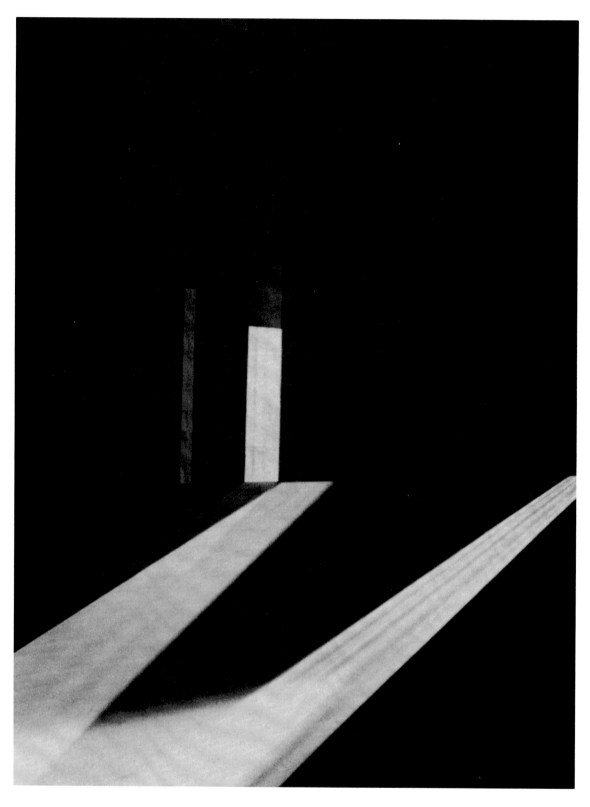

43 *Music for the Mendota*, 1969

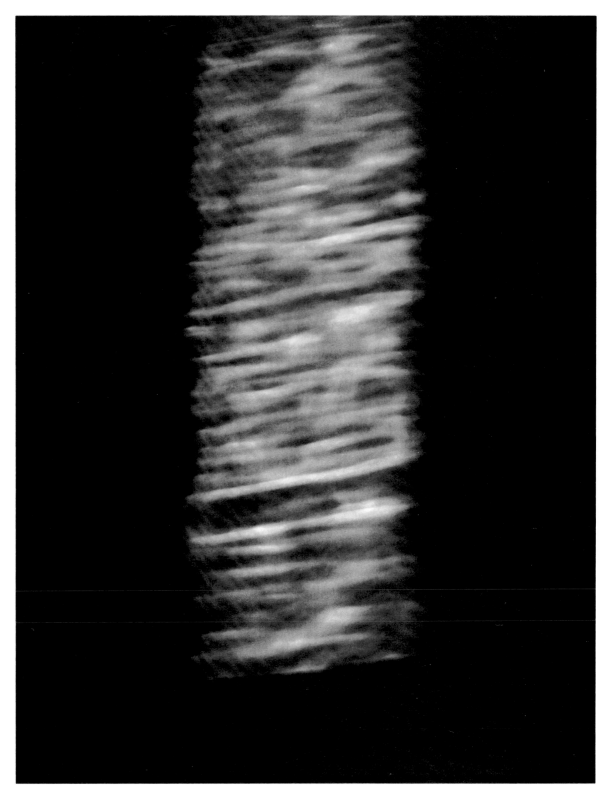

44 *Music for the Mendota* (detail from space 7), 1969

left Los Angeles, we saw a beautiful work by Maria Nordman at the U.C. Irvine gallery; it gave us information about another aspect of the activity of Los Angeles artists dealing with light and space.

Light was for centuries a primary problem for painters. During the Renaissance, man became interested again in looking at nature rather than at the relationship between the goal of life and man's will. Rendering of the radiating light, which fills space and gives to our eyes the possibility to see and to our intelligence the possibility to learn, was made by trying to give the illusion of something similar, using color on a flat surface.

In the Gothic cathedral, light filtered through colored glass. It did not come from the sun in its natural composition but was altered to reflect a human condition, to render visible an interior attitude. Then, Flemish and Italian painters in the fifteenth century began to paint landscape, and interest shifted from the inner world to the outside world, from behavior to nature. Baroque architecture increased the illusion of depth of space inside the building. Tiepolo's frescos are a typical example, as is the town view by Bellotto where a silver-grey light removes reality from the present and makes still-existing palaces and houses appear to be in an ideal, remote world. Caspar David Friedrich, the great German artist of the Romantic time, had a prophetic intuition of radiation as the origin of everything.

Things are a shadow of the real, which is behind us. Light leads to this hidden beginning; lights are a symbol of life, the metaphysical power that gives existence to everything. If the eyes of the mind are open, we can, while looking to Nature, read man's fate and our individual condition. Nature speaks to us not in a rational way but through the intuition of our deepest being. The universe is not only a huge mechanical system following the mathematical laws that Galileo and Newton found looking at the stars; it is also the Great Mother, loving us from faraway spaces. We can know truth not by science, which gives only analytical and limited knowledge, but through loving Nature. Our soul is able to overcome rational limits and reach some kind of total knowledge. Loving Nature's endless beauty is the way to reach the truth. Identity of love, truth, and beauty is the final statement of Turrell's art.

The impressionist painters saw reality as color vibration; objects had shapes made by different extensions of colored surfaces. Light is made by the addition of all the different wavelengths, which makes it white, though each wave is a color. Monet gave us the feeling of becoming part of the landscape – we became flowers, sky, and water because color and light filled everything and ourselves. It is reality and we became part of it; there is no more opposition, because we are the same thing. We are inside radiations, changing with them. This concept was different than the prevailing one at the time, when people were believing science could give us final knowledge of everything; it was only a matter of time and research. The realism of Bougereau, Meissonier, Cabanel, and Rosa Bon-

heur were the paintings of this belief that light is not important. To produce more and to become rich were the main goals of people: "Enrichez vous," advised Napoleon II to the French. The progress, the future, was sure and happy.

After impressionism, light almost disappeared from European painting. Two world wars were in the making, and a revolution would soon start shaking the foundations of Western society. Blood was spilled as never before. The opposition of strong color and broken images was more appropriate to the situation. Expressionism was the art of this time. De Chirico paintings of empty sites had their own light – a shifting time of day when the sun is no longer in the sky; the night is coming but it is not dark; no beautiful colors of the sunset; no moon, but a similar pale light. These paintings were called metaphysical art, but they are the art of dreams, where memory builds suggestions that are out of time and out of reality.

Marcel Duchamp, one of the most influential artists of our century, was more interested in the meaning of reality than in perception. He was concerned with the opposing situations that confront us. What looks real is not real; reality is something that is behind and hidden. The restless research of science, of this something that is behind, is endless because it does not belong to the things that have an extension. In one of his main works, *The Large Glass*, Duchamp used glass that is clear, that we can look through, and that is not opaque like matter. The glass is an allusion to his belief that the last reality is not material – we cannot see it. Picasso believed the opposite; matter was everything. Violence, death, and heroism were the three real, basic forces. For this reason he was interested in dialectical materialism. Cubism's destruction of the natural harmony of human shapes was inescapable. Two world wars were making real the image in the battlefield. The beautiful bodies of the Greek gods were lost forever; 2,500 years of classical culture were at an end.

The event that changed the art world after the Second World War was the rise of American art, which was for the first time in history winning worldwide recognition. Among the emerging New York painters in the 1950s, Rothko was the one most concerned with light. Usually, the illusion of light's existence on the flat surface of the canvas was given with the differences between bright and dark colors. Rothko was able to achieve an even stronger feeling using only very dark colors. In the almost black paintings of the Rothko Chapel in Houston, the light became a psychological condition of mind. Lost almost completely was any reference to something we can see with the eyes.

In the early 1960s, Dan Flavin made one of the biggest changes in art history. Before 1964 light was only painted, the illusion of its presence created by using different kinds of colors. With Flavin it was no longer necessary to use illusion; we realized that the qualities of real light exceed the qualities of illusory light perceivable by the human imagination. Man-made lamps give off a beautiful radiation, even if it is very poor in relation to the almost endless qualities of the

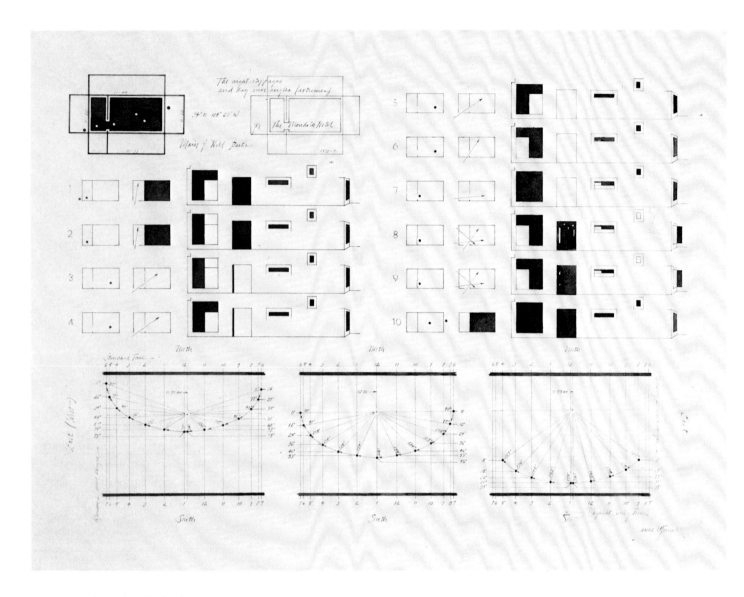

45 *Music for the Mendota: Mendota Stoppages*, 1970–71

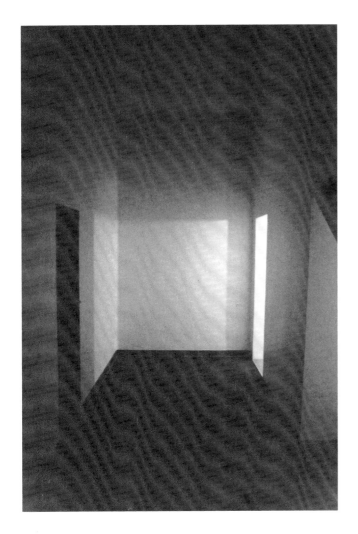

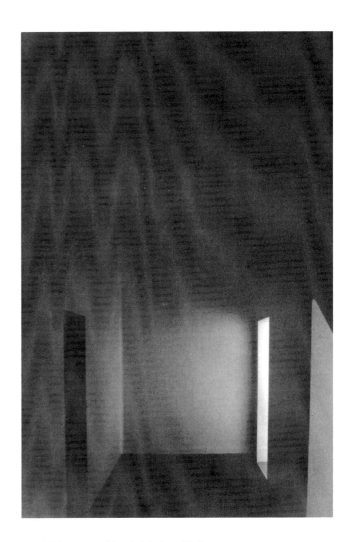

46　Dining room with hard light from kitchen, 1973

47　Dining room with soft light from kitchen, 1973

radiance coming from our star, the sun. A meaningless object like a fluorescent lamp, used every day by millions, became a tool for the emission of radiance that gives a very subtle, calm, but powerful, suggestion to the viewer. Countless emotions, never seen and never thought possible, were felt when walking under his colored light. For the first time in art, light filling the space was not used for seeing something else, but rather for its own qualities. It was no longer confined to a flat surface but filled the room where the works were. The reflections on surrounding walls and ceilings became parts of the work and played an important function in the work's appreciation. For the first time, after two centuries of separating art and the environment, they came back to work together again.

By 1973 it was the right time to engage in something beautiful and new. We started to discuss with Turrell the possibility of using some empty rooms in my house in Varese, which were to be restored, to create something similar to the works seen in his house. What was happening in Los Angeles seemed to be a challenging opportunity not to be lost. Few collectors, museum directors, or art critics were aware of the significance of what was happening. The work by Turrell shared common elements with that of other artists but at the same time was very different. With this goal in mind, we flew in a small five-seat plane from Los Angeles to Las Vegas and Overton, Nevada, near Lake Mead and Mormon Mesa. Here Michael Heizer's *Double Negative* was located; it was our starting point on the way to Walter de Maria's Las Vegas piece, which is located in a remote desert valley and possible to reach only with a full day's journey.

Flying in a small plane at low altitude was a new experience for us. To see the desert from above was very exciting, the best preparation for something unusual. Where vegetation grows, the past disappears because the presence of life is evident. Life is here now and acting, covering the land. Grass keeps the soil almost intact, preventing erosion. But in the desert we can read the history of the earth. Restless wind erosion makes bare the ground. From differences in colors, we can learn how strata were superimposed on each other – the tops of the mesas were at the bottom of the ocean billions of years ago, midway from the beginning of our planet. Lava beds from eroded craters show that a huge event happened, probably when dinosaurs were living fifty million years ago, near sand deposits made where it rained. Events happened when human beings were not yet in existence. Our individual history is nothing in relation to this past. Even the history of our civilization is very short. But even if our life is not lasting, we can know things.

When we think about our end, in a room in the city, we are sometimes afraid. We do not know where Fate leads us. It is very difficult to understand the meaning of life if everything has to disappear. We realize how short life is; we feel a painful wound. But when we look at this imposing landscape, we realize we are a part of Fate. Nature is beautiful and endless, and we are happy to be part of it.

Happiness can be found only when we know we are part of Nature, when we lose our individual condition but keep our awareness.

We spent the first day looking at Heizer's *Double Negative*, which we found abruptly when walking near the edge of Mormon Mesa; it is a deep excavation that could be seen only when we were above it. The second day, we went to see the Las Vegas pieces by de Maria, which we reached after six hours of slow travel on trails that were difficult to find in the desert. It was also impossible to see far away because it was a small excavation made in the land, one foot deep and four feet wide but one mile long to the west and another mile south. It was not possible to walk without being forced to look down, to avoid hitting large stones and bushes. On the trail it was possible to walk looking at the sky and the distant mountains and to listen to the desert sounds, which were very clear in the almost total silence.

Even living in large cities surrounded by an artificial landscape and closed between walls, Man's desire for the free horizon in a silent land is something that cannot die. In this land in the west, that desire can be fulfilled in the best way. Love of Nature is an innate instinct that has belonged to every human being since the beginning; modern man is losing it because of his interest in material goods and pleasures that can more easily be found in cities.

The circles of stones made by Celtic people four thousand years ago in England and Scotland were built in beautiful sites where people were very aware of their relationship to Nature. All the improperly called "primitive" cultures strongly felt the importance of this relationship. Beautiful sanctuaries were made in beautiful locations. Monte Alban in Mexico, near Oaxaca, built by the Toltec people in pre-Columbian time, is an example of this. It was built on the top of a hill surrounded by a plain. The view was free in all directions, and the sky and the horizon surround the site where the rites were performed.

The same kind of location was chosen for the Parthenon. When we climb the stairs, we see only the sky; the entire temple is seen in a single vision, emerging from the earth above the blue Aegean Sea. Today we can only imagine this beauty, as it is now surrounded by an ugly, polluted, modern city. Once in one's life it is a necessary visit, to think about what we are losing. The Egyptian pyramids had a similar function. Their minimal geometric forms have many complex symbolic relationships. The grave of the Pharaoh, the head of the people, was the visual representation of the capacity of man to think; the top of the shape points high to the sky. Even today the pyramids are the largest volumes made by man.

The towers of the Chartres cathedral rising from the surrounding flat land in summer, when the fields are a golden yellow from the wheat crop, are another impressive sight. The towers are narrow and very high, two vertical lines against the line of the horizon, with only the sky as background. When approaching them, the strength of the vertical volume rising ahead becomes very

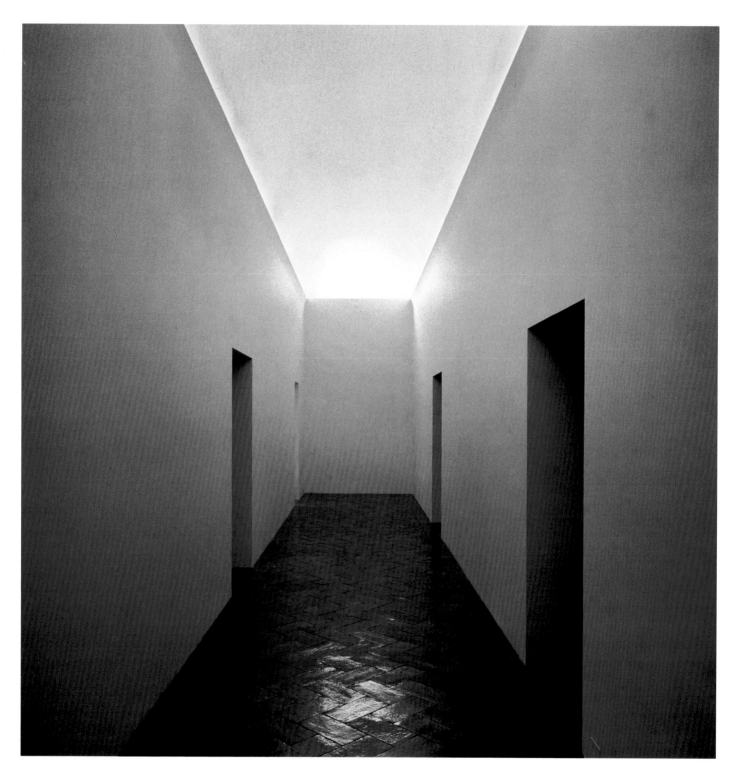

48 *Lunette* (day), 1974

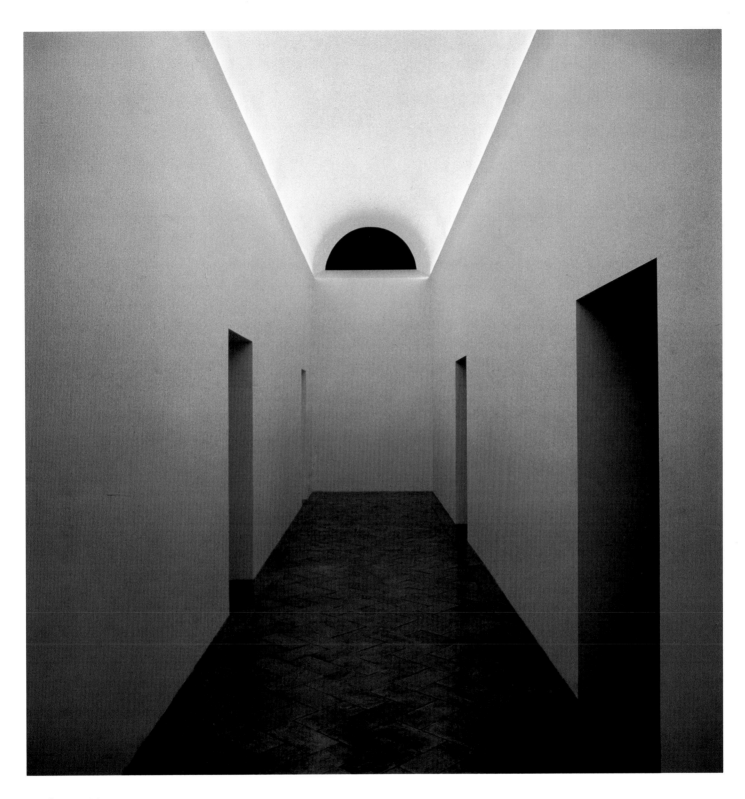

49 *Lunette* (night), 1974

evident. They seem to show a desire to reach the sky, to be near the origin of everything, but at the same time to show the skill of man to win over gravity pressing everything on the ground, to win freedom from natural limits.

The gardens made in the seventeenth century by Lenôtre for Louis XIV are an attempt to show how nature and human reason can join in a common vision. The perspective view running across the country, guided by the parallel walls of vegetation toward an end without visible shape, is an example of how reason could lead to an indefinite entity. The Roman consul Lucio Cornelio Silla, deeply concerned about Fate, built a temple on top of a hill overlooking Rome. As a valiant general, he was aware of chance in battle and politics. The temple was devoted to Fortuna Primigenia, a goddess who held that everything comes from a power that we do not know but that has command of the whole. The top of the temple is open to an endless view across the plain where the city lays out to the sea.

Fortune is a cosmic force involving matter and living being. In the past the biggest constructions were always related to the identification of the original power of Nature, an entity so great that it was above the possibility of definition, an entity that substantially affected man's destiny from the earliest culture to the most recent. But with the invention of the machine, we had a change. In the nineteenth century, railway stations were the biggest buildings made; in our century, skyscrapers.

These considerations help us to understand the meanings of the works made by artists in the desert of the American West. For us seeing the works, it was a unique experience, giving form to a belief that was latent in our minds, for many years awaiting the opportunity to find a way to become something real. The works seen in Turrell's house were a link to this great experience in the western desert. It was the way to have something similar at home. We cannot spend life in this beautiful land, but looking at the sky is a way to escape banality and the meaninglessness of life. Turrell's work was the best means to reach this goal. It was necessary to try to repeat the same experience – not in memory, imagination, or illusion, but in reality.

The same year, Turrell came to Varese to see the space and make plans for the installations. Five rooms were available: a large and high corridor, topped with a barrel-vault, in the center and two rooms on each side. In the corridor, it was easy to make a work similar to the one seen in Santa Monica. The far end of the barrel-vault was opened, with a window going up and down to avoid rain. When open, there is a clear cut between inside and outside. Neon is hidden behind a cornice running around the top of the walls, where the barrel-vault starts. The axis of the corridor looks northeast. In summer we see well the colors of the sunset.

The second wall on the left, fifteen feet square, has a small doorway, no window, but an opening on the ceiling that is above twenty-two feet. The sky open-

ing takes all the ceiling; only a part is reduced by a metal plate, painted white, that makes a linear edge against the sky above. The neon light is below, near the white floor which reflects the artificial light, in order to balance the bright light coming from above. To prevent incoming rain – as there is a lot in Varese, being near the Alps – a mobile steel roof closes the opening when people are away and totally disappears when it's open.

The first room on the left side of the corridor has light coming from a skylight on the roof, light that does not come directly into the room but is reflected from two small openings on the ceiling of the opposite side. The daylight is mixed with colored fluorescent light, but during the day we see only the first; at night it is completely different because we see only colors. On the right side of the corridor, there are two rooms with projectors that make shapes of light on the walls. These are the early works made by Turrell for the Pasadena Museum in 1967. These five rooms give examples of different combinations of natural and artificial light or of artificial light controlled in a special way.

Nearby rooms, devoted to the work of Robert Irwin, deal with the relationship of outside to inside in a completely different way than Turrell's. They deal mainly with perception and illusion. On the same floor, many rooms are used for works with colored fluorescent lights by Dan Flavin. It is a cluster of rooms devoted to the same basic element, light. Each room was developed by each artist in a different way, depending on their personalities and intellectual interests. Each time it is a new experience; they do not ever cease to attract.

When coming from the city, tired and depressed, the first thing I do is go up to the second floor and press the button to open the Turrell window. Immediately, my mind changes. I spend time regarding the sky from the opening, always so different and so beautiful. It is interesting to realize how so immense a thing as the sky looks even bigger if seen from a small opening. When we walk in a street or in the country where the view is open, we cannot perceive this fact, habit leaves this notion unnoticed. I leave these rooms because I have to go back home or I have something pressing to do, but always with a shadow of sadness for leaving. When driving back to Milan, I feel different – I see life as something that could be joyful. The idea that this vision generates stays with me for the remaining part of the day.

In all the rooms, the perception of what happens changes radically with the season, the hours of the day and night, and the sky condition. If it is a windy day in spring, in summer after a storm, or when the air is clear and there is no humidity, shadows are sharp, light is brilliant and joyful. In fall and winter, when fog reduces visibility, the space looks peaceful but a little sad, silence is deep. It is fine to stay and feel comfortable in a dreamlike condition. Walls and ceilings are painted white, with a very even surface reflecting all small color changes coming from the sky. Usually, it is very difficult to see these subtle changes, but when reflected by such a large surface they become visible. Light

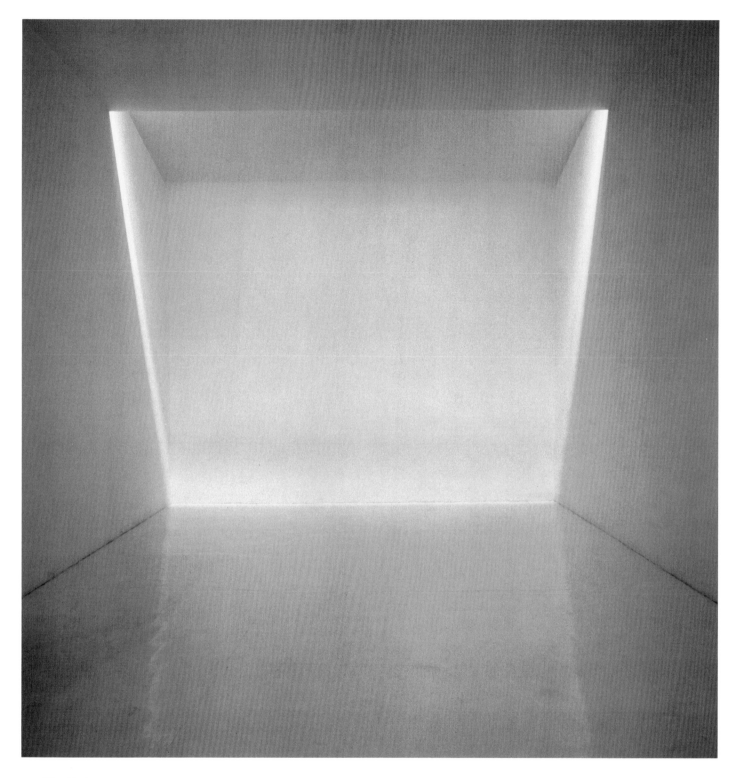

50 *Virga* (day), 1974

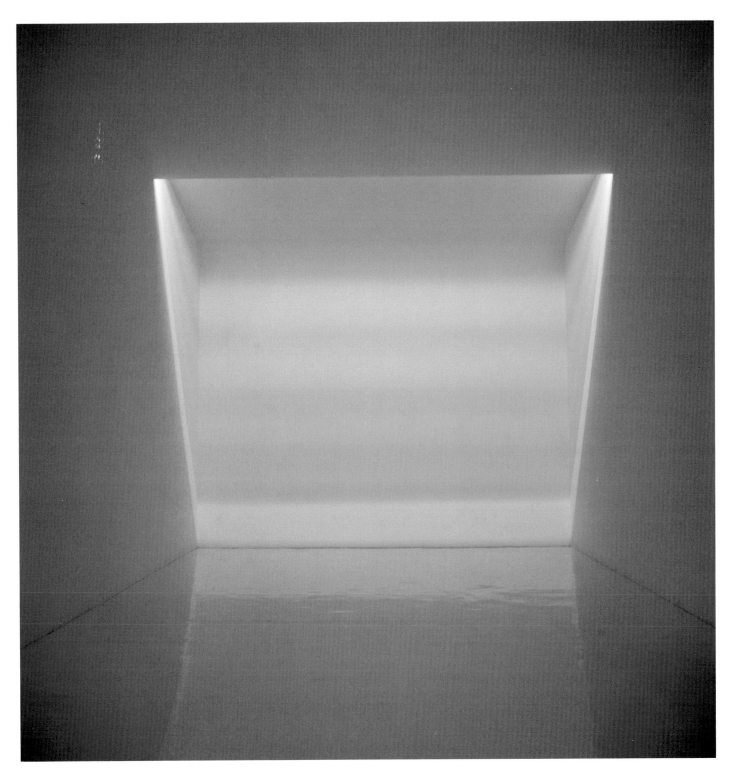

51 *Virga* (night), 1974

comes from the north sky and on a clear day gives a bluish coloration. From the rooms on the side of the garden comes a greenish light. When the sunlight is reflected by a tile roof below the Turrell opening the ceiling becomes reddish. In the long summer sunset, the light changes completely. All the spaces are filled with yellow, red, orange, gold, and violet, colors slowly changing and mixing, starting with the bright gold and ending with the dark violet. Each moment gives a different feeling and emotion, strongly joyful at the beginning, deeply calm at the end.

At night, there are only lamps, neon and fluorescent, which are bluish at first and then change to all colors. A different situation, no less surprising, is the qualities of interior light that change our perception of the color of the sky. The Turrell opening looking to the sky becomes a black hole. Although it is completely open to the sky and the stars, it is blacker than any surface because of the light in the room. The light is like that of a city, making fewer stars visible; except here the sky is completely black. The opening is deeply dark and endless, strongly attracting attention to the statement it makes: deep darkness as perpetual end. It could be frightening but is not. The darkness looks solid; we cannot see stars, but we know they are there.

The following spring, Turrell came back to Varese with the last works to be installed – the projectors which make shapes of light on the walls. He also spoke to me about a project he had in mind: to look for a very large space shaped like a bowl, perfectly elliptical and concave. From the center of a space of this kind, it would be possible to have a sky view that would be unique if the air was clear. He had already explored several locations in Arizona, Nevada, and New Mexico, but the rims of the bowls were not perfect, and this was very important in order to have a linear separation between earth and sky. A clear cut was the best way to join the two entities of sky and earth, making the two together look like a huge sphere, with the viewer contemplating the whole at the center – a wonderful idea! It would be too costly to make so big an excavation on a high plateau in the west where the air is clear; it is very costly to move earth around. The best solution was to find a dead volcano with a well-shaped crater. From preliminary investigations made while flying in Arizona and New Mexico, Turrell saw some craters that could be right.

The project sounded crazy but beautiful. Only an American artist could have so strange an idea. In Europe, artists live in the studio, make paintings, and have discussions with colleagues, but nobody would have the idea to use a mountain to make art. The only other artist I knew who flew was an Italian, Roberto Crippa; he liked acrobatic flight but had a very bad accident. Then he flew again and died in the second flight. But he never looked for a volcano.

Turrell was confident he would find the right crater. He spent most of his Guggenheim grant flying the western states, from the Pacific to the Rockies and from the Canadian border to the Mexican border, looking for the most suitable

volcano. When I came back to visit him the next October, he showed me the volcano he had found.

To give more time to this project, Turrell had moved with his family from Santa Monica to Sedona, Arizona, where Max Ernst had lived during the war, painting the landscape of huge, red natural towers sculpted by erosion.

After spending some days in Los Angeles, we flew to Arizona, landing in Phoenix, where Turrell was waiting for us with his plane. After another flight lasting about an hour, we reached Flagstaff; the airport was close to the area to be seen. This town is near a large volcano surrounded by many small volcanos, about one hundred kilometers from the Grand Canyon, on a plateau about two thousand meters high (as is most of northern Arizona). Nearby lies the Painted Desert. It is one of the most beautiful areas of the West. The weather is dry and the plateau, being high in the air, is very clear. There is little vegetation, the ground is bare, and many colors are visible because of the millions of years of erosion which have exposed the different compositions of the soil. The volcanic activity in this area has made materials of a great variety of colors: white, black, red, violet, brown, and ochre, pure or mixed, of changing intensity.

The following morning we flew in the Turrell plane to the Grand Canyon, seeing from a different altitude the gigantic landscape and the surrounding area of Monument Valley, with its red tower often seen in western films. Coming back to Flagstaff, we flew around the site selected by Turrell for making his work, near the end of the Painted Desert where all the colors of the ground are displayed. In the afternoon we left Flagstaff by car and, after a forty-seven-mile drive, stopped to view the volcano, which was some distance away. The road ended at a nearby ranch, so it was necessary to walk to the beginning of the crater, which was very imposing when seen from flat land and not as small as it seemed while flying over. The nearby ranch was the only man-made thing we found while traveling several miles on a small road.

Turrell was looking for an almost perfect cone with a truncated top, a very geometric shape. Coming to the side of the crater we saw several other volcanos, either smaller or larger, but not one with an almost ideal shape. The space around the crater was empty. Behind it the land sloped down, leaving its mass alone on the horizon. Walking on the hillside was difficult because of the soft cinder and the altitude, which was nine hundred feet above the surrounding land. After about two hours, we reached the center of the crater. When coming up along the slope, we saw, far away, the Painted Desert. Now, at the center of the bowl, surrounded by the inner walls of the crater, there was no horizon to be seen. The rim of the bowl was regular; only one part was a little lower.

The sunset was coming, the light was changing, and the crater was becoming darker. Around us there were walls of earth, and in order to see the sky, it was necessary to look up. To look up was the great change – from a closed and finite space to one open to infinity, two totally opposite entities. A common condition

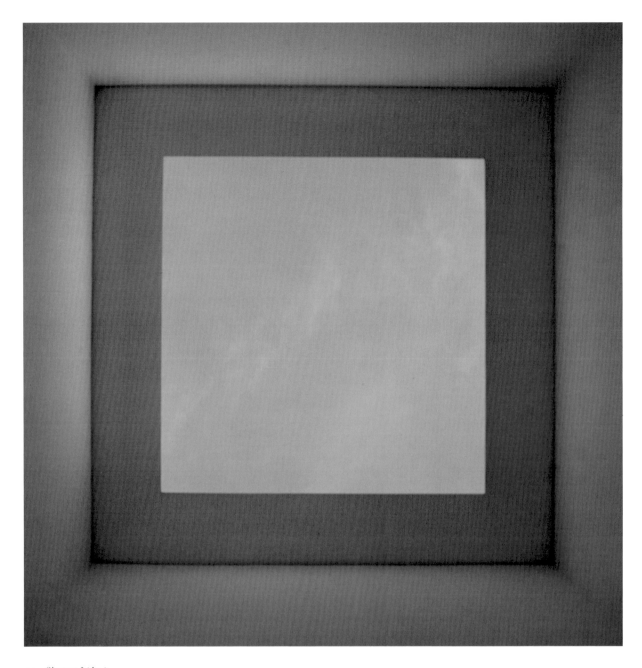

52 *Skyspace* I (day), 1972

53 *Skyspace* I (twilight), 1972

became clear: the limit of the real and the endless possibility of what is beyond the real, freedom and constriction opposing each other. The color of the sky began to change, as in Turrell's house in Santa Monica, though this time it was not the view from a small room with a ceiling above but the entire top of a very large space. We were below the full dome of the sky that is visible from north to south, from east to west. The change began with a deep, endless blue that became a soft, pale blue, looking like a painted surface made with a never-seen material; then came the gold, the red, the yellow, and the violet. Colors were not confined to the west side, where the sun was going down, but were filling all the space above and around.

When we are inside a room between walls, we have a psychological pressure from the matter surrounding us. But in the center of the crater, we had the feeling that our bodies were expanding, like our minds, to reach a level of unexpected knowledge because the universe was visible. The first star appeared with a strong light, and after a short time there were many others. Colors disappeared. The night was coming, but it was not dark; it was filled with a huge number of stars, many more than we can usually see from land with a normal humidity level. The night was giving light, not darkness, because of the stars.

In town the walls of the rooms, of the buildings, of the streets, cannot make us happy. Our home is familiar, comfortable, and warm, but it cannot be the best place to live because a better one could always be found. If our final desire can be fulfilled only by some kind of total knowledge, we have to look for something else. Surely it cannot be reached with money, fame, power, or success in life; the love of somebody who lives with us is more important than all these things. To be, for a moment, in a site where the entire universe can be seen is the only time we are closer to the goal – though unfortunately for only a short time because we do not have the strength to withstand so great a challenge; we are too weak. Even if for only an instant, it is worth it to go where such an experience is possible.

There are sites that are different from all others. Sometimes it's the quality of the building and the history – centuries of life where each generation added something good. Other sites are beautiful because they are connected to situations in which it is possible to have a communication with an entity that is invisible and endless – not only in terms of art and history – sites where people meet for a relationship with the power that is above everything. Nature is still better than any man-made object, which is too weak to withstand so great a vision. In nature there are so many stars all around, distant worlds that we cannot reach, which were born at the beginning of everything. But if we are able to hold on to the discomfort, a time of great pleasure will come. We believe ourselves to be sucked up from the ground toward the stars, not alone in a space without boundaries but surrounded by the peaceful presence of somebody who loves us in a powerful way. The crater looks to be the highest point on earth and the

nearest to the stars and galaxies. It's not like a spaceship traveling in an alien emptiness, but rather it causes us to be alive in the most beautiful place, so near the sky and the very beginnings of life.

Night was coming on and could begin to be felt, and the time to go back was coming. Following another pathway, we went down from the volcano, leaving behind something that after many years cannot leave our memory. Roden Crater is a place to which we must return. If it were possible to have a beautiful, not painful, end, it is the site to visit before disappearing, with the hope to lie again among the stars, the possibility to be happy without limit and without end. It is a journey necessary to make.

We can see not only nature, as when we walk in an open land, but something even larger: all the sky above us during the day and at night countless worlds that fill the deep space. In order to have a strong emotion with this view, our minds must be open to realizing that our being came from the universe. If this concept becomes clear, life becomes different. A hope that cannot die will lead us toward a goal that lasts forever. We are coming from something beautiful and we belong to something great, our expectation cannot be lost. We do not know that our desire for total happiness can be fulfilled, but it can be. In the middle of Roden Crater, this belief seems possible. If everyone were able to have this kind of experience, the use of drugs would disappear, no one would commit suicide, and violence would stop. Unfortunately, few people will make this journey – if they did, the world would change. We spend huge amounts of money for re-education centers and for many other institutions devoted to the solution of social problems, but this one place would provide the best education, giving real hope in front of the greatest reality.

Everything at the same time is the beginning of every other thing and of ourselves. We are allied because a long link joins us to the beginning, but our minds are able to establish some kind of communication with something that is always here and does not change, even if we change. Perhaps it is possible to overcome our own individual deaths. If this endless and boundless existence is forever, something of us must live on. It is not a reality that we can prove through a scientific experiment, but in some way it is more scientific than the experiment itself, which can tell us about only a small part of the whole – but we can have an intuition of the whole, which generates and includes the parts.

Back in Flagstaff, at late evening, Turrell explained in what way the project will be realized. The first thing will be to make the edge of the crater even on all sides. About 100,000 cubic meters of volcanic cinder will have to be moved to make a perfect shape. The topsoil will be removed and then reinstalled to avoid any alteration of the natural condition. But the main work will be to build a tunnel from the base of the volcano to the center of the crater, about three hundred meters long. In this way, after a walk underground, the viewer will have a

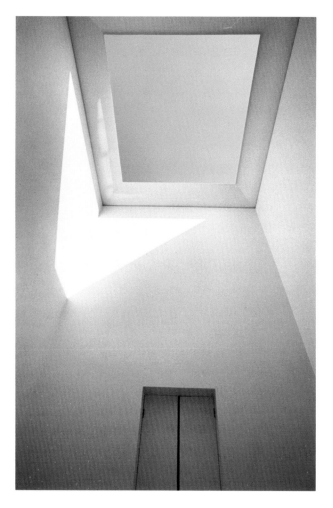

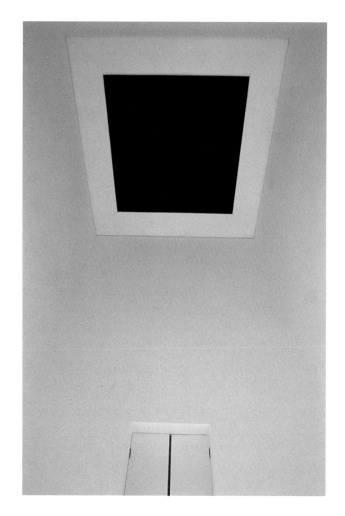

54 *Skyspace* I (day), 1972

55 *Skyspace* I (night), 1972

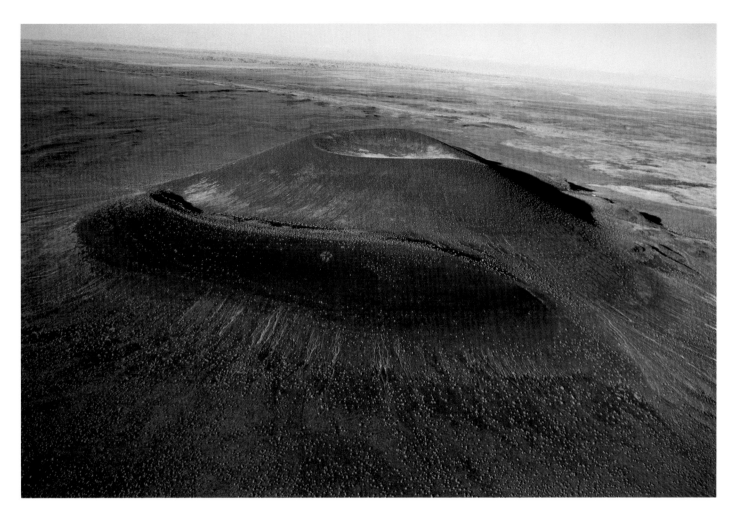

56 Roden Crater, 1982

total view of the sky, avoiding the boring ascent of the hilltop. The tunnel will be oriented to allow sunlight inside at the equinox twice a year and moonlight every eighteen-and-a-half years. Near the entrance, underground rooms will be made for seeing stars and astronomical events in a special way.

Many years have gone since our first visit. In the summer of 1986, Turrell hopes to finish the remodeling of the edge of the crater and complete the first phase of the program, but the main job, the tunnel, will still have to be made. Anybody else would have given up such a huge undertaking, consuming so much money and time, but Turrell will never stop working. In the beginning the Dia Art Foundation helped him to buy the volcano and the land around, after long negotiations with the previous owner. For several years Turrell has poured all the money he can save into carrying the project ahead, imposing a hard life on himself and his family. All the grants he has received from other foundations were spent on the crater. For most people it is a crazy project that will be a failure, but not for Turrell, or for anyone who believes in good things. Few people have the will and the endurance to carry ahead so huge and difficult a project, but he has this will, and for eleven years he has used all the money available to bring it, step by step, to completion. In eleven years there is a lot of time to get discouraged and give up the task, but we are sure this will never happen as long as he is still alive.

We have gone two more times to see the crater since 1974. Always we had the same great emotion; always we thought that his work could not be stopped. It is a task involving the reason to be, involving everything that is good. If we are not able to help complete a work like this, it will be difficult to give people the hope of something better, or to give those who want to destroy the present society because it's ugly something beautiful to look to. We make huge buildings, new towns, big factories, millions of consumer goods, machines that are marvels of technical ingenuity, but we haven't yet made a site in which we realize that everything we have, our life and our intelligence, is our heritage from Nature. There are some good museums, though very few that can give us some examples of something ideal existing in reality.

We are alive to work for beauty that is beyond our imagination but which we have to try to reach. The Roden Crater project is one of the few things that must be made, to prove that the light in the human mind is not gone.

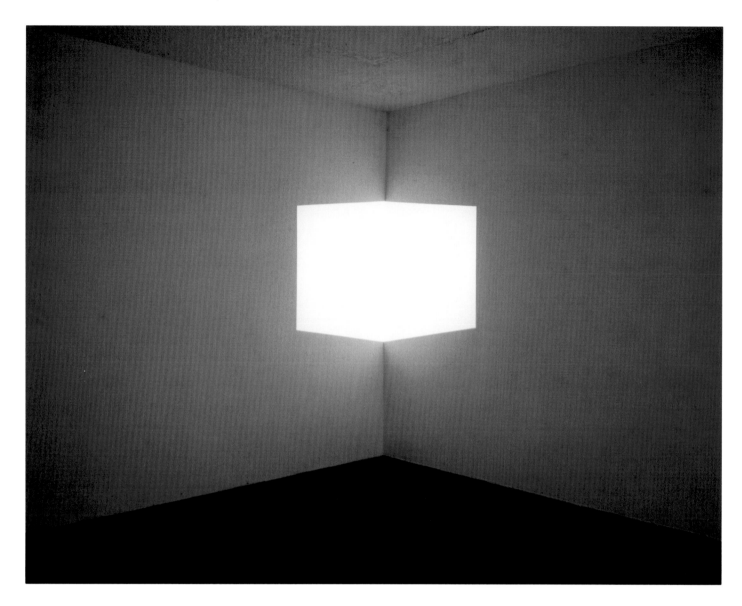

57 *Afrum-Proto*, 1967

Projected Light Images

<div style="text-align: right">John Coplans</div>

Turrell's images are projected from a slightly modified, but standard, high-intensity projector positioned on the gallery ceiling. No attempt is made to conceal the projectors, and as a consequence of the intensity of the projected light image, it is not necessary for the gallery to be in absolute darkness. His monochromatic images consist of simple geometric configurations – a square or a rectangle, for example. In some instances, the overall geometric shape is modified by the removal of a smaller, either similar or dissimilar geometric shape from one corner. In any event, each image is unique. The borders are crisply defined, and the internal field of the image is usually flat and without divisive incident.[1] The overall size varies from configuration to configuration, but the majority approximate eight feet at the largest dimension. The white images have a slightly discernible bluish cast, and the colored images are tinged a definite blue or pink. The position of the whitish images on the gallery wall is indeterminate. The colored images, on the other hand, assume a more definite position; the projected color-plane is read as a tangible surface effect and thus appears to be more objectified.

Turrell's images are not only static, nonrepetitive, and absolute, but they are also highly subjective. His art corresponds to the notion discussed by the sculptor Robert Morris: "The better new work takes relationships out of the work and makes them a function of space, light and the viewer's field of vision." Turrell's means, however, are purely pictorial. In other words, he uses luminosity not as a sculptor uses material to create three-dimensional form, but illusionistically, in a similar manner to an artist who uses paint on canvas.

Each image is focused upon the wall surface of the gallery by projection. Some images are positioned equidistantly across one of the internal angles of the wall, and others are projected directly onto the plane of the wall. Those images focused upon one plane of the wall usually rest on, or slightly above, floor level or crisply butt up to the angle of the adjoining wall or are placed in both positions. Each image is a self-contained entity and activates an arc of the gallery in its own particular manner. Thus it is possible to place several images in a gallery and have them apprehended as specific works with an individual character.

The intensity of the projected light dematerializes the wall surfaces enclosed

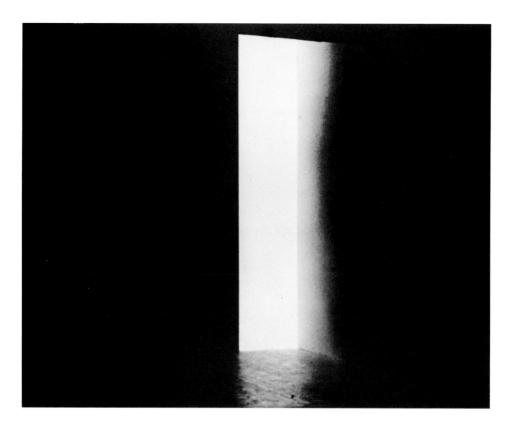

58 *Tollyn*, 1967

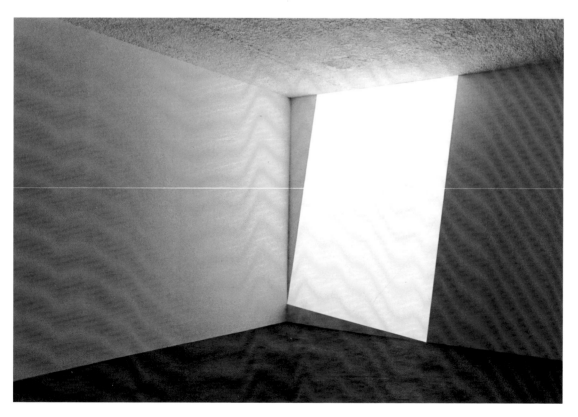

59 *Decker*, 1967

within the boundaries of the image and the unlighted wall surface abutting the image. However, walking close to the wall dissolves the physical-object qualities of the image, and the observer becomes aware of the actual disposition of the wall surface and that the image is merely reflected light. An awareness of the transient qualities of the images does not detract from the effectiveness of the work. In fact, it serves to intensify the idea that the image, although an illusion, can nevertheless be experienced as something tangible. The manner in which light is made physical and objectified in these images demonstrates that volumes can be engendered without references to structure and, further, that the transparency can be engendered without conventional employment of material.

The tangibility of the images is increased by the manner in which it modifies the lighted wall as well as the surrounding space of the gallery and, more than that, the ambient space – that is, the space beyond or outside the gallery. In the first instance, the definition and the brilliance of the image make it difficult to determine the position of the wall; the wall appears to lie somewhere behind the plane of the image. If the observer looks into the image, it appears to penetrate the wall. On the other hand, when the wall is focused upon, the position of the image then becomes less determinate. One is called upon to make simultaneous decisions as to where the image lies and where the wall lies. This is due to the fact that the viewer is involved in a space in which the "painting supports" have been enlarged to become congruent with the wall surfaces.

In the second instance, it is first necessary to differentiate between the viewer's awareness of space, or the space a viewer can perceive or imagine, and the actual space of the gallery. In other words, the viewer, when looking at one of these images, is not only forced to modify his awareness of the fixed position of the wall and image, but he also becomes aware that the image refers to an exploded space. This sensation is enhanced and increased by the very intangibility of the light. When a light image is projected under the circumstances given, the constant modification and fluctuation of the observer's spatial sense tends to expand the awareness of the physical limits of the gallery.

It must be added that in addition to the powerful modification of the observer's space created by these images, they also have considerable iconic power. This may not be clearly demonstrable, but the compelling sensuousness of the light and its inexhaustible brilliance are almost hypnotic. Furthermore, an apprehension of the means used does not rationalize the total effect but adds to its vividness and mysteriousness.

EDITOR'S NOTE: This essay first appeared in the catalog *Jim Turrell*, Pasadena Art Museum, September 1967 (illustrated). © John Coplans.

1. Except for *Afrum*, an image projected across the corner of the gallery. Although the projected field for this image is flat, the corner line of the gallery is highlighted as a consequence of reflected light.

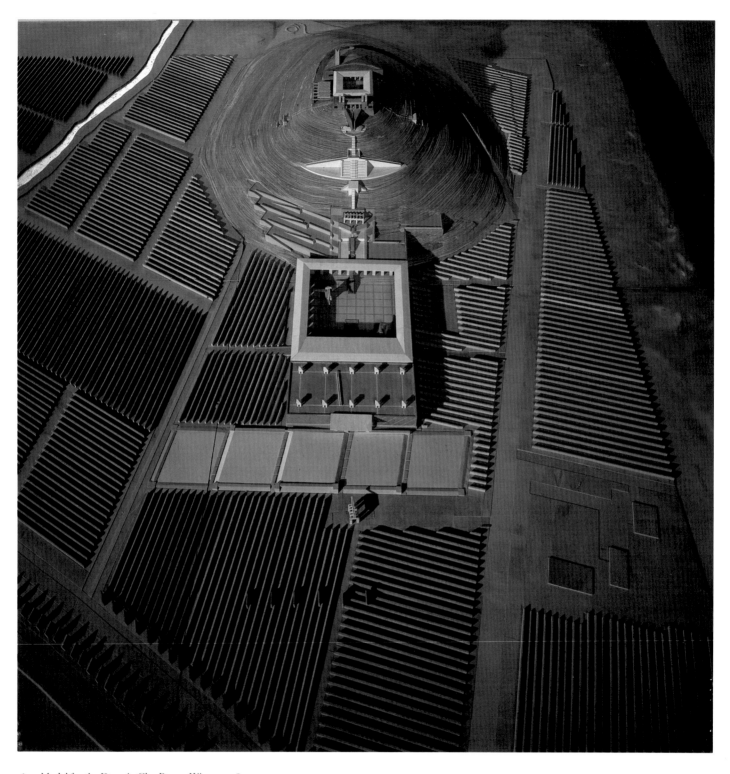

60 Model for the Domain Clos Pegase Winery, 1984

All the Ideas

Craig Hodgetts

Artist We've used up all the ideas either one of us will
ever have.

Architect We'll have to find another architect and artist.

With that, Robert Mangurian and James Turrell, architect and artist, playing out their roles, clearly enjoying the moment, completed work on the *Domaine Clos Pegase* competition project.

It had been an exemplary effort from the beginning, when vintner Jan Schrem and his wife were drawn to the singular geometry of a tiny knoll in Napa Valley and decided to establish within its precinct the winery they had envisioned. It was to produce a modest quantity of good wine, drawn partly from their own vineyards and bottled on the estate. The label would be derived from a fine little painting by Redon depicting a flying horse. Thus *Domaine.* Thus *Clos Pegase*, the red blood of Pegasus.

And it was to be more than that. The knoll spoke to Mitzko Schrem of its volcanic origins. Its worn shape suggested eons of rain and heat. They would need a symbolic structure as well as a factory – a residence, some fusion of function and art that would sustain life as well as industry.

When Curator Helene Fried suggested that a collaboration of artist and architect might produce a feasible design, it was against the lackluster history of such liaisons, which never seemed to match the brilliance of that achieved by Rauschenburg and Cunningham, or Stravinsky and Cocteau.

But the time was right. Crossover artists had migrated far from the constraints of their media to invade companion arts. Architects had already begun to plunder the vision of artists engaged in environmental work. The opportunity was ripe to provide a venue capable of spanning the void.[1]

In the proposal offered by Mangurian and Turrell, two main buildings, one a vast hollow factory surrounding a square at the base of the knoll, the other containing a smaller, but still square, residential courtyard surmounting the hill, are united by a jangle of platforms and grottos strewn along their common axis. To the North and South are two other, more conceptual axes, which cross the first at right angles. One, marked by huge portals fronting East and West in the factory square, will accommodate trucks laden with the harvest. The other, a tunnel piercing the hill beneath the residence, is designed to mark the vernal and autumnal equinoxes.

There are echoes of Turrell's earlier installations, especially those dealing with architectural space, and flashes of the cryptic geometry typical of Mangu-

rian. But the studies suggest more than the application of geometry and illusion: *Domaine Clos Pegase* sets the stage for collaborating artists to search beyond compatible motifs and decorative flourishes. Had it been built, it would have substantiated an even higher form of collaboration: the quest for shared meaning.

A mutual understanding of the uses of phenomena and gesture informs their work, providing a rare link between context and audience. Within a simple vocabulary of formal alignment and apertures, these devices can focus attention on, in fact *give meaning* to, the surroundings chosen by Mangurian and Turrell. Thus they are able to communicate by understatement, preferring passive, static markers to the formal invention favored by their more bombastic contemporaries – the drama of perception, as in the controlled oscillation of solar rays in the warehouse, to that of architectural gesture.

At the winery, this strategy of invisible instructions is manifest throughout the design, affecting the alignment of the entry road, the orientation of the paving, even the arrangement of ponds for settling out waste. Each element is, moreover, housed in a building of such ordinary (one is tempted to say *primitive*) description that one cannot doubt the functional rigor of the whole. Yet the buildings and their surroundings defy easy definition, seeming to cloak ever more intriguing mysteries within an apparently undistinguished Mediterranean form.

The perfectly square courtyards of the residence and winery have numerous precedents in farms throughout France and Italy. Robust construction and regular lines are evident in both. But Mangurian and Turrell want to unite the sky and the building, and so pare off the cornice to a pure, optically invisible edge rather than duplicating the embellishment normally employed to return our gaze to the building surface. Because of the precise calibration of sight lines between the courtyards, it is then possible to superimpose the cinnabar red wall of the residence on the blue sky plane seemingly stretched between those edges.

Such entertainments, couched in a language simultaneously architectural and sculptural, defy questions of authorship. Where the proposal is most intensely architectural (for instance, in the arcades surrounding the nearly twin courtyards), it is also most subtly artful (as in the choice of a color to enhance the effect of the *Ganzfeld*).[2] Or conversely, where it is most persuasive as a work of art (as in the placement of a horizontal tunnel beneath the house), it is also most memorable as an architectural device, summoning up images of blast tunnels, Jeffersonian bunkers, and the strange, inclined tunnels of pyramids.

Mangurian and Turrell give no practical explanation of its purpose, leaving it to the visitor to discover what is going on. But it does have a purpose, which becomes more evident each day, as the earth keeps ticking on its orbit like the hand on a clock until, incredibly, light from the rising sun rushes up the inclined floor of the tunnel, contacts a prism stationed at the crossing, deflects

skyward, then scatters through exotic metal halide filters to project a fleeting corona on the floor of a small, intensely geometric space positioned directly above, within the house. This room is known, without a trace of irony, as the Sun Room – which it immediately ceases to be until the earth comes around once more, and the instrument again registers an impulse.

Heron of Alexandria conjured up similar spectacles for the temple-goers of his own time, devising trumpets that sounded at the opening of a ceremonial door and a mechanism which opened the temple doors in "spiritual" response to a sacrificial fire on the altar.[3] His motive power, described in *Pneumatica*, was that of air, the "earth's breath," and like Mangurian and Turrell, his aim was less the productive use of his various inventions than their remarkable effect upon his audience.

Resonance, not regulation, is the ticket. Mangurian and Turrell have perfected the aesthetics of the tweak, funnelling the forces of cosmic order through minimal devices to maximum effect. Gravity, light, space, and time have been assembled as though they were themselves architectural elements, and it is their composition, not that of stone and glass and steel, which we perceive as art.

The various axes which terminate in a sister volcano across the valley, the equatorial position of the sun, and the *Nebula Pegase* – each primeval fix indicates that Mangurian and Turrell were trying to fine-tune the buildings, the vineyards, and the harvest to the spiritual and mechanical resonance of the seasons; trying to use that congruence to leap into the metaphysics of viticulture and create a winery dedicated not to the cliché-ridden "Good Life" to be imagined every time we pull a cork, but to the poetic realities of time, nature, and enterprise exemplified by the process itself. So, the image will not, indeed *cannot*, decorate a label or be captured in the most intricate T.V. spot.

It must be experienced.

However, wine-making is a business. It is a good business, with a lengthy pedigree and near-institutional status. It is even possible, given a good year or superb craftsmanship, to bottle a wine of exceptional quality. But the *mythos* of the wine-maker neither requires nor deserves the pious tone implicit in much of Mangurian and Turrell's design. One can understand their need to invest the complex with enduring values, and they have; but aren't there other values, equally persuasive, in the American imagery of farms and warehouses? After all, Northern California is a long way from Europe; and stainless steel, refrigeration, and spectral analysis have transformed beyond recognition the processes housed in traditional buildings.

So what motivated Mangurian and Turrell's choice of imagery? The answer is in their work, in the obsession with abstract qualities of light and space which formed the basis for their collaboration.

Like Malevich, who sought to transcend the bonds of referential imagery, Mangurian and Turrell have attempted to create an architecture of pure geo-

metric simplification. By banishing symbolic elements and concentrating on technical means to achieve geometric purity, they have divested their buildings of associative imagery and achieved a vocabulary of self-contained, harmonic experiences.

"An ineffable sensation," says Melinda Wortz, "much like that sought in transcendental philosophy . . . the dissolution of opposites like figure and ground can be seen as a precise correlate for mystical states."[4] This weaving in, eliminating the edge between wall and universe, function and art, has much to do with Islamic tradition, wherein the space demands to be seen as a whole. Explicit devices like cornices, moldings, or capitals are replaced by contextual, visually ambiguous motifs which function to eradicate, rather than elaborate, the syntax of construction.

As architectural substance is removed, to be replaced by invisible sutures, the alchemical translations of enclosure, from stone to water to air, form spatial vessels unlike any we've experienced. Its totality delivers the message (rather than an emblem which denotes it) so that, like the music of Terry Riley and Philip Glass, melody is abandoned, leaving the undefined rhythmic chant: the rhythm of the arcade or, as Louis Kahn has said, the rhythm of "Light, no light, light, no light . . ."[5]

In the system of architecture currently in vogue, the message is represented in the work. If the architect wishes to express elegance, let him show something reminiscent of aristocracy; if vulgarity, let him display a billboard. But these messages can only be deciphered by the conscious, *analytical* part of ourselves, rather than the unconscious. Historicism insists that we isolate a corner of the whole, react to its message, proceed to the next, and so on, until we have digested its entirety. Moreover, in its insistence on the literal embodiment of cultural precedent, it presupposes a world of finite dimensions, excluding the realm of the spirit and limiting access to those who share the code.

Thankfully, for Mangurian and Turrell there are no codes, no hidden messages. Yet, far from the foreign abstraction we might expect to encounter, their design provokes a surprisingly visceral response, accessible only by participation. Those stairs, that tangle of platforms and grottos, placed to lead visitors through what might otherwise be a labyrinth of close encounters, have much in common with French landscape architecture, particularly that at Vaux-le-Vicomte and Pontchartrain. There, the unparalleled elegance of Cartesian geometry, organized by André Le Nostre and his architect-collaborators Louis Le Vau and Jules Hardouin-Mansart, knits a family of fences, statuary, fountains, and moats into a compositional unity much as Turrell and Mangurian unify their assortment of illuminated rain birds, black-pool settling basins, and obsidian stairs.

Both embrace the spaces between objects and people, peppering the terrain with a witty interplay of near and far objects. Both animate reality with vir-

tuoso illusions. Both create harmony between various individual components in order to ensure the perception of the whole.

This could not succeed if Mangurian and Turrell had not interwoven perception on so many levels, with such obvious authority, so as to create a panoply of art experiences within the working principles of the whole. Art is infused throughout the site to create a place where the sky and the stars and the seasons will suffice.

EDITOR'S NOTE: This essay refers to the project proposed by Mangurian and Turrell. Theirs was part of an open, international, two-phased competition. The team was one of five teams of finalists that were asked to develop conceptual designs for a winery, private residence, and sculpture garden located in the Napa Valley, California. The jury, by unanimous acclamation, found two design concepts to be of the highest excellence, of which theirs was one.

1. Thus, in principle at least, the collaborative project by Mangurian and Turrell, shown for the first time at San Francisco's Museum of Modern Art, is a significant prototype. Other projects invited for the competition, by Solomon/Bofill/Dillon/Stauffacher, Solomon/Carpenter, Saitowitz/O'Brian/Levey/Zimmerman, Batey/Mack/Saari, and the winning scheme by Graves/Schmidt covered the spectrum of professional collaboration without the exhilaration of a true duet, while that of Mangurian and Turrell offered a tantalizing glimpse of truly harmonic sensibilities.

2. The *Ganzfeld* is a space in which there is no perception of form due to a homogeneous color field.

3. Heron describes his inventions in remarkable detail, as the following text will reveal:
"Let the temple stand on a pedestal, on which lies a small altar. Through the altar insert a tube with its mouth inside the altar and the mouth contained in a globe below, reaching nearly to its center. The tube must be soldered into the globe, in which a bent siphon is placed. Let the door-hinges be extended downwards and turn freely on pivots: and from the hinges let two chains, running into one, be attached by means of a pulley to a hollow vessel, which is suspended – while other chains . . . are attached by means of a pulley to a leaden weight, on the descent of which the door will be shut."
From Jack Lindsay, *Blast-power and Ballistics* (New York: Harper & Row, 1974):332.

4. Wortz, Melinda. "Architects of Emptiness." In *Architectural Sculpture*, 30. Los Angeles: Los Angeles Institute of Contemporary Art, 1980.

5. Kahn, Louis I. "Space and the Inspirations." *Architecture d'aujourd'hui* (February-March 1969):15.

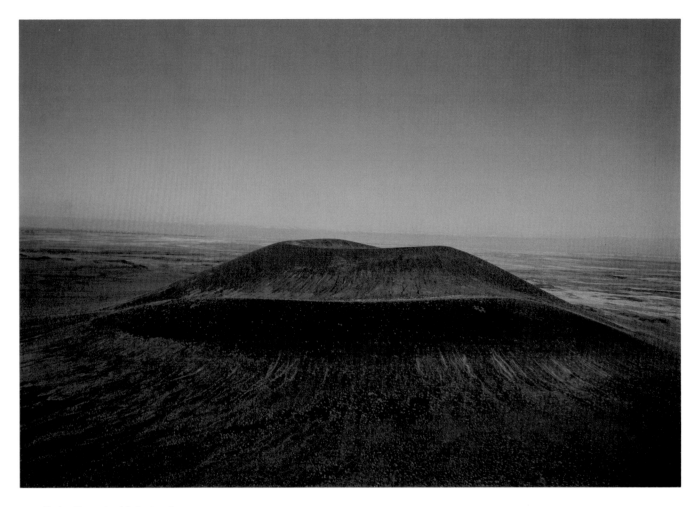

61 Roden Crater (aerial view), 1982

Light, Space, Time: The Visual Parameters of Roden Crater

Craig Adcock

The Concept

James Turrell's Roden Crater project is concerned with light and space, with how they develop and change through time. The work is about their subtle interaction.[1] The extinct cinder cone is one of the more than four hundred craters that make up the San Francisco volcanic field lying to the north of Flagstaff, Arizona.[2] Roden Crater has been dormant since the mid- to late Pleistocene,[3] but there has been relatively recent volcanic activity in its immediate vicinity: Sunset Crater, about fifteen miles to the west, last erupted in 1064–65.[4]

Roden Crater is on the eastern edge of the field, off to itself, but many other cinder cones are visible from its flanks. Among the most prominent are Merriam Crater to the south and Black Bottom Crater to the west. Sunset Crater can be seen to the far west, nestled at the foot of the San Francisco Peaks. These peaks are the remnants of a much older stratovolcano that may have originally risen to over fifteen thousand feet. When the central magma chamber of the volcano collapsed some five hundred thousand years ago, it left the present ring of mountains.[5] Mount Humphreys, the tallest of the group, rises to 12,633 feet, the highest point in Arizona.

To the north and northeast of Roden Crater, a plain stretches toward a series of mesa formations. This sequence of cuestas runs along the northern side of the Little Colorado River Valley. Ward Terrace and the Moenkopi Plateau can be seen in the distance. From the north-northeast to the south-southeast, the Painted Desert extends across the Navajo Indian Reservation. The far eastern horizon is punctuated by the prominent volcanic necks that make up the Hopi Buttes volcanic field fifty miles away.[6] The earth here is layered and ancient. An enormous amount of time lies exposed in the desert that surrounds Roden Crater.

When complete, the Roden Crater project will disclose the manifold of time – a manifold ranging from the geologic and astronomic to the immediate and transient – by revealing the interconnections between light and space. Turrell says he is interested "in the perception of space and how light inhabits space":

I'm also interested in the reflexive act of coming to see your own perceiving. My work is more about your seeing than it is about my seeing, although it is a product of my seeing. I'm also interested in the sense of presence of space; that is, spaces where you feel a presence, almost an entity – that physical feeling and power that space can give.[7]

Roden Crater is already a place with presence. Simply as a volcano, it has a powerful sense of "entity."[8] But through a series of subtle alterations, the crater's natural presence will be conjoined with art.[9] Turrell will transform the crater into a stage for a wide range of light and space experiences. Time and again, the crater will alter space with light and change the quality of light with space. It will empower both light and space by using time, by using sequence and order.

The Approach

The Roden Crater project will allow us to confront our own perceptions in ways that are personal, often liminal. An important part of this process will involve our arrival at the site. There are a number of ways to approach Roden Crater, but the one that Turrell finds particularly effective is the drive north from Flagstaff to the Sunset Crater National Monument and, from there, east to the site. Along this approach, we can see many of the cinder cones in the San Francisco volcanic field as we make our way to Sunset Crater through the young lava beds associated with the 1064–65 eruption.[10] From the Cinder Hills Overlook at the base of Sunset Crater, we first see Roden Crater in the distance, out on the slope that gradually descends toward the Painted Desert. But as we drop down from the higher elevations near the mountains, the crater momentarily disappears. After roads are established, we will be able to continue on from the eastern edge of the national monument and cross the uneven plateau developed on the overlapping basalt flows that over the millennia have again and again spilled out from the volcanic field and run down toward the Little Colorado River Valley. When we arrive at a point about four miles west of Roden Crater, the top of the volcano will reappear.

Continuing along this approach, we will drop down from an elevation of around 5,500 feet, about two hundred feet onto the surface of a lower lava flow, entering this second terrace through a notch in the upper lava bed. As we descend into this box-shaped depression, the volcano will again disappear. Transportation will be left here, where it cannot be seen from the crater. This area is surrounded by high lava cliffs on three sides. As we walk out from this enclosure, the crater will again become visible, and from this lower vantage, we will no longer have a sense of looking down toward Roden Crater but rather at it, full-face. This kind of presentation and re-presentation is an important part of the work. It gives the crater a visual history and places it in time, in memory.

By walking to the north, we will come to the cliff face running along the margin of the upper lava flow. A series of architectural spaces are planned for

this area and will be constructed inside the cliffs. These rock-cut spaces will include a hangar, a planetarium, a museum to house Turrell's other works, and a visitors' center with a library containing information about the crater. An airfield is planned for the triangular-shaped expanse in front of the escarpment. Flying, Turrell's avocation, is a source for the imagery of Roden Crater; when the project is completed, it will be an important alternate way of arriving at the site.

From the port area, we will walk to the crater; this slow approach will establish a proper cadence. Making our way along the southern limb of the landing field, we will come to the eastern edge of the terrace, where there is another steep drop-off. Climbing down a sloping embankment, we will arrive at the floor of a wash near Roden Spring, somewhat to the south of our arrival point on the upper plateau and about a mile and a half to the east. The crater will now be to the northeast, displaying its classical conical profile. From here we will walk the two miles or so to the crater, across an open flat at an elevation of nearly five thousand feet; the volcano rises to a height of 5,415 feet. Our approach will reveal the mass of Roden Crater. As we get closer and closer, it will loom larger and larger, and, increasingly, we will have a sense of looking up at it.

By circling around the main body of Roden Crater on its northern side, we will become aware of its complex shape: the ridge that cups its western side, the prominent fumarole, or secondary vent, on its northeastern flank and, finally, the circular lava scarp along its eastern edge will become visible. After circling the crater and arriving at its eastern side, we will enter an arroyo that leads up to an esplanade fanning out around the fumarole.

The tightening spiral of our approach will present and re-present the crater and the desert environment it inhabits. Our route across the open plain will establish the space of the crater. Out on the floor of the desert, we will be dwarfed by the openness. As we proceed up into the entrance ravine, this huge space will narrow and contract. When we come out at the level of the esplanade, our sense of vista will again expand outward toward the horizon, but it will expand even further. Our awareness of the immense plain surrounding the crater will be emphasized and extended by the two hundred foot increase in elevation.[11]

Throughout our approach to Roden Crater, our relationship with the environment will constantly shift – yet this particular approach is but one way, one path, to the mountain. It alone offers almost infinite variety. It is one path in the morning, another in the evening; one path in the summer, another in the winter.

How we perceive the crater is contingent upon how we make our journey to it. In one of his discussions of "powerful places," Turrell emphasizes the importance of arrival, of approach:

The Grand Canyon is one of those places. It's possible to come up to the canyon in such a way that you don't even know you're arriving, and then suddenly burst out into it. I like to fly up the Colorado River to a canyon that you have to climb into through a tiny valley. I fly through the bottom of that valley, in a slow climb, to a small opening; as you fly through the opening, boom, suddenly you're in it, and the ground falls away for five thousand feet. Thus, the approach can order your experience. You can come in through the side door . . . and have a different experience than if you enter through the front door; you can reorder it as you get in, but entry is important.[12]

The Four Cardinal Spaces

When we arrive at the esplanade, our options for reordering our visual experiences will become complex. At this level of the crater, four interior architectural spaces will be constructed, positioned in relation to the four cardinal directions: North, South, East, and West. Built inside the mountain, each of these rock-cut chambers will open onto a portion of the external environment. Turrell compares the spaces to bunkers: they will dominate segments of the landscape in front of them and will be fundamentally tied to specific directions.[13] The powerful austerity of bunker architecture appeals to Turrell, and the crater's interior chambers will share its characteristics. He points out, however, that the architectural forms of the spaces will be less important than the forces they contain. As in his earlier pieces, the work will consist of, as Turrell puts it, "shaping the things that are not it."[14] The interior spaces at Roden Crater will be "open, yet protective. They will have a positive kind of clearness, but they will not be empty."[15]

The spaces will be far from empty; they will be filled with light. The minimal forms of the architecture will receive light from the surrounding environment and give it shape and texture. The interiors will, in a sense, make the light. In turn, the light will energize the spaces; it will give them a sense of presence, and then make us aware of that presence. In Turrell's terms, the neutrality of the structures will focus our attention on the light, the space, and their mutual interaction.

The Northern Space When we arrive at the top of the arroyo, we will enter a wedge-shaped structure bridging the saddle formed by the juncture of the esplanade and the ridge that runs along its northern side. From this entry portal, we will make our way into a large, circular chamber, about forty feet across, inside the northern ridge. A stairway will lead up out of the space, at a forty-five degree angle, to a walkway running along the northern side of the ridge. This north-facing stairwell will allow the interior to receive a variety of subtle lights, including the silver-gray luminance long sought by painters. In the daytime, only a small amount of light will come into the chamber; at nighttime, it will be virtually black, just above criterion.

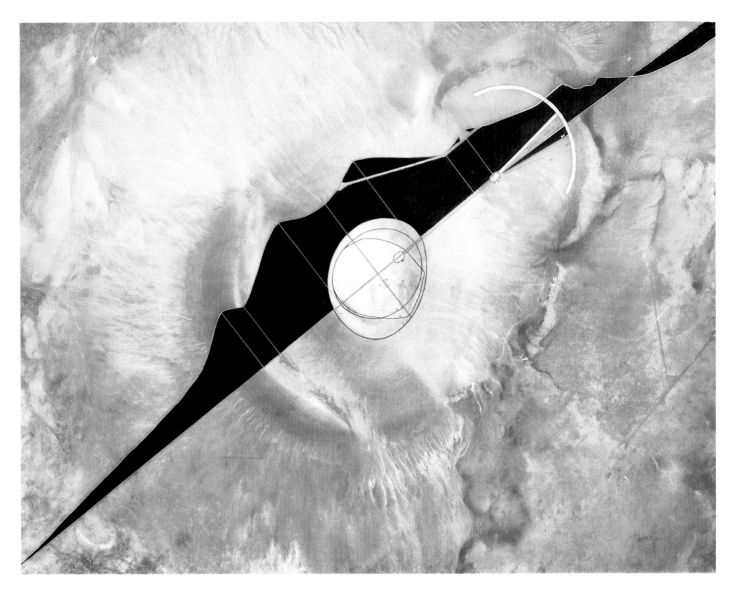

62 Roden Crater and cross-section with fumarole arc, 1985

From the side of the chamber opposite the stairwell, the opening will subtend about one-half degree of arc; that is, it will frame an area of sky about the size of the sun or the moon as they appear to us. From this position, we will be able to look up through the opening, at an angle of approximately twenty-six degrees, in the direction of the polestar. At a conceptual level, the stairwell will be a small skyspace framing the slow precession of the earth's axis and the consequent succession of polestars. A complete "precession of the equinoxes," as this slow cycle is known, requires some 25,800 years. Among the brighter stars that periodically mark the position of the pole are Vega, Thuban, and Polaris.[16] The immense period of the precession is essentially incomprehensible. Nevertheless, light from the current North Star, and from subsequent north stars, will enter the interior space on the north side of Roden Crater. During those periods when there is a north star, it will be framed by the stairwell's aperture. Our perception of its light will be conditioned by our knowledge of what it implies; it may allow us to look, however dimly, beyond our own specific moment.

The stairwell in the Northern Space will not only allow light to enter, it will also allow us to exit. We will come up out of the lower chamber into the huge outer space of the northern desert. The effect will vary throughout the day and night. At night, the ridge will provide an important station for looking at the stars in the northern part of the sky and for observing such ephemeral events as the aurora borealis. At the latitude of Roden Crater, these northern lights are infrequent, but they can be remarkable, even so far south. They are most often seen as reddish glows of light in the northern sky and are visible only during the intense atmospheric substorms that occur shortly after very large solar flares.[17] By going back inside the inner chamber, we will be able to experience the subtle auroral light as it comes through the skyspace opening of the stairwell. At those times, the inner space will have just a blush of rosy color.

During the day, the northern walkway will be a good place to look at the mesa formations in the distance. Ward Terrace, the Moenkopi Plateau, Newberry Mesa, Padilla Mesa, the First, Second, and Third Hopi Mesas, and many others are conspicuous at different times of the day. They are all particularly interesting during the early morning and late evening. The low-angle illumination of sunrise and sunset strikes the cliffs full-face, lighting them into virtual incandescence. For a few moments, they ignite into prominence – pink, golden, brilliant – and then slowly fade back into the general intricacy of the landscape.

The Western Space From the Northern Space, we will make our way back out through the entrance structure up onto a walkway circling around the esplanade. To the west, this path will lead to a kind of hummock located near the point where the esplanade comes back into the side of the crater. An oval chamber, approximately thirty feet wide at its minor axis and forty feet wide at its major axis, will be carved out inside this formation, echoing its natural shape.

From the eastern side of this space, we will look through a large, rectangular opening in the western wall toward the horizon in the distance. The floor of the interior chamber will slant downward toward the west; when we are at the western side, the large window will be well above our heads. During much of the day, ambient light will fill the chamber, and when we stand beneath the window and look back toward the curved wall at the opposite end of the space, the light will create a *Ganzfeld*, a homogeneous visual field.[18] The light will take on a grain and seem to hang suspended inside the space. During the day, as the sun moves from east to west, the quality of this fog, or mist of light, will change constantly until, finally, at sunset, direct light will burst through the opening, causing the suspended light to disappear.

The Western Space will perhaps be most spectacular during this twilight period. Clouds accumulate along the San Francisco Peaks and make the evening sunsets especially impressive. Outside, from the top of the hummock, we will be able to see the full display of the sky; inside the chamber, our visual field will narrow, and only a portion of the western horizon will be visible through the opening. This embrasure will focus our attention on the astonishing range of colors visible during a sunset.[19]

The horizon that will be seen from the Western Space has a ragged, uneven aspect, and the ever-changing cloud formations that pile up along the line of peaks are impressive. The visual possibilities of interacting clouds and sky, while apparent in every direction around Roden Crater, seem especially evident in the west. The surfaces and openings of moving clouds allow the light to take on rapidly shifting patterns. Often, the western mountains gather in the thunderstorms that move across the desert. These storms are prevalent around the crater, especially during summer. Thunderheads, and the sheet lightning they produce, will be framed by the space's opening. When the lightning discharges through the cloud banks, the interior of the chamber will be flashed with brilliant, momentary light.

Far more rarely, but equally dramatically, the sun itself may sometimes produce a flash of light. If conditions are right, the sun can generate a *green flash*. Because it so seldom occurs, the green flash is a holy grail for observers of atmospheric phenomena, and Roden Crater is a place where we can expect to see it happen.

The green flash results from the dispersion, scattering, and absorption of the sun's light by the atmosphere just after sunset and just before sunrise.[20] When it happens, a band of intense green light appears at the upper margin of the sun's disc. During its transition across the horizons at twilight, the sun's light has to shine through a large amount of atmosphere because of its low angle. The accumulated air acts like a prism, separating the sunlight into its spectral colors. The longer the wavelength of the light, the less it is bent. Thus, the long wavelengths of the sun's red light are dispersed less than its violet wavelengths. Un-

der ideal refractive conditions, the setting and rising sun would be red and orange at its bottom and green, blue, and violet at its top. But atmospheric gases, water vapor, and suspended dust particles absorb red and orange light and scatter blue and violet light, leaving green as the color most likely to be seen.[21]

Green flashes are among the most unusual visual phenomena. They are rare partly because the atmosphere normally filters out the green light, just as it does the other spectral colors of the setting and rising sun. But clear desert air improves our chances of seeing the event. That green flashes are sometimes seen from Roden Crater gives some indication of the range of its observational potential. Turrell, who has spent more time at the crater than anyone, has seen the green flash there twice at sunset. But the topography of the area around the crater – mountains to the west and flat plains to the east – may make the green flash more likely in the east at sunrise than in the west at sunset. A low, flat horizon is another parameter that increases the likelihood of the green flash and explains why the phenomenon is most often seen at the ocean or other large bodies of water. When the setting sun produces a green flash at the crater, its light will enter a space filled with a complementary light. In metaphorical terms, the space, like us, will await its occurrence.

The Eastern Space On the opposite side of the esplanade, carved into the edge of the scarp, a space will face toward the east, its opening framing the almost straight horizon line at the far edge of the Painted Desert. The shape of the Eastern Space will be somewhat complex: its eastern half will be rectangular; its western half will flare out along its sides like a wedge, and end in a long, curved wall.

We will enter the Eastern Space through stairways leading underneath the circular walkway. As we come back up into the main chamber, we will arrive at a kind of first-viewing platform that will allow us to look through the rectangular opening of the space, across a reflecting pool placed at eye level. One of the engineering problems presented by the site is the surprisingly large amount of water that annually drains through the volcano. Turrell has decided to incorporate into some of the spaces the control system necessary for handling this excess water, and part of the flow will be diverted through the Eastern Space. From the platform, the mirror-like pool will seem to be just at the horizon line. At sunrise, we will look out across the water and watch the morning sunglow gradually become more intense, until the sun itself finally comes up over the surface of the pool, reflects across the water, and fills the space with brilliant light.

The light of the morning sun is, by itself, intrinsically interesting, but it will also illuminate a number of physical features in the surrounding environment that will engage our attention when we are inside the Eastern Space. It will bring alive such things as the mist that is sometimes thrown high into the air by

Grand Falls, an unusual formation on the Little Colorado River about four miles east of the crater.[22] The falls are so far away that they are very difficult to see during the day, but at dawn the light glints across the surface of the river, and in the morning coolness, plumes of condensed moisture shoot up into the air, making the falls the most prominent feature on the landscape. Sometimes the mist mixes with the fog banks that follow the river along the floor of the valley.

The waterfall is only one of a number of objects visible to the east of Roden Crater. There are buttes, mesas, and complex patterns cut into the easily eroded Chinle Formation, on which the badlands of the desert have developed.[23] All of these features change depending on the angle of incident sunlight that strikes them. At sunrise they seem particularly conspicuous – the long shadows make them stand out. The rising sun also illuminates the spectacular colors of the Painted Desert and its seasonally changing vegetation. Desert plants come into bloom very quickly and then disappear just as rapidly.[24] During times of efflorescence, they cover the rocks with bright color; during times of quiescence, they leave them virtually bare, unmasking the more subtle earth tones that give the famous desert its name.

The primary orientation of the Eastern Space will be toward the section of the horizon where sunrises occur. The chamber's opening will delimit the yearly oscillation of the rising sun back and forth along the horizon, from one solstitial extreme to the other. Both the window and the back part of the Eastern Space will measure the movement of the sun. When the sun comes over the horizon, its light will shine through the main opening, across the pool and, finally, through a narrow passage into the back part of the chamber.

The light effects engendered by this architectural arrangement will recall Turrell's early Wedgework Series, first realized in 1969.[25] Throughout the year, this sun-generated wedgework, a subtly colored, translucent partition of light, will scissor back and forth in response to the sun's movement from winter to summer solstice. The wedgework will go through a daily sequence of changes. The sun traverses one degree of arc every four minutes, and will thus cross the eastern opening of the chamber fairly quickly. Throughout the day, the wedgework partition of light will evolve. At daybreak, brilliant light will cut through the back part of the chamber, and then, as the day progresses and the sun passes out of and above the opening, the light will become more and more subdued.

Like most of the spaces at the crater, the Eastern Space will present a variety of light qualities. What we see will depend as much on our orientation as the space's. When inside the chamber, we will, as Turrell puts it, be "watching the space look at something."[26] We can look outward with it or we can turn around and look into the light the space perceives. Metaphorically, we will be able to look at the space's vision. In this regard, the orientation of the art will present a model for our perceiving our own perceiving.

The Southern Space After we have left the Eastern Space and made our way back up to the esplanade, we will be able to continue around the circular walkway until we come to a fourth architectural area. The Southern Space, like its northern counterpart, will be round, but will be much larger, seventy to eighty feet in diameter, with a thirty-foot opening in its ceiling. Constructed partially above ground and surrounded by black malpais rock, the Southern Space will be located inside a kind of small secondary crater, an upwelling of basalt lava, on the southeast side of the esplanade. Like many of the other spaces at the crater, the shape of the Southern Space will reflect the natural formation of its specific location.

The upper opening in the central, kiva-like chamber will be a large skyspace with enough width to frame both the summer and the winter zeniths of the sun.[27] As the sun passes over the meridian, very bright sunlight will come into the space. The effect of this intense light will often be similar to Turrell's early projection pieces.[28] In the heat of the summer, it will slam into edges. When there are no clouds overhead, the area of sky visible through the opening will be intensely blue. Throughout the year, the desert sky will give the Southern Space a sense of clarity and precision. Its character will be brilliant, sunshot, in contrast to the subtle obscurity of the Northern Space.

The Southern Space will also be impressive during twilight transitions. Clouds at varying altitudes directly overhead come sequentially into view: first the low cumulonimbus clouds; then the higher cirrus clouds; sometimes the nacreous clouds, very high up in the stratosphere; and, on rare occasions, the noctilucent clouds at the mesopause are, in turn, illuminated by the reddened light from the sun.[29] Looking up at these changes from inside the Southern Space will afford some of the most interesting viewing available at the crater.

The cloud formations will also make us aware of distant spaces in the sky above the crater. They will provide us with visual clues to shapes in the sky – spaces that might otherwise be undetectable. The large lenticular clouds that form around the San Francisco Peaks reflect waves in the jetstream, giving indications of patterns in the wind currents. The clouds are particularly appealing to Turrell, who sees them as metaphors for the visual experiences available while flying, particularly while soaring.[30]

The unusual perceptual aspects and the sheer visual magnitude of flight are important sources for Turrell. Much of what he will do at the crater will involve pulling the visual qualities of the sky down to the surface. Making things that are usually perceptible only when flying part of the earthbound visual phenomena of the spaces will serve to indicate something about the limits of our perceptual capacities. In the air, we are out of our element. The visual anomalies concomitant with flying – sometimes dangerous, sometimes supremely beautiful – tell us about seeing. When completed, the spaces at the crater will do the same thing.

One of the crater's revelations will seem particularly apropos in the Southern Space. As the day gets darker and darker, our visual systems switch from photopic to scotopic vision. When the rods in the eye activate, the retina seems to produce its own illumination.[31] The *Purkinje Effect*, as this self-contained, momentary increase in brightness is called, will take on a kind of metaphorical significance in the brightest space at the crater. It will demonstrate one of Turrell's primary concerns and one of the crater's central themes: the perception of light involves not only the physical state of the external environment, but also the internal physiological and psychological states of the perceiver.

The Seven Major Spaces
The spaces at the level of the esplanade will deal predominantly with the light from the sun, although there are important exceptions to this rule, such as the Northern Space, which deals with the precession of the polestar. At the next higher level, however, located at the fumarole, the light from the moon and other astronomical objects will become much more central to Turrell's project and to the crater's interactive network of light and space. From the esplanade, at a point across from the Eastern Space, a walkway will lead up to a series of spaces located beneath the apex of the fumarole. The upward path will begin as a ramp and then, as the inclination gradually increases, become a shallow stairway. The architectural character of this structure will recall the naked-eye observatories built by Jai Singh in central India in the eighteenth century.[32] As the stairway approaches the top of the fumarole, it will wedge itself into the side of the mountain. The perspective will be arranged so that as we approach, the entrance to the spaces will seem to fall away. Visually, our arrival will be delayed by the organization of the architecture.

The top of the fumarole is 180 feet higher than the level of the esplanade, and our ascent up the side of the mountain will make us aware of this difference. The climb will first increase our sense of openness and then, as we walk into the notched entryway, again decrease it. There will be five chambers inside the fumarole: the four lower rooms will be aligned with the axis of the northernmost sunrise and the southernmost moonset; the fifth, above them, will be open to the sky.

The First Fumarole Space The wedge-shaped opening of the First Fumarole Space will measure the extreme positions of both sunrise and moonrise. At the latitude of Roden Crater, the position of the sunrise moves through approximately sixty degrees of azimuth. At summer solstice, the sun is at its northernmost position, which is sixty degrees, thirty-six minutes; at winter solstice, it is at its southernmost position, 119 degrees, twenty-four minutes. This yearly swing of the sun back and forth along the horizon is mimicked by the monthly oscillation of the moon from standstill to standstill. The orbit of the moon,

however, is inclined some five degrees, nine minutes relative to the ecliptic. Furthermore, the nodes of its orbit slowly precess or, more accurately, regress. This wobble complicates the moon's swing back and forth along the horizon. Its major and minor standstills vary according to an 18.61-year cycle.[33] At its major standstill, the moon rises about 6.5 degrees outside the solstitial extreme of the sun; at its minor standstill, which occurs 9.3 years later, it rises 6.5 degrees inside the solar extreme. Then, after another 9.3 years, it again returns to its major excursion outside the solstitial position of the sun. The entrance space at the fumarole will be aligned with these extreme positions of the sunrises and moonrises.

The Second Fumarole Space The second space inside the fumarole will not receive as much direct light as the first space; it will be designed for more subtle light effects. One of the most beautiful natural light phenomena occurs at sunset or, perhaps more accurately, at "nightrise."[34] Even after the sun has set in the west, the eastern sky continues to present remarkable prospects. If we look east during sunset, rather than at the more brilliant displays of red and orange in the west, we can see the shadow between the day and night sides of the earth advancing toward us. As the terminator passes, the sun drops below the western horizon, but light rays continue to illuminate the eastern sky for more than an hour after the sun has gone down.

Just after sunset, the earth casts a shadow up into the sky.[35] We can see the bluish-gray shadow rise up into the atmosphere, an effect that is enhanced when the air is hazy, because the haze provides something in the sky for the shadow to fall upon. When the twilight arch is visible, the bottom of the eastern sky is filled with the silver-blue shadow of the earth itself and the top with the pinkish tones of the attenuated sunlight, which for a while continues to rake through the sky. From inside the second space, the eastern opening will look directly into the shadow, but the light from the upper, sunlit part of the sky will also enter the space. During the first few minutes after sunset, the second space at the fumarole will be filled with an ethereal blue and pink light.

The Solar Space Once a year, the northern extreme sunrise will illuminate the first three spaces at the fumarole. The spaces are linked together in such a way that during the winter solstice the sun's light will shine through all three chambers. This arrangement will allow the sun's image to be projected onto the back wall of the third space according to the principles of the pinhole camera.

The spaces at the fumarole will be charged and then recharged with different kinds of light. Most of the time they will seem to be light-filled. A great deal of effort will be expended making the interior surfaces disappear. The walls in each space will be constructed out of plaster combined with a specific type of desert sand chosen for that space's light qualities. The space will then be sand-

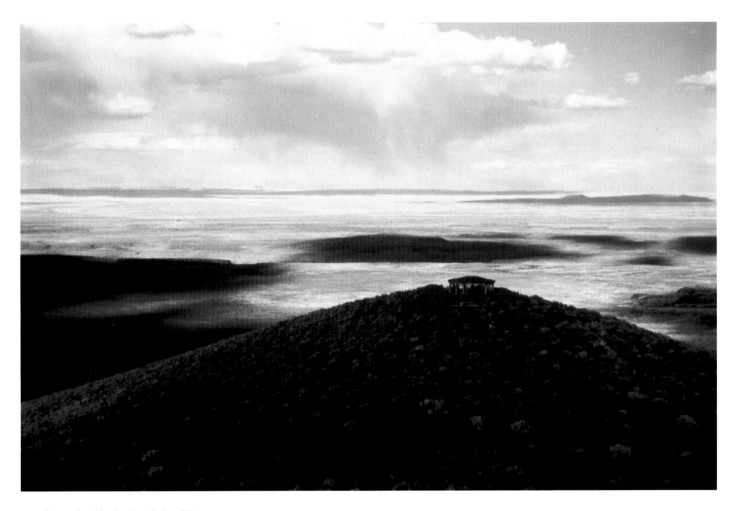

63 Fumarole with view into Painted Desert, 1981

blasted with the same sand; the residue will be left as a covering for the floor. This treatment, when combined with carefully controlled inclination of the walls, will cancel out reflectance. As a result, our visual experiences inside the spaces at the crater will be like those in one of the sensing spaces of Turrell's earlier "Space-Division" pieces: the light will be unfocusable. In the low-level illumination, our visual systems will not be able to accommodate to the space, and we will perceive a kind of textured light hanging in midair and extending indefinitely into the distance.[36]

As we proceed through the spaces at the fumarole, we will experience a special kind of light that, as Turrell points out, somehow looks just like we expect pure light to look.[37] Each of the chambers will receive ambient light from different portions of the external environment, and each will thus be filled with different colored light. These colors will change subtly and slowly throughout the day and will be especially sensitive to changing cloud cover. The qualities of the light inside the different spaces will diverge as the day progresses – a process that will accelerate during twilights. These daily rhythms will be punctuated by periodic image events. The light in the spaces will be unstructured; it will constitute a *Ganzfeld*. When an image of an astronomical phenomenon is projected into one of the spaces, it will empty it of suspended light. The structured light of the image – like the projection of the sun into the third fumarole space – will act as a catalyst, causing the delicate lattice of the *Ganzfeld* to collapse.

The Lunar Space The fumarole spaces will be connected to the main bowl of the crater by a 1,035-foot-long tunnel; when we enter the fourth fumarole space, we will be in the antechamber of this tunnel. We will be able to look up the length of the tunnel toward an opening that, from this distance, will be approximately the size of the moon. Every 18.61 years, when the moon is at its southernmost declination, it will pass in front of this opening. And at that moment, the moon's image will be projected down the tunnel onto the wall of the fourth fumarole space, echoing the sun's projection into the adjacent space on the opposite side of the wall.[38]

As we proceed deeper into the spaces inside the fumarole, the light will become increasingly obscure. Most of the time, the Lunar Space will be one of the darkest rooms at the crater. Its walls will be covered with a whitish, moon-colored sand found in the Painted Desert not too far from Roden Crater. This light-colored sand will pull in the very small amount of light that penetrates the sequence of chambers to the east or comes in through the long tunnel from the west. Nevertheless, the thickened light will remain almost subthreshold. The lunar projection will affect this space much as the sun projection will the adjacent solar room; it will clean the chamber of its darkened mist, but the Lunar Space's light and the moon's imaging will be far less intense. The moon's projection will fall onto a surface covered with sand almost its own color.

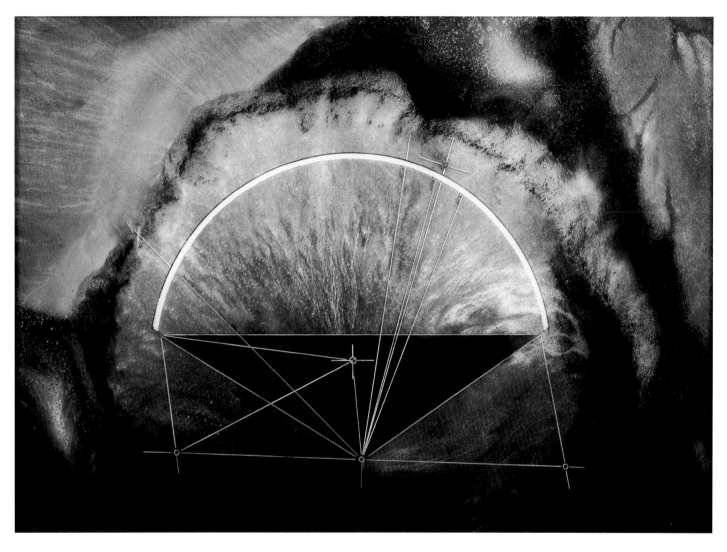

64 Fumarole walkway with solar and lunar alignments, 1983

The rhythm of the Lunar Space will also be much slower; it will remain fairly inactive for over eighteen and a half years, and then experience a relatively brief period of recurring, dramatic change. The long period of the moon's regression means that it will remain near its southernmost excursion for several months. The image events at the tunnel will thus take place on several consecutive days each month, for several consecutive months that year. Then the moon will again move out of the alignment, not to return for another 18.61 years.

The syncopation of the solar and lunar events in the adjacent third and fourth fumarole chambers will be tied to a much longer cadence involving a sequence of eclipses. The *Saros*, as this cycle is called, has an interval of approximately eighteen years, eleven days and recurs over the centuries. The cycle involves some seventy lunar eclipses during a period of 870 years and some fifty solar eclipses during a period of twelve hundred years.[39] While the paths of total eclipses will pass over the Roden Crater only a few times during the cycle, the pattern of the Saros will be measured by the crater, and serve to establish a remarkable aspect of our space, albeit a somewhat complicated one. The light will disclose something of the geometry of our astronomical position.[40]

The eclipses that occur at the crater will be projected into the fumarole spaces. Special windows in the chambers will be opened only during such periods. Thus, over the very long reach of time, the image of an eclipse will periodically enter a fumarole space and act to clear it of suspended light. In this regard, eclipses will be analogous to the far more frequent sun and moon projections. Windows in the fumarole spaces will also be opened to mark other unusual conjunctions, such as planetary appulses. In addition, they will frame the apparently retrogressive motion, relative to our observational position on the earth, of the outer planets. These various image events will affect the light quality in the inner chambers in different ways – some of the effects will be subtle, others more dramatic.

The Upper Fumarole Space The Upper Fumarole Space will be open to the sky and will receive light and sound from the environment around Roden Crater. Some of the sources for this light and sound are relatively close and some very distant. Locally, the space will pick up sound from Grand Falls. The falls have their own rhythms: sometimes the river is virtually dry, but during spring thaws and after summer rains, a large amount of water rushes along its route. The drop of the falls is higher than Niagara, and the water can sometimes be quite spectacular. If the wind is right, the sound can be heard very well from any point on the crater. The space at the fumarole, however, will amplify this varying sound. Shaped architectural forms will focus the roar of the water into the upper chamber.

In its more distant aspects, the Upper Fumarole Space will pick up radio noise and light from astronomical sources. The chamber will be sensitive to a

wide range of the electromagnetic spectrum. One area of the upper chamber will, like the Eastern Space, have water flowing through it. A large bath will be built at the center of the space. Turrell's interest in this bath is sensory; floating will remove us, to some degree, from the external world and allow us to focus on our own perceptions. Turrell cites the ancient waterworks and cisterns at Masada and Qumran as sources for the architectural quality he wants the space to have.

Beyond the apperceptive conditions it will establish, Turrell's bath will receive signals. The entire space will act like a small radio telescope. As celestial objects like quasars and Seyfert galaxies pass overhead, their emissions will be picked up inside the chamber. While the sound waves from Grand Falls come into the space above the water, radio waves will be amplified through the water. Inside the space, we will be able to hear the sound of Grand Falls four miles away, and then, by lowering our heads underneath the water's surface, be able to hear the sound of astronomical sources many light years away.

The upper space will also receive light from celestial objects. Turrell will place a quartz ring at the top of the water and then pump light into it. Because the quartz will transmit light to its edges, the surface of the water will appear to be a layer of light. Only by leaning out over the water and looking straight down will we be able to detect its transparency. During the day, the light coming into the upper layer of the water will vary from the subdued tones of the early-morning sun to the intense brightness of the noonday sun. At night it will sometimes approach the limit of perceptibility, consisting of the combined colors of just a few stars.[41]

The Tunnel and Upper Tunnel Spaces From the fourth fumarole space, we will walk up the long tunnel joining it with a space at its upper end. The Tunnel will be about fourteen feet in diameter and inclined at an angle of about nine degrees. Its opening will encircle a small area of sky. As we proceed upward, this patch of blue will increase in size, but at no point during our ascent will the opposite side of the crater bowl become visible. From the fumarole's Lunar Space, the Tunnel will point to the position of the southernmost moonset which is just outside the band of sky forming the ecliptic. Thus, from the Lunar Space, we will not be able to see events involving the sun, the planets, or even the moon at times other than its major southern standstill. As we proceed upward, however, the increased size of the opening will take in the entire area of the ecliptic. A way station will be located midway up the Tunnel so that celestial events occurring in the ecliptic can be observed from inside the Tunnel.

At the upper end of the Tunnel, an oval-shaped skyspace will be set into the slope of the bowl. Like most of the spaces at the crater, this chamber will alter our perception of light and space. The inside of this space will be covered with white sand and, therefore, will be particularly receptive to the colors of the

65 Topographic survey drawing, 1980

66 Topographic drawing (cut and fill and tunnel alignment), 1980

ambient light reflected from the crater bowl around it. This color will go through several important changes, depending on the time of year.

During the winter, the rust-colored cinder, which is a predominant component of the soil on the crater, will have little vegetation growing on it, causing the light that reflects into the chamber to be red. It will thus complement and intensify our perception of the blue of the sky from inside the space. The interior of the crater bowl will sometimes be covered with snow. This white blanket will make the interior space very bright, and will also affect the intensity of the sky seen through the opening. At night the white of the space will gather enough light to make seeing the stars difficult and to give the area of sky stretched across the opening a gunmetal inpenetrability.[42]

In spring, grass covers the bowl of the crater. It is green for about two weeks before turning a deep amber, although it goes through several subsequent periods of verdancy after summer rains. During most of the spring and summer, the color is very nearly the exact complement of the sky. Thus, the grass, depending on its color, will also affect the ambient light coming into the chamber, modifying the blue of the sky seen through the skyspace.

The Crater Bowl

Along with manipulating light, Roden Crater will manipulate space. One of the most important instances of its power to alter the quality of spatial perception will occur in the bowl of the crater. When we come up into the skyspace chamber at the end of the Tunnel, the sky will seem to be stretched across its opening. It will look like a surface, but it will have a ponderance, a kind of three-dimensionality, as if the sky had come right down to the edge of the space. As we make our way up out of the chamber by means of a staircase, the upper margin of the crater will suddenly appear. When this happens, our sense of a blue "surface" immediately above our heads will change radically. The sky will expand outward and upward, changing from a small ceiling into a huge vault of space seeming to rest on the rim of the crater.

The Crater Bowl, Turrell's initial impetus for seeking out a volcano, will be the first space constructed. By reshaping the bowl of the crater, he will be able to focus our attention on the phenomenon of *celestial vaulting*.[43] From his experience as a pilot, Turrell has learned that we alter the shape of the sky with our point of view. The importance of our point of view vis-à-vis perception will become dramatically apparent when we enter the Crater Bowl. The phenomenon of celestial vaulting can be observed from almost any position on the earth's surface, but it is especially noticeable from open plains or the open sea. As we approach the crater, across the desert, our awareness of celestial vaulting may only be subliminal. But the Crater Bowl will bring it to the center of our attention. By changing the shape of the crater, Turrell will change the shape of the sky. Dirt on one upper portion on the north side of the rim will be moved into

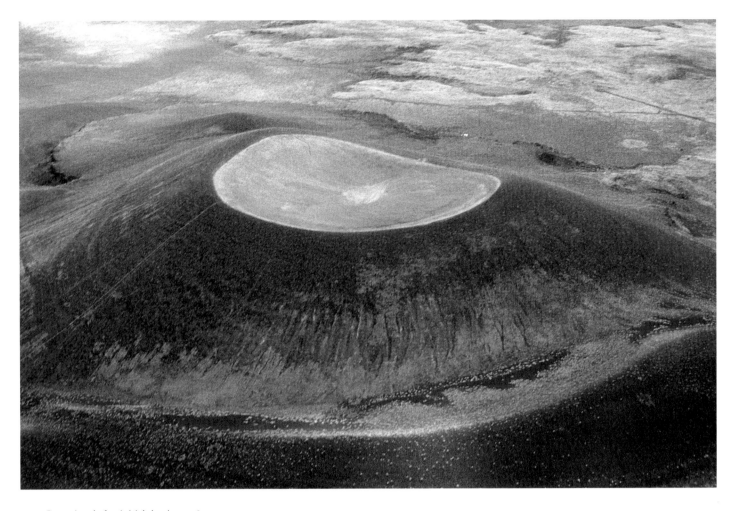

67 Crater bowl after initial shaping, 1984

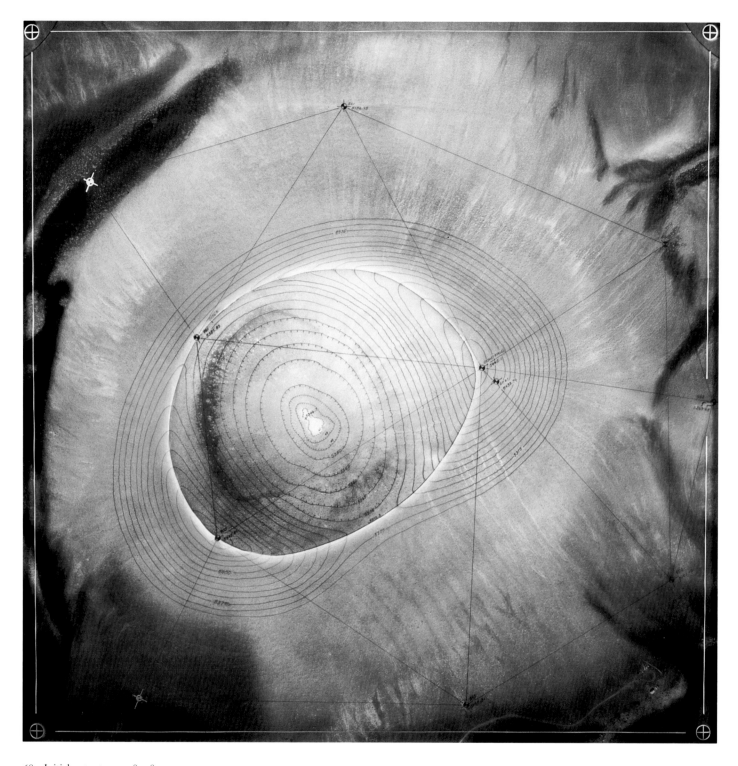

68 Initial crater topo, 1983–84

122

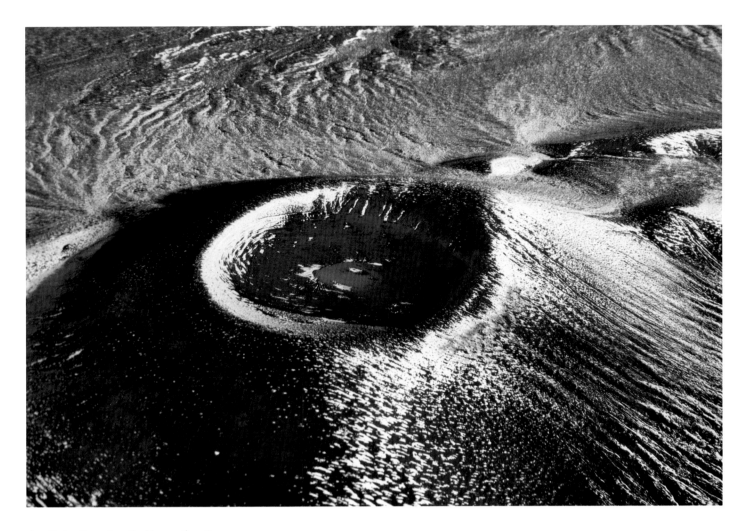

69 Roden Crater bowl looking north, 1984

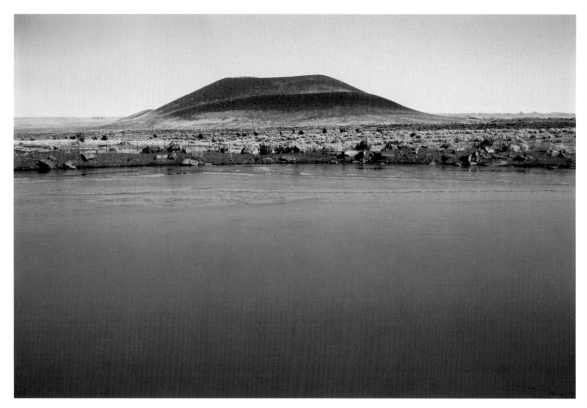

70 Roden Crater, 1982

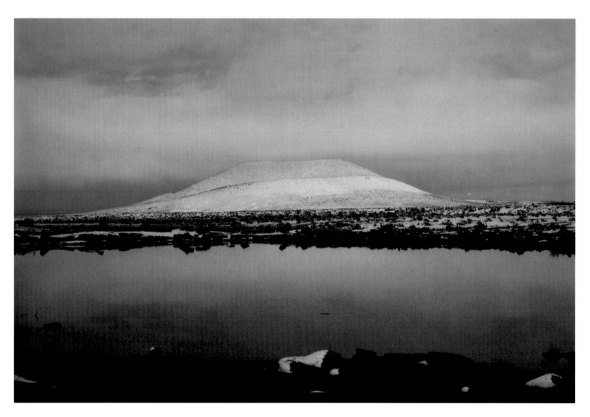

71 Roden Crater, 1983

72 Roden Crater, 1984

73 Roden Crater, 1984

two low areas on the east and west side of the bowl to give the crater an upper boundary all of one height. When the construction process is completed, twenty or more inches of topsoil will be put back in place, and the crater will be replanted with the grasses that were originally there.

From inside the Crater Bowl, the sky will seem to be attached to the upper margin of the crater. As we proceed up the inner slope of the bowl, our sense that there is a vault of space above our heads will change again. The flattened dome of sky will peel away from the circumscribed rim of the crater and then expand outward to the far horizon. Perhaps during this climb we will become most aware of just how much we do, in fact, perceptually modify the shape of the sky.[44]

When we arrive at the rim of the crater, about five hundred feet above the surrounding plain, we will notice that from this elevation the earth seems to be concave rather than convex. It appears to curve the wrong way. Especially from positions along the southwestern section of the rim, the ground below us will seem to be hollowed out and to curve up and away from the crater, even though that part of the desert floor is actually quite flat. When this concave-earth illusion is linked with the celestial vaulting above us, it will seem as though we are inside a gigantic lens of space.

The bowl of Roden Crater will also affect our perception of the color of the sky. Blue wavelengths of light are scattered by atmospheric gases and suspended dust particles and are absorbed by water vapor. In areas with a great deal of moisture in the air, more of the blue is absorbed, and the sky looks more gray.[45] But in the dry, limpid air of the high-altitude desert around Roden Crater, the sky already looks very blue. Yet, even here the sky tends to gray along its lower margins. From a position near the bottom of the bowl, the rim of the crater will cut off the lower twelve degrees of sky. By removing the gray portion of the sky, the crater will intensify its blue color and focus our attention upon it.

At night, too, the bowl will eliminate what little light pollution exists in the area around the crater. It will make the sky seem very black. There will also be a doming effect at night; larger and more hemispherical than the daytime version, it will appear to come down somewhere beyond the rim of the crater. The night sky seen from inside the Crater Bowl will have its own drama. During the day, the sky is opaque because the light from the sun is dispersed. Because we stand in a pool of light at the bottom of the atmosphere, we cannot visually plumb the depth of the space above us. But the night sky is not lit by the light from the sun. It becomes transparent, allowing us to see objects that are thousands, even millions, of light years away.

At night, inside the reshaped Crater Bowl, this immensity will be a velvet black vault of space populated with thousands of stars. From the upper rim, on a starry, moonless night, we will be able to look into what is probably the maximum amount of space visually comprehensible. On such nights, the seeing will

be very good. We will be able to observe the maximum number of stars visible to the naked eye. Within this multitude, careful observers will be able to distinguish a wide range of star colors.[46] This kind of observation will also be affected by our position on the crater. From the black basaltic cinder that covers many areas, we will be better able to perceive delicate detail. If we move onto surfaces with higher albedos, we will be less able to see detail. Standing on the bright areas of the crater is analogous to being at the bottom of the light-well of the atmosphere during daytime, although the effect will be far more subtle. The small increase in the amount of ambient light surrounding us will be sufficient to wash out such details as the fine structure of the Milky Way.

The Experience

Roden Crater will not be regimentally organized, and we will not have to enter its spaces in any given order. We will be able to choose – but how we choose will influence the way we perceive both the interior and exterior light. We may want to follow several different routes at several different times. At the esplanade level alone, there will be twenty-four ways of going through the four spaces. Each path will represent a variation, sometimes a dramatic variation, on the visual possibilities. As we move from place to place, as we enter one space after another, each will establish a specific visual receptivity that will change the way we see the next.

The story that Turrell uses to emphasize the importance of how we come to an experience is a good one and worth repeating here:

It has to do with how you load a situation with information before entry to an experience. Here's an example that might be called a performance piece: you take a plane to Albuquerque or Phoenix and then go by car up to an area in Canyon de Chelly on the night of the year when the Night-blooming Cereus *blooms. You go down in a jeep and then go by horseback or mule into the canyon at sunset. Finally, you come to an area where the* Cereus *can be found, and you spend several hours looking for one that hasn't quite begun to open. You go through the experience of watching this flower bloom, and then it withers and is gone. Now, by the same token, there might be someone who raises this plant in a wonderful hothouse. You go there, have a few drinks, stand around watching the flower bloom, and then it's over. The object is the same, yet it's a totally different experience. And if you work with the limits of experience, you pay attention to how the experience is brought about, and you don't worry as much about the object. In fact, the same experience might be had without the flower.[47]*

In addition to the interactive aspects of the various spaces at the crater, their entryways will often modify our perceptual tendencies. For example, it may sometimes be necessary to remain at an entryway long enough to allow our eyes to dark-adapt. Some of the color effects will be just at the border of perceptibil-

ity and, thus, essentially invisible to unadapted eyes. This process will be further complicated by changes in the external environment. The *Ganzfelds* inside the spaces will be generated by the natural setting. They will be tied to the colors of the surfaces outside – red cinder, black malpais, and the vegetation, all of which will constantly change through time.[48]

The light effects in the architectural spaces and their entrances, along with the various adjacent chambers themselves, will involve simultaneous contrasts. Our route through the rooms will again and again *pre-load* our visual systems. Each step in our journey through the mountain will involve both a disclosure and a preparation. When we arrive at the celestial vault shaped by the bowl of the crater, we will have already seen many other skyspaces at the esplanade and the fumarole. These earlier experiences will sharpen the final experience. Then, after we have seen the huge vault of space at the top of the crater, the skyspaces in the chambers below us will look different. As we make our way back down to the lower levels, we will notice that our abilities to perceive the shape and color of the sky have been altered yet again. Such processes will be as much psychological as physiological. On any of its possible pathways, Roden Crater will do more than pre-load our visual apparatus; it will alter our perceptual sets by making us willing to attend to the things that we might otherwise ignore. The crater will make us ready to look at the visual possibilities that are normally encrypted in the perceptual noise of the day-to-day and our own disregard.

When all of the levels of the crater are taken into consideration, the permutations of order and sequence become almost infinite. Variations on most of the experiences in given spaces will be available in other spaces as well. For example, dramatic thunderstorms and the lightning they produce will be visible from almost all the spaces at Roden Crater. Thus, other spaces, in addition to the Western Space, will be flashed with intense light. The storms sometimes pass directly over the crater. Indeed, the magma core of the volcano acts something like a giant lightning rod, drawing the electrical discharges down to the mountain. These displays will be awesome from inside the spaces that open directly up into the sky – especially the Southern Space and the Upper Tunnel Space.

Such variations can be expanded almost indefinitely. The green flash may occur on the eastern horizon and be visible from the Eastern Space. From that direction, it will appear before the sun does and thus illuminate a space filled with a different colored light than that in the Western Space. The twilight arch will be visible from the Eastern Space as well as from the fumarole space above and, from the lower vantage, look different. And so, on and on.

Light and its perception at Roden Crater will involve sequence. Our relationship with the light will be affected by our position on the crater and by the way and the order in which we move from one area to another. As we proceed from

74 Roden Crater rim (dusk), 1981

location to location across the exterior open spaces of the mountain, we will precondition ourselves for the perception of the interior spaces we are about to enter. Within the inner spaces, as we move from chamber to chamber, the light that comes into these rooms will be affected not only by its direction but also by ours. The light will sometimes hang suspended inside the spaces; it will sometimes divide them. As the day changes, the light will soften; as the seasons change, it will shift. How it looks will depend on where we are: the light in the spaces facing north and south will have different rhythms from those facing east and west. All these myriad lights will be altered by a hundred factors, including the variables that we ourselves bring to their perception.

The visual parameters of Roden Crater will involve light and space, and how they change through time. In Turrell's words:

> . . . Roden Crater has knowledge in it, and it does something with that knowledge. Environmental events occur; a space lights up. Something happens in there, for a moment, or for a time. It is an eye, something that is itself perceiving. It is a piece that does not end. It is changed by the action of the sun, the moon, the cloud cover, by the day and the season that you're there . . . and it keeps changing. When you're there, it has visions, qualities, and a universe of possibilities.[49]

The universe of possibilities at Roden Crater is complex. The volcano will order our interactions with light, space, and time. It affects not only the intensity but also the whole nature of our perceptual experiences. The Roden Crater project is informed by the works Turrell has been producing for a long time: the spaces will be like the projection pieces, the shallow space constructions, the wedgeworks, the skyspaces, and the space division pieces, but they will be hewn from the natural materials of the volcano and surfaced with the sands and stones of the surrounding desert.

The geology of the surrounding environment provides an important metaphor for more encompassing temporal change. It seems to emphasize that we are on the surface of a planet that has existed for a very long time. The immense age of the landscape connects us with our astronomical surroundings. Turrell points out that "from within a visual setting of geological time, the crater will sense and respond to celestial time."[50] In these terms, the Roden Crater project will expose what are perhaps the most profound connections between light and space.

It is also metaphorically, or perhaps just poetically, important that the site is a volcano. Our very existence is fundamentally tied to volcanic processes. The evolution of the planet and the life on it has depended to some large degree on tectonic events.[51] Not only Roden Crater, but also the light in the sky around it will suggest something of this importance. Sunrises and sunsets are connected with volcanic activity because suspended particles affect the scattering and ab-

sorption of sunlight. The amount of particulate matter in the air depends to some degree on local conditions, such as dust storms in the desert, and to an even greater degree on far distant events, such as eruptions in other parts of the world. The explosion of El Chichón in southern Mexico in 1982, less famous but far more powerful than the earlier eruption of Mount St. Helens, placed huge amounts of dust in the upper atmosphere and produced spectacular sunrises and sunsets throughout the world, including those seen at Roden Crater.[52] How we see the light in these twilight displays is conditioned by what we know of it.

The Roden Crater project will work in phase with nature. It will extend our knowledge of the relationships between different kinds of spaces, including our own internal psychological spaces and the external world. Seeing the visual components of Roden Crater will require time. In order to understand the complexities of the place, we will need to become aware of our own perceptual range, since a major part of the crater's content will involve processes of apperception. In this regard, it is not so much the object that interests Turrell, but what the object makes us aware of – the power and compass of our own perception. The crater is a focusing device that puts us within view of a great many things, including our own seeing. As we progress through the site, through its various levels and spaces, it will prepare us to look at the light. In Turrell's terms, the crater will make us pay the price of admission, and, having done so, we will have some interest in opening our eyes.

EDITOR'S NOTE: James Turrell initially conceived what would become the Roden Crater project in 1972. Roden Crater, in northern Arizona, was chosen as the project site in 1974 and purchased by the artist in 1977. Construction on the Roden Crater project began in 1979 and is scheduled for completion in the 1990s.

1. Much of the information in this essay is based on my conversations with James Turrell while visiting the site in June and July 1983, June and August 1984, and March 1985. During these visits I spent several weeks at the crater, under varying weather conditions.

2. For a discussion of this volcanic field see Henry Hollister Robinson, *The San Franciscan Volcanic Field, Arizona*, U.S. Geological Survey Professional Paper 76 (1913); Harold S. Colton, *The Basaltic Cinder Cones and Lava Flows of the San Francisco Mountain Volcanic Field*, rev. ed. (Flagstaff: Museum of Northern Arizona, 1967); for an authoritative update of these earlier classics see Edward W. Wolfe, "The Volcanic Landscape of the San Francisco Volcanic Field," in *Landscapes of Arizona: The Geological Story*, ed. Terah L. Smiley, J. Dale Nations, Troy L. Pewe, and John P. Schafer (Lanhan, Maryland: University Press of America, 1984), 111–136; for a useful general discussion see Dale Nations and Edmund Stump, *Geology of Arizona* (Dubuque, Iowa: Kendall/Hunt, 1981), 155–170.

3. Roden Crater is described in geological litera-
ture as being of "Tappan Age," a local designation
referring to lava flows near Tappan Spring dating
from a period between 700,000 and 200,000 years
ago. See Richard B. Moore, Edward W. Wolfe and
George E. Ulrich, "Geology of the Eastern and
Northern Parts of the San Francisco Volcanic
Field, Arizona," and "Field Guide to the Geology
of the Eastern and Northern San Francisco Vol-
canic Field, Arizona," in *Geology of Northern Arizona
with Notes on Archaeology and Paleoclimate*, ed. Thor
N. V. Karlstrom, Gordon A. Swann, and Ray-
mond L. Eastwood, Pt. 2 (Geological Society of
America, Rocky Mountain Section Meeting,
Flagstaff, Arizona, 1974), 465–520.

4. The eruption can be dated so precisely be-
cause it covered the pit houses of the Sinagua Indi-
ans then living in the area. The roof beams of these
dwellings have been excavated and used for tree
ring dating. See Harold S. Colton, "The Sinagua:
A Summary of the Archaeology of the Region of
Flagstaff, Arizona," *Museum of Northern Arizona
Bulletin* 22 (1946); idem, "The Prehistoric Popula-
tion of the Flagstaff Area," *Plateau* 22, no. 2 (1949):
21–25; see also Albert H. Schroeder, "The Hoho-
kam, Sinagua and the Hakataya," *Archives of Ar-
chaeology*, no. 5, The Society for American Archae-
ology (Madison: University of Wisconsin Press,
1960); idem, *Of Men and Volcanoes: The Sinagua of
Northern Arizona* (Globe, Arizona: Southwest Parks
and Monuments Association, 1977); for a more re-
cent interpretation of the archeological evidence see
Peter J. Pilles, Jr., "Sunset Crater and the Sinagua:
A New Interpretation," in *Volcanic Activity and Hu-
man Ecology*, ed. Payson D. Sheets and Donald K.
Grayson (New York: Academic Press, 1979), 459–
485.

5. Troy L. Pewe and Randall G. Updike, *San
Francisco Peaks: A Guidebook to the Geology*, 2nd ed.
(Flagstaff: Museum of Northern Arizona, 1976);
see also Nations and Stump, *Geology of Arizona*,
160.

6. For the Hopi Buttes see Nations and Stump,
Geology of Arizona, 171; see also J. Keith Rigby, *Field
Guide: Southern Colorado Plateau* (Dubuque, Iowa:
Kendall/Hunt, 1977), 45–50; A. B. Reagan, "Stra-
tigraphy of the Hopi Buttes Volcanic Field," *Pan
American Geologist* 41 (1924): 355–366; J. T. Hack,
"Sedimentation and Volcanism in the Hopi
Buttes," *Geological Society of America Bulletin* 53
(1942): 335–372; for an authoritative recent report
see Robert L. Sutton, "The Geology of Hopi
Buttes, Arizona," in *Geology of Northern Arizona*,

647–671; for a general description of the area
around Roden Crater see Charles W. Barnes,
"Landscapes of Northeastern Arizona," in *Land-
scapes of Arizona*, 303–325; see also Donald L. Baars,
The Colorado Plateau: A Geologic History (Albuquer-
que: University of New Mexico Press, 1983).

7. James Turrell, "Light in Space," in *Glass Art
Society Journal* (Corning, New York) (1983–84): 5.

8. See Turrell's statement in his exhibition cata-
log *James Turrell: Light and Space*, ed. Barbara Has-
kell (New York: Whitney Museum of American
Art, 1980), 39.

9. See, for example, Turrell's statement quoted
in Keith M. McDonald, "The Roden Crater Proj-
ect," *Sedona Life* 4 (January 1979): 20: "Of all the
gardens in the Japanese culture, the kind that I like
very much is the kind where you do not see the
hand of man. There are the traditional rock gardens
with the raked sand and rock, and then there are
those where you can't tell that they're man-made.
That is very fascinating to me, because you cannot
tell where the piece of 'art' ends. This is where the
ego of the artist begins to dissolve into the grand
scale of things, and there's no signature. This is the
kind of effect I am seeking with Roden Crater – a
piece that does not end."

10. For discussions of the eruption see T. L. Smi-
ley, "The Geology and Dating of Sunset Crater,
Flagstaff, Arizona," in *Guidebook of the Black Mesa
Basin, Northern Arizona* (New Mexico Geological
Society, Ninth Field Conference, 1958); D. A.
Breternitz, "The Eruption(s) of Sunset Crater:
Dating and Effects," *Plateau* 40, no. 2 (1967): 72–
76; E. M. Shoemaker, "Eruption History of Sunset
Crater, Arizona: Investigator's Annual Report,"
manuscript on file at the Sunset Crater National
Monument.

11. Turrell points out that from the higher point
of view, objects out in the landscape will appear to
be constructed in miniature. The experience is
analogous to the way things look from airplanes at
one particular moment during landing approaches.
Turrell refers to this phenomenon as the "dollhouse
effect." The esplanade is the first level in a series of
higher and higher positions on the crater that will
each in their turn engender a special visual effect.

12. Turrell, interviewed by Kathy Halbreich,
Lois Craig, and William Porter, "Powerful Places,"
Places 1 (Fall 1983): 32.

13. Paul Virilio, *Bunker Archéologie* (Paris: Centre
Georges Pompidou, Centre de Création Indus-
trielle, 1975).

14. Turrell, personal communication with au-

thor, March 1985. This is Turrell's term. In many of his earlier works, the major effort was expended of making walls disappear so the light could be seen.

15. Turrell, personal communication with author, March 1985.

16. These are the successive north stars most often mentioned in introductory astronomy books. For a discussion of the geometry of precession see W. M. Smart, *Textbook on Spherical Astronomy*, 6th ed. (Cambridge: Cambridge University Press, 1977), 226–248.

17. Auroras result from the interaction of the earth's atmosphere with the sun's atmosphere. During intense magnetic storms, high-velocity electrically charged particles in the solar "wind" bombard the earth's upper atmosphere. As the particles come into the ionosphere along the lines of forces of the earth's magnetic field, they energize or ionize molecules in the thin upper air – chiefly oxygen and nitrogen molecules. When these molecules return to their normal states, they emit light at characteristic wavelengths. The upper atmosphere essentially fluoresces, producing shimmering bands of light. See Syun-Ichi Akasofu, "The Aurora," *Scientific American* (December 1965): 54–62, reprinted in *Atmospheric Phenomena*, ed. David K. Lynch (San Francisco: W. H. Freeman, 1980), 141–149; see also Aden Meinel and Marjorie Meinel, *Sunsets, Twilights, and Evening Skies* (Cambridge: Cambridge University Press, 1983), 112.

18. One of the original *Ganzfeld* experiments used a curved wall in front of the viewer to engender the visual effect. See Wolfgang Metzger, "Optische Untersuchungen am Ganzfeld, 11. Zur Phanomenologie des homogenen Ganzfelds," *Psychologische Forschung* 13 (1930): 6–29.

19. In this regard, it is perhaps appropriate to use the old designation from discussions of the Sublime; "astonish" comes from the Latin *attonare*, meaning "to strike with thunder." The highly dramatic light may often occasion an aesthetic response we will still wish to call sublime. This etymology is pointed out by Edmund Burke, *A Philosophical Enquiry into the Origin of Our Ideas of the Sublime and Beautiful*, ed. James T. Boulton (Notre Dame: University of Notre Dame Press, 1969), 57–58.

20. See D. J. K. O'Connell, S.J., *The Green Flash and Other Low Sun Phenomena* (Amsterdam: North Holland; New York: Interscience Publishers, 1958); idem, "The Green Flash," *Scientific American* (January 1960): 112–122, reprinted in *Atmospheric Phenomena*, 91–97; see also Meinel and Meinel, *Sunsets*, 19–27.

21. Even more rarely than the green flash, a red flash is sometimes seen at the bottom of the sun's disk just before it begins to drop below the horizon. Blue flashes and even violet flashes at the upper margin of the sun's disk are also very rarely seen.

22. Grand Falls were created 150,000 years ago when huge amounts of basalt lava flowed out from the base of Merriam Crater, the somewhat larger and younger cinder cone six miles south of Roden Crater. The liquid rock flowed down the sloping plain and into the deep canyon that had been cut by the river, and then advanced on beyond it for about another half mile. The deep gorge was filled with lava and the river was diverted. It now follows a northward path around the lava flow and finally returns to its former course, falling over the edge of the earlier canyon. See Nations and Stump, *Geology of Arizona*, 170; see also Richard Hereford, "Climate and Ephemeral-Stream Processes: Twentieth-Century Geomorphology and Alluvial Stratigraphy of the Little Colorado River, Arizona," *Geological Society of America Bulletin* 95 (1984): 654–668.

23. J. H. Stewart, F. G. Poole, and R. F. Wilson, *Stratigraphy and Origin of the Chinle Formation and Related Upper Triassic Strata in the Colorado Plateau Region*, U.S. Geological Survey Professional Paper 690 (1972); see also Ronald C. Blakey and Richard Gubitosa, "Late Triassic Paleogeography and Depositional History of the Chinle Formation, Southern Utah and Northern Arizona," *Mesozoic Paleogeography of the West-Central United States: Rocky Mountain Paleogeography Symposium* 2, ed. Mitchell W. Reynolds and Edward D. Dolly (Rocky Mountain Section Society of Economic Paleontologists and Mineralogists, Denver, Colorado, 1983), 57–76.

24. Charles H. Lowe, *Arizona's Natural Environment: Landscapes and Habitats* (Tucson: University of Arizona Press, 1980); Arthur M. Phillips and Barbara G. Phillips, "Spring Wildflowers of Northern Arizona," *Plateau* 55, no. 3 (1984): 1–32.

25. These works are discussed by Turrell in *James Turrell: Light and Space*, 24–27.

26. Turrell, personal communication with author, March 1985.

27. Traditional Anasazi Kivas were also circular in shape, with openings in their roofs. They were possibly arranged in relation to astronomical events. See Ray A. Williamson, Howard J. Fisher, and Donnel O'Flynn, "Anasazi Solar Observatories," in *Native American Astronomy*, ed. Anthony F.

Aveni (Austin: University of Texas Press, 1977), 203–217; see also E. C. Krupp, *Echoes of the Ancient Skies: The Astronomy of Lost Civilizations* (New York: Harper & Row, 1983), 231–236.

28. For Turrell's discussion of the projection pieces see *James Turrell: Light and Space*, 14–19. Similar effects were also created at Turrell's Hill and Main Street studio in Ocean Park, California, from the late 1960s to the mid-1970s using sunlight. For Turrell's discussion of these "Mendota Stoppages" see 28–31.

29. Noctilucent clouds are almost never seen except at northern latitudes. See Robert K. Soberman, "Noctilucent Clouds," *Scientific American* (June 1963): 50–59, reprinted in *Atmospheric Phenomena*, 131–140; see also Meinel and Meinel, *Sunsets*, 87–89.

30. Joachim P. Kuettner, "The 2000-Kilometer Wave Flight," *Soaring* (May 1984): 14–19 and (March 1985): 23–27. This two-part article was recommended to me by Turrell.

31. Leo M. Hurvich and Dorothea Jameson, *The Perception of Brightness and Darkness* (Boston: Allyn and Bacon, 1966), 35–41.

32. G. R. Kaye, *The Astronomical Observatories of Jai Singh* (Calcutta, 1918); Ben Mayer, "Touring the Jai Singh Observatories," *Sky & Telescope* 58 (July 1979): 6–10; for an interesting discussion of Jai Singh's instruments, accompanied by very beautiful illustrations, see Hermann Kern, *Kalenderbauten: Frühe A.tronomische Grossgeräte aus Indien, Mexico und Peru* (Munich: Die Neue Sammlung, n.d.), 17–72.

33. The 18.61 year cycle of the moon is explained by E. C. Krupp, "A Sky for All Seasons," in *In Search of Ancient Astronomies*, ed. E. C. Krupp (Garden City, N.Y.: Doubleday, 1977), 21–31. Dr. Krupp, the director of the Griffith Observatory in Los Angeles, and Richard Walker, an astronomer at the U.S. Naval Observatory in Flagstaff, Arizona, are advising Turrell about the astronomical aspects of the Roden Crater project.

34. Turrell's term. See, for example, his statement to MacDonald, "The Roden Crater Project," 47: "Contrary to popular opinion and the poet's standard prose, the night does not fall; it rises. And it rises like a veil. It is tremendously beautiful."

35. See Meinel and Meinel, *Sunsets*, 29–32; see also Georgii V. Rozenburg, *Twilight: A Study in Atmospheric Optics*, trans. Richard B. Rodman (New York: Plenum Press, 1966).

36. For a discussion of Turrell's use of *Ganzfeld* environments in his earlier work see Craig Adcock,

"Perceptual Edges: The Psychology of James Turrell's Light and Space," *Arts Magazine* 59 (February 1985): 124–128.

37. Turrell, personal communication with author, November 1984.

38. The image event will involve the fourteen to fifteen day-old moon, near full. Its first projection is planned for the early part of the next millennium.

39. The *Saros* is explained in Frank Dyson and R. v. d. R. Woolley, *Eclipses of the Sun and Moon* (Oxford: Oxford University Press, 1937), 24–28; see also Andrew Chaikin, "Saros: The Clockwork of Eclipses," *Sky & Telescope* 68 (October 1984): 299.

40. The details of how the Saros might be indicated at the crater are still under discussion by Turrell and his astronomical advisors.

41. For an interesting discussion of the perception of stars and their colors see David Malin and Paul Murdin, *Colours of the Stars* (Cambridge: Cambridge University Press, 1984).

42. The effect will be similar to that achieved in the "Skyspaces." For a discussion of these earlier works see Turrell's remarks in *James Turrell: Light and Space*, 32–33.

43. For a discussion of celestial vaulting see the classic book by Marcel Minnaert, *The Nature of Light & Color in the Open Air*, trans. H. M. Kremer-Priest, rev. K. E. Brian Jay (New York: Dover, 1954), 153–166.

44. Turrell recalls that among his earliest important reading experiences were two books by Antoine Saint-Exupéry: *Wind, Sand, and Stars* and *Night Flight*. These books contain references to the perceptual anomalies involved in flying and discuss how increases in altitude seem to alter the shape of the sky and the land below the sky. Saint-Exupéry was a pilot.

45. For a discussion of the variables affecting the color of the sky see Minnaert, *Nature of Light*, 235–297; see also Meinel and Meinel, *Sunsets*, 9–12.

46. Marcel Minnaert could accurately tell the difference between eight different star colors; see *Nature of Light*, 300–301; see also Malin and Murdin, *Colors of the Stars*, 22–24.

47. Turrell, "Powerful Places," 37.

48. In this regard, the crater spaces will be analogous to the *Ganzfeld* spaces that Turrell created for his exhibition at the Stedelijk Museum in Amsterdam in 1976. The four chambers in that piece, called the *City of Arhirit*, were each lit with natural light. The light was reflected into each of the interior chambers from different colored surfaces outside the building. In a lecture published in the *Glass*

Art Society Journal (1983–84): 7, Turrell describes how these different lights were perceived:

I had a series of four spaces. The first space was a very pale moon green, and it received its light from the outside, through a window. The light came in off the lawn outside – I had baffles that directed it in so that it was essentially a space without any definition. You entered that space and you could literally hold the color for not quite three minutes – somewhere between a minute and a half and three minutes – and then it began to gray. While you were in the space, you felt as though someone was turning down the color, or turning the color off.

The next room was a very pale deep red that came off a brick wall of the building across from the Stedelijk. When you first entered it, you had the afterimage of the green, so you entered with a pink afterimage which made the already slightly red space intensely red. The afterimage would only last for ten seconds or so, then you would see what was actually there; then that began fading. As you stood, the color would decay in each space, so that you would enter one space with the pre-loaded afterimage of the previous space.

49. Turrell, quoted in McDonald, "The Roden Crater Project," 47.

50. Turrell, personal communication with author, March 1985.

51. For a discussion of the iconography of Roden Crater in regard to both volcanic and impact craters see Craig Adcock, "Anticipating 19,084: James Turrell's Roden Crater Project," *Arts Magazine* 58 (May 1984): 76–85.

52. For a discussion of volcanic twilights, including those caused by El Chichón, see Meinel and Meinel, *Sunsets*, 51–61. Eruptions will also affect the character of image events at the crater; see R. A. Keen, "Volcanic Aerosols and Lunar Eclipses," *Science* 222 (December 2, 1983): 1011–1013.

75 Dr. Richard Walker, astronomer, U.S. Naval
 Observatory, and Michael Yost, Project Director,
 Roden Crater, 1985

Roden Crater

Jim Simmerman

A day and a half we lugged those pipes –
a hundred fifty pounds apiece
of gunmetal-gray Korean steel –
lugged them, shoved them, dragged them,
cussed them finally through cinder and sand,
through gaunt cholla cactus
that bit at our ankles and up
the crusty grade of the bottom-most ridge.
Two thousand plus of them, ten foot each:
from a low-flying plane it must have looked
like some slow-motion godgame of pick-up-sticks.
Our job was to replace the waterline
that ran a mile and more from a well
up and over and into the thing,
with the desert wind whistling
for its supper of bones, and the sun
on our heads like a ton of hot bricks.
Our job was dirty, draining and dumb.
We did it for nothing, did it for art.
We knew it was art but it felt like work.
It looked and tasted and smelled like work,
like every peanut-paying, back-busting job
I ever swore I'd never do again.
What we were doing was "sculpting" a crater
in a landscape of volcanic slag
so primitive and grim we had to squat
on our heels not to blister our butts,
had to scrabble and scrounge like lizards
for enough shade to collapse in.
We collapsed. We revived. We evolved
in reverse: shedding clothes
like worn-out skin, thinking from our bowels.
We thought we understood our end,

had devoured the literature, digested the plans:
according to someone, "the Sistine Chapel
of America"; to someone else,
"the Stonehenge of the nuclear millennium."
In a hundred degrees of brain-broiling heat
the sum of *my* thoughts for the future
was getting home, a bath, some sleep.
It was hard to dream of the dead
conic mess twenty, a hundred, a thousand
years hence: a tunnel gouged
through the guts of the earth; "skyspaces"
there like picture windows onto the universe.
The universe. Damn. How to dream of that
·sprawling state, its black flag unfurling
on every horizon, its anthem
of silence to deafen the dead?
How to dream fast-forward through some
twelve thousand years: the new gods, the new
extinctions, the insouciant do-si-do of the stars?
The North Star having strayed by then
and a new, perhaps more brilliant star
to steer some burned-out workman home. . . .
There'd be a place to pinpoint *that*
in a place already eons old.
Or exiting the tunnel in the bull's-eye
of the crater bowl, the sun precisely aligned,
you'd swear you were walking out on the world
and into a heaven made wholly of light.
I had no experience to measure it by, but
for a movie I saw as a boy: *The Mole People*,
a race of mutants so long underground
darkness had made blisters of their eyes;
light was lethal. Fallen into sudden holes,
our heroes blundered the length of the film
down every blind alley in that buried town
until, at long last, they're collared and sentenced:
the Tunnel of Death was a torturous
tease, a hike into the waxing dawn.
I wouldn't know art if I fell in it
but know that movie worked for me;
for all its schlock and cheap effects
it kept me wide-eyed all the night,

checking the closets and under the bed.
Imagination made me sweat.
I forged the oomph for one last climb
up and over the crater's east wall –
dragging my shadow along by the heels,
breathing double-time –
to watch the Painted Desert
burn away into the smoke of night. . . .
I might have been a Moleman then,
or at least a kid who believed in them –
that's how mortal and measly
that time-warped vista made me feel,
alone up there with nothing
to look forward to but darkness
and a long haul home, a few hours rest,
then back to the university where I teach
each year more of what I understand less.
Still, there was a moment or two,
perched at the peak of that desolate place,
when I thought I understood as well
as probably I ever will
that where we live and breathe and sweat
is a blind rock lunging through space. . . .
And thought I understood, for that,
what had dragged us to Roden Crater
with nothing to leave in the world but our work
and nothing to take out of it forever.

EDITOR'S NOTE: This poem first appeared in, and
was copyrighted by, *Quarterly West* in 1985, and is
reprinted here with their permission.

76 Construction photograph with view of Pioneer Square, 1982

Biography and Bibliography

BIOGRAPHY

Born May 6, 1943, Los Angeles, California. Graduated Pasadena High School, 1961; BA Psychology, Pomona College, 1965. Art Graduate Studies, University of California, Irvine, 1965–1966. MA Art, Claremont Graduate School, 1973.

AWARDS

National Endowment for the Arts, 1968.
Guggenheim Fellowship, 1974.
National Endowment for the Arts, Matching Grant, 1975.
Dia Art Foundation, 1977.
Arizona Commission for the Arts and Humanities, Visual Arts Fellowship, 1980.
Lumen Award, New York Section Illuminating Engineering Society with the International Association of Lighting Designers, 1981.
MacArthur Foundation Fellowship, 1984.

PUBLIC COLLECTIONS

Chase Manhattan Bank, New York, New York
Chicago Art Institute, Chicago, Illinois
Dia Art Foundation, New York, New York
Moderna Museet, Stockholm, Sweden
Museum of Contemporary Art, Los Angeles, California
Philadelphia Museum of Art, Philadelphia, Pennsylvania
The Prudential, Newark, New Jersey
Seattle Art Museum, Seattle, Washington
Skystone Foundation, Flagstaff, Arizona
Stuart Collection, University of California, San Diego, La Jolla, California
Whitney Museum of American Art, New York, New York

BIBLIOGRAPHY

OF ONE-MAN EXHIBITIONS

Light Projections. Pasadena Art Museum, California. October 9–November 9, 1967. Catalog.
Coplans, John. "James Turrell: Projected Light Images." *Artforum* 6 (October 1967): 48–49.
Rose, Barbara. "A Gallery Without Walls." *Art in America* 56 (March–April 1968): 60–71.
Von Meier, Kurt. "Los Angeles." *Art International* (Zurich) 11 (November 1967): 54–57.

Light Projections (Xenon Source). Main and Hill Studio, Santa Monica, California. Summer 1968.
Junker, Howard, and Ann Ray Martin. "The New Art." *Newsweek* 72 (July 29, 1968): 56–63.
Perreault, John. "Literal Light." In *From Aten to Laser* (Art News Annual XXXV). Edited by Thomas B. Hess and John Ashberry. New York: The MacMillan Company, 1969. Reprinted in *Light in Art.* New York: Collier Books, 1969.

Light Spaces (Existing outside light as source). Main and Hill Studio, Santa Monica, California. Summer 1969 and Summer 1970.
Davis, Doug. "The View from Hill and Main." *Newsweek* 74 (October 27, 1969): 111.
Piene, Nan R. "L.A. Trip." *Art in America* 58 (March–April 1970): 138–141.
Sharp, Willoughby. "New Directions in Southern California Sculpture." *Arts Magazine* 44 (Summer 1970): 35–38.

Light Projections and Light Spaces. Stedelijk Museum, Amsterdam. April 9–June 23, 1976. Catalog.
Frenden, Ton. "Oppenheim, Ruscha, en Turrell, Amerikaanse Kunst in Nederlandse Musea." *Eindhoven Dagblad* (Eindhoven) (May 1, 1976).
van Ginneken, Lily. "Turrell Bespeelt Licht en Ruimte." *der Volkskrant* (Amsterdam) (April 8, 1976): 13.
———. "Kors Greep Jim." *Uitkrant Vor Amsterdammers* (Amsterdam) (May 1976): 8.
Heyting, Lien. "Zonlicht in een Dode Vulkaan." *NRC Handelsblad* (Rotterdam) (April 9, 1976): 3.
Kelk, Fanny. "Sculpturen van Licht in Stedelijk." *Het Parool* (Amsterdam) (May 10, 1976).
Knook, Piet. "Jim Turrell, een Wonderbäarlijk Mooie Tentoonstelling." *Nieuwe Nordhollandse Courant* (Amsterdam) (April 30, 1976): 35.
Visser, Mathilde. "Stedelijk Museum, Jim Turrell en het Licht." *Het Financieele Dagblad* (Amsterdam) (April 16, 1976): 12.

Light Space (Ambient Light). ARCO Center for Visual Art, Los Angeles. November 16–December 24, 1976. Plans.
Hazlitt, Gordon. "Art Review, Questions that Amuse, Delight." *The Los Angeles Times*, pt. 4 (November 29, 1976): 5.
Wortz, Melinda. "Walter Gabrielson and James Turrell." *Artweek* 7 (December 11, 1976): 1, 16.
———. "Exposure to Process." *Art News* 76 (January 1977): 88–89.

Avaar – Light Installation. Herron Gallery, Herron School of Art, Indianapolis, Indiana. May 16–January 14, 1981. Catalog.

Brooks, Chris. "Visual Arts Reviews." *Arts Insight* (Indianapolis) 2 (May 1980): 14.

Burns, Sarah. "Illusions." *The New Art Examiner* (Midwest Edition) 8 (November 1980): 21.

Fry, Donn. "Light Itself is James Turrell's Medium." *The Indianapolis Star* 77, sec. 8 (May 18, 1980): 11.

———. "'Illusions' Fool the Eye at Herron." *The Indianapolis Star* 78, sec. 8 (July 20, 1980): 11.

Garmel, Marion. "Throwing Light on the Subject." *The Indianapolis News*, FT Sup. (May 2, 1980): 29.

———. "Amazing Avaar." *The Indianapolis News*, FT Sup. (May 24, 1980): 1, 6.

———. "Artists Create Fine Illusions at Herron." *The Indianapolis News*, FT Sup. (July 19, 1980): 8.

Koplos, Janet. "James Turrell." *The New Art Examiner* (Midwest Edition) 8 (October 1980): 21.

Iltar – Light Installation. Museum of Art, University of Arizona, Tucson. September 5–October 12, 1980.

Cheek, Lawrence W. "Iltar: The Doorway to Space?" *Tucson Citizen* 110, sec. B (September 8, 1980): 1.

Horne, David. "Turrell, 'Iltar' Make Room for Higher Art Consciousness." *The Arizona Daily Star* 139, sec. I (September 14, 1980): 8.

Light and Space. Whitney Museum of American Art, New York. October 22, 1980–January 1, 1981. Catalog.

Frank, Peter. "James Turrell: Light and Space." *Art Express* (Providence) 1 (May-June 1981): 77.

Hughes, Robert. "Poetry Out of Emptiness." *Time* 117 (January 5, 1981): 81.

Larson, Kay. "James Turrell, Light Work." *New York Magazine* 13 (November 17, 1980): 92–93.

———. "Dividing the Light from the Darkness." *Artforum* 19 (January 1981): 30–33.

Levin, Kim. "James Turrell." *Arts Magazine* 55 (December 1980): 5.

Lipsius, Frank. "James Turrell." *Financial Times*, sec. Arts (January 15, 1981).

Marmer, Nancy. "James Turrell: The Art of Deception." *Art in America* 69 (May 1981): 90–99.

———. "*James Turrell, L'Art de L'illusion*." *Art Press* (Paris). Translated by Suzanne Selvi (November 1981): 12–15.

Marzorati, Gerald. "New Light on the Whitney." *The Soho News* 8 (October 29, 1980): 62–63.

"News – Hopper and Turrell, '80–81'." *Domus* (Milan) no. 613 (January 1981): 56.

Russell, John. "James Turrell: Light and Space." *The New York Times* 130, sec. C (October 31, 1980): 22.

Sharp, Christopher. "People." *Women's Wear Daily* 141 (December 8, 1980): 10.

"The Talk of the Town – Light." *The New Yorker* 56 (December 15, 1980): 29–31.

Vascotto, Luisa. "Turrell's 'Light and Space' at the Whitney Museum." *The Hunter Envoy* (New York) (November 24, 1980): 14–15.

Wetzsteon, Ross. "Do Not Go Gentle Into That Good Light." *The Village Voice* 25 (November 19, 1980): 95.

"Whitney Light and Space Show." *News* (Westport, Connecticut) (August 13, 1980).

Wolff, Theodore F. "Turrell's Astonishing Art: Illusions Made Solely of Light." *The Christian Science Monitor* 72 (November 12, 1980): 23.

Zimmer, William. "Now You See It, Now You . . ." *Art News* (New York) 80 (February 1981): 225.

James Turrell. Castelli Gallery, New York. November 29, 1980–January 15, 1981.

James Turrell. Portland Center for the Visual Arts, Oregon. September 19–October 16, 1981.

Ullman, Sabrina. "James Turrell, The Limits of Perception." *Willamette Week* (Portland) 7, sec. 2 (October 6, 1981): 13.

James Turrell. Center on Contemporary Art, Seattle, Washington. January 29–July 28, 1982. Catalog.

Campbell, R. M. "Let There Be Light." *Seattle Post-Intelligencer* 119, sec. E (January 31, 1982): 5.

Edmunds, Jim. "The Esoteric Challenge: James Turrell." *Via Northwest Fashion Magazine* (Seattle) 1 (June/July 1982): 34–35.

Glowen, Ron. "Light Illusions." *Artweek* (April 3, 1982): 4–5.

Hammond, Pamela. "James Turrell, Light Itself." *Images & Issues* 3 (Summer 1982): 52–56.

Heagerty, Ned. "The Turrell Exhibition Without Touching It." *Madison Park Post* (Seattle) 2 (March 1982): 7, 14–15.

Hogatt, Tina. "Funded by a Generous Grant." *Spar* (Seattle) no. 6 (March 1982): 21.

Kentro, Linda, and Judy Kleinberg. "Art: Turrell." *Arcade* (Seattle) 2 (April/May 1982): 6.

Lewis, Louise, ed. "Now Art – Now c.o.c.a." *Via Northwest Fashion Magazine* (Seattle) 1 (April/May 1982): 15.

Scigliano, Eric. "Center on Contemporary Art Scores a Hit with James Turrell." *Artstorm* (Seattle) (February 10, 1982): 10.

Tarzan, Deloris. "Turrell's 'Vanishing' Art Inspires Long Lines." *The Seattle Times*, sec. H (February 7, 1982): 6.

Two Spaces. Israel Museum, Jerusalem. September 12, 1982–June 1983. Catalog.

"An Exhibition. Jimmy Plays With Space and Light Till He Makes You Realize That You Can't Count Even on Your Own Eyes." *Ma'ariv* (Jerusalem) (1982).

"Illusive Vision." *Ha'aretz* (Jerusalem) (December 3, 1982).

"Light and Space in the Museum." *'Al Hamishmar* (Jerusalem) (September 9, 1982).

"Light and Space in the Museum." *Davar* (Jerusalem) (September 16, 1982).

"Light and Space in the Museum." *Yediot Ahronot* (Jerusalem) (September 16, 1982).

Ronnen, Meier. "Something Out of Nothing." *The Jerusalem Post Magazine* (New York) (October 8, 1982): 14.

"Who Will Win the Competition Between the Museums?" *Ma'ariv* (Jerusalem) (September 9, 1982).

Batten Installation. Massachusetts Institute of Technology (Cambridge). January 22–February 27, 1983.

Altman, China. "A Wonderful Puzzlement." *Tech Talk* (MIT, Boston) 27 (February 16, 1983): 1, 5.

Doll, Nancy. "Review." *Art New England* 4 (March 1983): 8.

Porter, William L. "Powerful Places, An Interview with Artist James Turrell." *Places* (MIT, Boston) 1 (Fall 1983): 32–37.

"Review." *The Boston Phoenix*, sec. 3 (February 1, 1983): 12–13.

Laar – Installation. Flow Ace Gallery, Venice, California. April 8–September 21, 1983.

Drohojowska, Hunter. "He Brings Light to Art." *Los Angeles Herald Examiner*, sec. B (April 28, 1983): 1, 8.

Norklun, Kathi. "Pick of the Week." *L.A. Weekly* 5 (May 6, 1983): 113.

Light Installation. The Mattress Factory, Pittsburgh, Pennsylvania. October 29, 1983–February 1, 1984.

Baker, Kenneth. "Meg Webster and James Turrell at The Mattress Factory." *Art in America* 73 (May 1985): 179.

Jida – Space and Light Installation. University of Delaware Art Gallery, Newark. November 21, 1983–January 21, 1984.

Cope, Penelope Bass. "Turrell Uses Light to Mystify." *Sunday News Journal* (Wilmington, Delaware) sec. F (November 27, 1983): 1–2.

Donohoe, Victoria. "An Artist Works with Light, Space." *Philadelphia Inquirer*, sec. H (December 4, 1983): 22.

Mitchell, Kim. "Intriguing Sculpture Pokes Curiosity." and "Sculptor Works in Light of Individual Reactions." (University of Delaware, Newark) 107 (November 29, 1983): 15.

"Space and Light Display to Fill University Gallery." *UpDate* (University of Delaware) 3 (November 7, 1983): 5.

Tarbell, Roberta K. "Jim Turrell." *Art News* 83 (April 1984): 137.

Timinski, Janice. "James Turrell." *New Art Examiner* (Chicago) 11 (March 1984): 17.

Three Installations. Musée d'Art Moderne de la Ville de Paris. December 19, 1983–January 29, 1984.

la Bardonnie, Mathilde. "Le Californien James Turrell à l'Arc: Les Chambres de Lumière." *Le Monde* (December 23, 1983): 16.

Bouisset, Maiten. "Deux Americains à Paris." *Le Matin* (Paris) (December 23, 1983).

Cremin, Anne. "Acting on Impulse: Artists Plug Into the New Technology." *Passion* (Paris) (January 1984).

Nurisdany, Michel. "Dans la Lumière de James Turrell." *Le Figaro* (Paris) (January 1, 1984): 21.

"Temps et Lumière: James Turrell, Gérard Collin-Thiebaut et Bill Viola à l'Arc." *Magazine D'Informations Parisiennes* (January 1984).

James Turrell. Flow Ace Gallery, Venice, California. February 28–April 14, 1984.

Light Spaces. Capp Street Project, San Francisco, California. May 15–June 30, 1984. Catalog.

Boettger, Suzaan. "James Turrell, Capp Street Project." *Artforum* 23 (September 1984): 118–119.

Curtis, Cathy. "Light as Art: It's a Heavy Experience." *San Francisco Examiner* 1984, Review Section (June 3, 1984): 11.

Goldstein, Barbara, ed. "Turrell at Capp Street." *Arts & Architecture* 3 (1984): 72.

Miedzinski, Charles. "James Turrell: The Capp Street Project." *Artweek* 15 (June 16, 1984): 1.

Shere, Charles. "Sculptural Rooms That Instill Visitor With Tranquility." *The Tribune* (Oakland) 111, sec. E (May 31, 1984): 6.

Roden Crater: Drawings from Aerial Survey. Marion Locks Gallery, Philadelphia, Pennsylvania. September 14–October 5, 1984.

Donohue, Victoria. "One Sculptor's Grand Plan to Alter a Volcano from Within." *Philadelphia Inquirer* 311, sec. C (September 15, 1984): 3.

Locks, Marian. "James Turrell to Exhibit Drawings." *ML Newsletter* (Philadelphia, Pennsylvania) no. 1 (Winter 1984): 5.

James Turrell. Bernard Jacobson Gallery, Los Angeles. December 7, 1984–January 5, 1985.

Deep Sky (Portfolio of Seven Aquatints). Marian Goodman Gallery, Multiples, Inc., New York. January 11–February 8, 1985.

Cecil, Sarah. "New Editions–James Turrell." *Art News* 84 (March 1985): 67.

"James Turrell, Deep Sky (1984)." *The Print Collector's Newsletter* (New York) 15 (January–February 1985): 218.

Deep Sky (Portfolio of Seven Aquatints). Roger Ramsay Gallery, Chicago. February 16–March 7, 1985.

Artner, Alan G. "Though Small, Turrell Exhibit Is Essential." *Chicago Tribune* 138, sec. 7 (February 22, 1985): 44.

"James Turrell at Roger Ramsay Gallery." *Gallery Guide* (Kenilworth, New Jersey) 15, sec. NY (February 1985): 13.

Aerial Stereos. Karl Bornstein Gallery, Santa Monica, California. February 26–March 30, 1985.

Rico, Diana. "Turrell Does Double Take of Crater in 'Stereo'." *Daily News* (Los Angeles) 75, sec. Life (February 26, 1985): 19.

Schipper, Merle. "James Turrell, Aerial Stereo Photographs." *Art Scene* (Los Angeles) 4 (March 1985): 9.

Zone, Ray. "Cyclopean Images." *Artweek* 16 (March 23, 1985): 11.

BIBLIOGRAPHY
OF GROUP EXHIBITIONS

Aerial Skywriting Pieces With Planes and Clouds. In collaboration with Sam Francis. Pasadena, California, and Amsterdam, Holland, 1969–1970.

Sharp, Willoughby. "Rumbles." *Avalanche* 1 (Fall 1970): 2–3.

Art and Technology (in collaboration with Robert Irwin and Dr. Edward Wortz). Los Angeles County Museum of Art. 1968–1971. Catalog.

Antin, David. "Art and the Corporations." *Art News* 70 (September 1971): 23–26, 52–56.

Davis, Douglas. *Art and the Future: A History/Prophesy of the Collaboration between Science, Technology and Art*. New York: Praeger Publications, 1973.

Kozloff, Max. "The Million Dollar Art Boondoggle." *Artforum* 10 (October 1971): 72–76.

Livingston, Jane. "Some Thoughts on 'Art and Technology'." *Studio International* 181 (June 1971): 258–263.

Tuchman, Maurice. *A&T: A Report on the Art and Technology Program of the Los Angeles County Museum of Art, 1967–1971*. Los Angeles County Museum of Art, 1971: 127–142.

Wilson, William. "Two California Artists Are Busy Exploring Inner Space." *The Los Angeles Times* 78, sec. D (May 11, 1969): 2.

———. "'A&T' Catalogue Paints Picture of Struggle." *The Los Angeles Times* 90, sec. Calender (August 8, 1971): 57.

3D Into 2D: Drawing for Sculpture. The New York Cultural Center. January 19–March 11, 1973. Catalog.

Borden, Lizzie. "3D Into 2D: Drawing for Sculpture." *Artforum* 11 (April 1973): 73–77.

Group Exhibition: University of California, Irvine, 1965–1975. La Jolla Museum of Contemporary Art, California. October–November 1975.

Drawing Show. Heiner Friedrich Gallery, Cologne, Germany. Summer 1977.

California Perceptions: Light and Space. Selections from the Wortz Collection. Visual Arts Center, California State University, Fullerton. November 16–December 13, 1979. Catalog.

Muchnic, Suzanne. "Shining in Contemporary Light." *The Los Angeles Times* pt. 4, sec. View (November 26, 1979): 14.

Drawing Distinctions, American Drawings of the Seventies. Louisiana Museum, Denmark. August 15–September 20, 1981; Kunsthalle Basel, Switzerland. October 4–November 15, 1981; Stadtische Galerie Im Lenbachhaus, München. February 17–April 11, 1982; Wilhelm-Hack-Museum, Ludwigshafen. September–October 1982. Catalog.

Selections From The Chase Manhattan Bank Art Collection. University Gallery, University of Massachusetts, Amherst. September 19–December 20, 1981.

Selections From The Chase Manhattan Bank Art Collection. Robert Hull Fleming Museum, University of Vermont, Burlington. January 22–March 21, 1982.

Selections From The Chase Manhattan Bank Art Collection. Upper Rotunda, Faneuil Hall Marketplace, Boston. Presented by the DeCordova Museum, Lincoln, Massachusetts. April 30–June 6, 1982.

The 74th American Exhibition. The Art Institute of Chicago. June 12–August 1, 1982. Catalog.
Artner, Alan G. "American Exhibition Spots Trends But Misses Realism." *Chicago Tribune*, sec. 6 (June 13, 1982): 12.
Schulze, Franz. "Post-Pluralism – A New Dimension?" *Chicago Sun-Times*, sec. Show (June 13, 1982): 24.

Visiting Artists Revisited. College of Art and Architecture, University of Idaho, Moscow. October 7–October 31, 1982.

Selections From The Chase Manhattan Bank Art Collection. David Winton Bell Gallery, Brown University, Providence, Rhode Island. October 16–November 11, 1982.

Selections From The Chase Manhattan Bank Art Collection. The Ritter Art Gallery, Florida Atlantic University, Boca Raton. January 11–February 20, 1983. Catalog.

ARS, 1983. Ateneumin Taidemuseo Suomen Taideakatemia. Art Museum of the Ateneum, Helsinki, Finland. October 13–December 1, 1983. Catalog.
Hjorne, Nordens Hojre. "Helsingfors har kunstens mestlevende modested i Norden." *Politken* (Amsterdam) sec. 3 (December 18, 1983): 6.
Nopola, Sinikka, and Christian Westerback. "Naru aukon edessa." *Helsingin Sanomat* (Helsinki) (January 14, 1984).

Olsson, Anna. "Generalmonstring I." *Svenska Dagbladet* (Stockholm) (November 12, 1983).
Pallasmaa, Ullamaria. "ARS 83." *Look At Finland* (Helsinki) 1 (1984): 45.
Ratcliff, Carter. "James Turrell's 'Deep Sky'." *The Print Collector's Newsletter* (New York) 16 (May–June 1985): 45–47.
Valkonen, Markku. "Tilantekijat valloittivat ARS-in." *Helsingin Sanomat* (Helsinki) (October 16, 1983).

Projects: World Fairs, Waterfronts, Parks and Plazas. Rhona Hoffman Gallery, Chicago. June 20–July 31, 1984.

Menil Collection. École des beaux-arts, Paris. May 3–July 1, 1985. Catalog.

Cucchi-Fischl-Kruger-Stalder-Turrell. Lorence-Monk Gallery, New York. May 30–June 29, 1985.

Art & Architecture & Landscape: The Clos Pegase Design Competition. San Francisco Museum of Modern Art, California. June 6–August 25, 1985. Catalog.

Severe Clear. Radcliffe Dance Studio, Radcliffe College, Cambridge, Massachusetts. June 9–June 23, 1985.
Jowitt, Deborah. "Denizens of the Twilight." *The Village Voice* 30 (July 9, 1985): 71.
Reeve, Margaret. "James Turrell and Dana Reitz: A Collaboration in Dance and Light." *Art New England* (Brighton, Massachusetts) 6 (June 1985): 5.
Temin, Christine. "In an Unfathomable Twilight." *Boston Globe* 227 (June 15, 1985): 24.

RODEN CRATER PROJECT
Northern Arizona. 1974–present.
Adcock, Craig. "Anticipating 19,084: James Turrell's Roden Crater Project." *Arts Magazine* 58 (May 1984): 76–85.
Beardsley, John. "Monument and Environment: The Avant-Garde, 1966–1976." *Earthworks and Beyond* (New York) (1984): 37–39.
Butterfield, Jan. "A Hole in Reality." *Images and Issues* 1 (Fall 1980): 53–57.
Cauthorn, Robert S. "Artist Working in Crater Building an Observatory." *The Arizona Daily Star* 143, sec. D (July 22, 1984): 1–5.
Galloway, David. "Report from Italy – Count Panza Divests." *Art in America* 72 (December 1984): 9–10.

Heyting, Lien. "Zonlicht in een Dode Vulkaan." *NRC Handelsblad* (Rotterdam) sec.cs (April 9, 1976): 3.

Holmes, Lorna. "Roden Crater, Artwork and Observatory." *Arizona Highways* 60 (September 1984): 9.

House, Dorothy. "James Turrell's Roden Crater Project." *Museum Notes* (Museum of Northern Arizona) 10 (March–April 1982): 1–2.

Larson, Kay. "New Landscapes in Art." *The New York Times Magazine* 128 (May 13, 1979): 20–38.

Maza, Michael. "James Turrell." *People Weekly* 23 (January 7, 1985): 54–55.

McDonald, Keith M. "The Roden Crater Project." *Sedona Life* (Arizona) 4 (January 1979): 16–23.

Miyauchi, Jay. "American Dream." *Common Sense* (Tokyo) 1 (October 1984): 128–135.

Monson, Karen. "Turning a Volcano Into a Planetarium." *The Wall Street Journal* 110 (April 24, 1984): 28.

Montini, E. J. "Artistic Eruption." *The Arizona Republic* 94 (July 15, 1984): 1–3.

Muchnic, Suzanne. "Gonna Carve a Mountain." *The Los Angeles Times* sec.Calendar (April 1, 1984): 1, 100–101.

Olsson, Anna. "Naturen – Ett Granslost Konstverk." *Expressen* (Stockholm) (February 26, 1983): 5.

Radice, Barbara. "Un Pezzo Fatto nel Cielo." *Data* (Milan) (February–March 1977): 40–43.

Sakane, Itsuo. "The Art of Roden Crater." *Asahi Shimbun* (Tokyo) (March 16, 1981): 5.

———. "The Art of Roden Crater." In *Travelling the Borderland Between Art and Science*, 138–141. Tokyo: The Asahi Shimbun, 1984.

Schroeder, John. "Dormant Volcano in Painted Desert is Ideal for Artist's Space." *The Arizona Republic* 91,sec. B (January 5, 1981): 1.

Schuyt, Michael, Joost Elffers, and George R. Collins. "Jim Turrell, Roden Crater Project." In *Fantastic Architecture*, 50–51. New York: Harry N. Abrams, Inc., 1980.

Shinoda, Morio. "Performance of the Celestial Sphere." *Bijutsu Techno* (Tokyo) 34 (April 1982): 151–155.

Trotter, Marian W. "Artist Carves Observatory Out of Crater." *Western's World* (Los Angeles) 16 (September 1985): 80–82.

Wada, Masaki. "Earth Works." *Box Magazine* (Tokyo) 65 (August 1985): 91–95.

Wainwright, Loudon. "The View from Here – To Each His Own Reality." *Life Magazine* 7 (April 1984): 7

BIBLIOGRAPHY

OF OTHER WORKS

Six Installations in the Villa Panza (for Count Giuseppe Panza di Biumo in Varese, Italy. 1975–1979).

Castelli, Tommaso Trini. "Nelle Stanze dell'Arte." *Casa Vogue* (Milan) no. 79 (February 1978): 50–67.

Davis, Douglas. "The New Supercollectors." *Newsweek* 86 (August 11, 1975): 68–69.

Gandel, Milton. "If One Hasn't Visited Count Panza's Villa, One Doesn't Really Know What Collecting Is All About." *Art News* 78 (December 1979): 44–49.

Tilroe, Anna. "de Schatkamers Van Panza." *Avenue* (Amsterdam) (October 1979): 14–21.

MISCELLANEOUS PUBLICATIONS

Adcock, Craig. "Perceptual Edges: The Psychology of James Turrell's Light and Space." *Arts Magazine* 59 (February 1985): 124–128.

Celant, Germano. *Ambiente/Arte dal Futurismo*. Edizioni La Biennale di Venezia. Venice: Alfieri Edizioni d'Arte (1977): 128–129.

———. "Das Bild einer Geschichte 1956/1976 Die Sammlung Panza di Biumo." (Milan) (1980): 329.

Failing, Patricia. "James Turrell's New Light on the Universe." *Art News* 84 (April 1985): 71–78.

Hart, Claudia. "Environments of Light: Ornament in Search of Architecture." *Industrial Design* 31 (March/April 1984): 22–27.

Isenberg, Barbara. "Count Panza: Patron of American Art." *The Los Angeles Times* sec.Calendar (July 10, 1983): 1, 4–6.

Lucebert. "james turrell." In *Voor Vridenden Dierne en Gedichten*, 88–89. Amsterdam: van Lanschot Bankiers N.V., 1979.

Matta, Marianne. "Die Sammlung Panza di Biumo." *Du* (Zurich) 474 (August 1980): 6–9.

Viladas, Pilar. "Interiors: The New Modernism, Speaking in Metaphors." *Progressive Architecture* (Cleveland, Ohio) 64 (September 1983): 108.

Wolff, Theodore F. "The Many Masks of Modern Art." *The Christian Science Monitor* 74 (September 9, 1982).

77 James Turrell, 1982

Photo Notes and Credits

1
Under the overcast, Channel Islands, 1975
Photo: James Turrell

2
Hover, 1983
Natural light and fluorescent mix. Installation at
the Musée National d'Arte Moderne, Paris.
Photo: Nance Calderwood

3
Cumo, 1976
Tungsten light, 12′2 5/8″ × 36′6″ × 17′. Installation
at the Arco Center for the Visual Arts, Los Ange-
les. Collection of Regina Dehr, Flagstaff, Arizona.
*Photo: Philip J. Kirkley, Jr., courtesy Arco Center for the
Visual Arts*

4
James Turrell and Julia Brown, 1985
Photo: Squidds & Nunns

5
Construction photograph, *Razor*, 1982
View of light source. Center on Contemporary
Art, Seattle.
Photo: Colleen Chartier

6
Construction photograph, *Razor*, 1982
View of light from behind. Center on Contempo-
rary Art, Seattle.
Photo: Colleen Chartier

7
Razor, 1982
Outside light and fluorescent. 12′ × 22′ 1/4″ ×
23′ 5/8″. Center on Contemporary Art, Seattle.
Photo: Mark Sullo

8
Construction photograph, *Amba* and *Razor*, 1982
The artist during frame construction. Center on
Contemporary Art, Seattle.
Photo: Colleen Chartier

9
Construction photograph, *Amba*, 1982
Paint and finish. Center on Contemporary Art,
Seattle.
Photo: Mark Sullo

10
Amba, 1982
Fluorescent mix, 11′6″ × 32′ × 34′. Installation at
the Center on Contemporary Art, Seattle. Collec-
tion of the artist.
Photo: Mark Sullo

11
Construction photograph, *House of Wax*, 1982
Inspection of finish painting. Center on Contempo-
rary Art, Seattle.
Photo: Mark Sullo

12
Mikva, 1982
Fluorescent light. Israel Museum, Jerusalem. Col-
lection of the artist.
Photo courtesy Israel Museum

13
Orca (left), *Kono* (right), 1984
Argon light, helium light. Installation at Capp
Street Project, San Francisco. Collection of the
artist.
Photo: M. Lee Fatherree

14
Wolf (day), 1984
Capp Street Project, San Francisco.
Photo: M. Lee Fatherree

15
Wolf (dusk), 1984
Upstairs window transparent, downstairs window
transluscent. Capp Street Project, San Francisco.
Photo: M. Lee Fatherree

16
Wolf (twilight), 1984
Capp Street Project, San Francisco.
Photo: M. Lee Fatherree

17
Wolf (night), 1984
Upstairs window transparent, downstairs window
transluscent. Capp Street Project, San Francisco.
Photo: M. Lee Fatherree

18
Blue Walk (night), 1983
Natural light and fluorescent mix. Installation at
the Musée National d'Arte Moderne, Paris.
Photo: Nance Calderwood

37
Ronin, 1969
Fluorescent light, 16′8″ × 12′ × 8″. Installation at the Stedelijk Museum, Amsterdam, 1976. Collection of the artist.
Photo courtesy Stedelijk Museum

38
Hallwedge, 1976
Fluorescent light, 8′ × 3′2″ × 12′8″. Installation at the Stedelijk Museum, Amsterdam.
Photo courtesy Stedelijk Museum

39
Dr. and Mrs. Giuseppe Panza di Biumo with Helen Winkler (formerly of the DIA Foundation), 1974. Flagstaff, Arizona.
Photo: James Turrell

40
Main and Hill Street Studio, 1972
Santa Monica, California
Photo: James Turrell

41
James Turrell, 1966
Main and Hill Street Studio, Santa Monica, California
Photo: James Turrell

42
Studio interior, 1966
Main and Hill Street Studio, Santa Monica, California
Photo: James Turrell

43
Music for the Mendota, 1969
Black and white photograph by the artist, 6″ × 8″. Light, multiple exposure of spaces 4 and 5. (See drawing 54, *Music for the Mendota*.) Collection of Ed and Melinda Wortz, Pasadena, California.
Photo reproduction: Squidds & Nunns

44
Music for the Mendota (detail from space 7), 1969
Polaroid photo by the artist 4 1/2″ × 5 1/2″. (See drawing 54, *Music for the Mendota*.) Collection of Ed and Melinda Wortz, Pasadena, California.
Photo: Squidds & Nunns

45
Music for the Mendota: Mendota Stoppages, 1970–71
Ink on paper. Collection of Thordis Moeller, New York.
Photo: Friedrich Rosenstiel

46
Dining room with hard light from kitchen, 1973
Main and Hill Street Studio, Santa Monica, California
Photo: James Turrell

47
Dining room with soft light from kitchen, 1973
Main and Hill Street Studio, Santa Monica, California
Photo: James Turrell

48
Lunette (day), 1974
Interior light, argon light, and direct sky. Collection of Dr. Giuseppe Panza di Biumo, Varese, Italy.
Photo: Giorgio Colombo

49
Lunette (night), 1974
Interior light, argon light, and direct sky. Collection of Dr. Giuseppe Panza di Biumo, Varese, Italy.
Photo: Giorgio Colombo

50
Virga (day), 1974
Skylight and fluorescent mix. Collection of Dr. Giuseppe Panza di Biumo, Varese, Italy.
Photo: Giorgio Colombo

51
Virga (night), 1974
Skylight and fluorescent mix. Collection of Dr. Giuseppe Panza di Biumo, Varese, Italy.
Photo: Giorgio Colombo

52
Skyspace I (day), 1972
Interior light and open sky. Collection of Dr. Giuseppe Panza di Biumo, Varese, Italy.
Photo: James Turrell

53
Skyspace I (twilight), 1972
Interior light and open sky. Collection of Dr. Giu-

seppe Panza di Biumo, Varese, Italy.
Photo: Giorgio Colombo

54
Skyspace I (day), 1972
Skylight and tungsten light. Collection of Dr. Giuseppe Panza di Biumo, Varese, Italy.
Photo: Giorgio Colombo

55
Skyspace I (night), 1972
Interior light and open sky. Collection of Dr. Giuseppe Panza di Biumo, Varese, Italy.
Photo: Giorgio Colombo

56
Roden Crater, 1982
Looking east.
Photo: James Turrell, Dick Wiser

57
Afrum-Proto, 1967
Quartz-halogen, scaled for 10′ ceiling. Installation at the Whitney Museum of American Art, New York, 1980. Collection of Ed and Melinda Wortz, Pasadena, California.
Photo: John Cliett

58
Tollyn, 1967
Tungsten light, 12′ × 28″. Studio installation, Los Angeles. Collection of Dr. Giuseppe Panza di Biumo, Milan, Italy.
Photo: James Turrell

59
Decker, 1967
Projected xenon light, scaled for 10′ ceiling. Installation at the Whitney Museum of American Art, New York, 1980. Collection of the artist.
Photo: Warren Silverman

60
Model for the Domaine Clos Pegase Winery, 1984
Robert Mangurian/James Turrell collaboration. Plaster and pigments on plywood base, 36″ × 60″ × 60″. Collection of Robert Mangurian, Venice, California.
Photo courtesy San Francisco Museum of Modern Art

61
Roden Crater (aerial view), 1982
Looking east.
Photo: James Turrell, Dick Wiser

62
Roden Crater and cross-section with fumarole arc, 1985
Photographic emulsion with conte crayon and graphite on mylar, 41 1/4″ × 55 3/4″. Collection of Gail and Barry Berkus, Santa Barbara, California.
Photo: William Nettles, courtesy Malinda Wyatt Gallery

63
Fumarole with view into Painted Desert, 1981
Temporary survey pithouse shown at top of fumarole.
Photo: George Wray

64
Fumarole walkway with solar and lunar alignments, 1983
Photographic emulsion, graphite and conte crayon on mylar, 27″ × 37″. Collection of Robert and Mary Looker, Santa Barbara, California.
Photo: William Nettles, courtesy Ace Gallery

65
Topographic survey drawing, 1980
Ink and pencil on mylar, reverse print, 42″ × 72″. Collection of Robert Rowan.
Photo courtesy Skystone

66
Topographic drawing (cut and fill and tunnel alignment), 1980
Ink and pencil on mylar, reverse print, 36″ × 72″. Collection of Peter Coan, New York.
Photo courtesy Skystone

67
Crater bowl after initial shaping, 1984
Photo: Michael Yost

68
Initial crater topo, 1983–84
Wax and pastel on mylar and velum sandwich, 34″ × 34″. Collection of Joan and Frederick M. Nicholas, Los Angeles.
Photo: William Nettles

69
Roden Crater bowl looking north, 1984
Photo: Michael Yost

70
Roden Crater, 1982
Looking northeast.
Photo: James Turrell

71
Roden Crater, 1983
Looking northeast.
Photo: Michael Yost

72
Roden Crater, 1984
Looking northeast.
Photo: Michael Yost

73
Roden Crater, 1984
Looking northeast.
Photo: Michael Yost

74
Roden Crater rim (dusk), 1981
Photo: George Wray

75
Dr. Richard Walker, astronomer, U.S. Naval
Observatory, and Michael Yost, Project Director,
Roden Crater, 1985
Laying pipe at Roden Crater, 1985.
Photo: Kris McClusky

76
Construction photograph with view of Pioneer
Square, 1982
Installation at the Center on Contemporary Arts,
Seattle.
Photo: Colleen Chartier

77
James Turrell, 1982
Construction photograph of *Nada*, Israel Museum,
Jerusalem.
Photo courtesy Israel Museum

Roden Crater (survey frame 5752), 1982
10,200 ft., 9 1/2" × 9 1/2" contact.
Collection of the artist.
Photo: I. K. Curtis

Fellows of Contemporary Art

The concept of the Fellows of Contemporary Art, as developed by its founding members, is unique. We are an independent organization established in 1975. We do not raise funds. Monies received from dues are used to underwrite our exhibitions and to support tax-exempt educational institutions active in the field of contemporary art. We maintain no permanent facility and no permanent collection but rather utilize alternative spaces. In addition to the exhibition schedule, the Fellows maintain an active membership education program.

1976
Ed Moses Drawings 1958–1976
Frederick S. Wight Art Gallery
University of California, Los Angeles
July 13–August 15, 1976
Catalog with essay by Joseph Masheck

1977
Unstretched Surfaces/Surfaces Libres
Los Angeles Institute of Contemporary Art
November 5–December 16, 1977
Catalog with essays by Jean-Luc Bordeaux, Alfred Pacquement, and Pontus Hulten

1978–80
Wallace Berman Retrospective
Otis Art Institute Gallery, Los Angeles
October 24–November 25, 1978
Catalog with essays by Robert Duncan and David Meltzer
Exhibition traveled to: Fort Worth Art Museum, Texas; University Art Museum, University of California, Berkeley; Seattle Art Museum, Washington.

1979–80
Vija Celmins, A Survey Exhibition
Newport Harbor Art Museum
Newport Beach, California
December 15, 1979–February 3, 1980
Catalog with essay by Susan C. Larsen
Exhibition traveled to: The Arts Club of Chicago, Illinois; The Hudson River Museum, Yonkers, New York; The Corcoran Gallery of Art, Washington, D.C.

1980
Variations: Five Los Angeles Painters
University Art Galleries
University of Southern California, Los Angeles
October 20–November 23, 1980
Catalog with essay by Susan C. Larsen

1981–82
Craig Kauffman Comprehensive Survey 1957–1980
La Jolla Museum of Contemporary Art
La Jolla, California
March 14–May 3, 1981
Catalog with essay by Robert McDonald
Exhibition traveled to: Elvehjem Museum of Art, University of Wisconsin, Madison; Anderson Gallery, Virginia Commonwealth University, Richmond; The Oakland Museum, California.

1981–82
Paul Wonner: Abstract Realist
San Francisco Museum of Modern Art
San Francisco, California
October 1–November 22, 1981
Catalog with essay by George W. Neubert
Exhibition traveled to: Marion Koogler McNay Art Institute, San Antonio, Texas; Los Angeles Municipal Art Gallery, California.

1982–83
Changing Trends: Content and Style
Twelve Southern California Painters
Laguna Beach Museum of Art
Laguna Beach, California
November 18, 1982–January 3, 1983
Catalog with essays by Francis Colpitt, Christopher Knight, Peter Plagens, and Robert Smith. Exhibition traveled to: Los Angeles Institute of Contemporary Art, Los Angeles, California.

1983
Variations II: Seven Los Angeles Painters
Gallery at the Plaza
Security Pacific National Bank
Los Angeles, California
May 8–June 30, 1983
Catalog with essay by Constance Mallinson

1984
Martha Alf Retrospective
Los Angeles Municipal Art Gallery
Los Angeles, California

March 6–April 1, 1984
Catalog with essay by Suzanne Muchnic
Exhibition traveled to: San Francisco Art Institute,
San Francisco, California

1985
Sunshine and Shadow: Recent Painting in South-
ern California
Fisher Gallery
University of Southern California
Los Angeles, California
January 15–February 23, 1985
Catalog with essay by Susan C. Larsen

Mr. & Mrs. Bernard A. Greenberg
Mr. & Mrs. James C. Greene
Mr. & Mrs. Murray A. Gribin
Mr. & Mrs. Jay Gustin
Mr. Robert H. Halff
Mr. & Mrs. Richard Hammerman
Mr. Gordon F. Hampton
Mr. & Mrs. Thomas E. Hatch, Jr.
Dr. & Mrs. Alfred H. Hausrath III
Ms. Evelyn Hitchcock
Mr. & Mrs. Alexander P. Hixon
Mr. & Mrs. John F. Hotchkis
Mr. & Mrs. Stirling L. Huntley
Mr. & Mrs. William H. Hurt
Mr. & Mrs. Avram A. Jacobson
Mr. & Mrs. Jerome Janger
Mr. & Mrs. Frank Kockritz
Mr. Robert B. Krueger
Mrs. Virginia C. Krueger
Mr. & Mrs. Russel I. Kully
Dr. & Mrs. Gerald W. Labiner
Dr. & Mrs. Eldridge L. Lasell
Mr. & Mrs. Hoyt Leisure
Mr. & Mrs. Bernard Lewis
Mr. & Mrs. Edwin A. Lipps
Dr. & Mrs. John E. Lusche
Mr. & Mrs. Leon Lyon
Mr. & Mrs. Paul R. Maguire
Mr. & Mrs. Brian L. Manning
Mr. & Mrs. J. Terry Maxwell
Mr. & Mrs. Charles E. McCormick
Mr. & Mrs. Philip H. Meltzer
Mrs. John Simon Menkes and Dr. John H. Menkes
Ms. Jeanne Meyers
Mrs. Alathena Miller
Mr. & Mrs. Charles D. Miller
Mr. D. Harry Montgomery
Mr. & Mrs. Courtenay Moon
Mr. & Mrs. Richard L. Narver
Mr. & Mrs. James Neville
Dr. & Mrs. Robert M. Newhouse
Dr. & Mrs. Richard E. Newquist
Mr. & Mrs. Frederick M. Nicholas
Mrs. Jack L. Oatman
Mr. & Mrs. Bob Ray Offenhauser
Mr. & Mrs. George E. Osborn
Mr. & Mrs. David B. Partridge
Mr. & Mrs. Rodman W. Paul
Mr. & Mrs. Theodore Paulson
Mr. & Mrs. J. Blair Pence II
Mr. & Mrs. Frank H. Person
Mrs. Marlys Ferguson Peters
Peggy Phelps

Drs. James B. and Rosalyn Laudati Pick
Mr. & Mrs. Lawrence J. Ramer
Mr. & Mrs. John Rex
Mr. & Mrs. George R. Richter, Jr.
Mr. & Mrs. Chapin Riley
Mr. & Mrs. Gerry Rosentswieg
Mr. & Mrs. Barry A. Sanders
Mrs. Richard Schuster
Mr. & Mrs. J. C. Schwarzenbach
Mr. & Mrs. Russell Dymock Smith
Mr. & Mrs. Howard Smits
Mr. & Mrs. Lawrence Spitz
Mr. & Mrs. Milton R. Stark
Ms. Laurie Smits Staude
Mr. & Mrs. David H. Steinmetz
Mr. & Mrs. Richard L. Stever
Brig. Gen. and Mrs. Marvin G. Sturgeon
Mr. and Mrs. Stanford H. Taylor
Mrs. Charles Ullman
Mrs. Norton S. Walbridge
Mr. & Mrs. Francis M. Wheat
Mrs. Corinne Whitaker
Mr. & Mrs. George F. Wick
Mr. & Mrs. Toby Franklin K. Wilcox
Mr. & Mrs. James Williams Wild
Mr. & Mrs. John H. Wilke
Mr. & Mrs. Richard A. Wilson
Mrs. Maybelle Bayly Wolfe
Mr. & Mrs. Robert J. Woods, Jr.
Mr. & Mrs. Leo Wyler
Mr. & Mrs. George T. Yewell, Jr.
Mr. & Mrs. Paul Yost, III
Mrs. Billie K. Youngblood

The Museum of Contemporary Art, Los Angeles

List of Contributors

Craig Adcock
Art Historian, Florida State University, currently resides in Tallahassee, Florida.

Julia Brown
Senior Curator, The Museum of Contemporary Art, Los Angeles, currently resides in Santa Monica, California.

John Coplans
Assistant Poet, New York.

Edy de Wilde
Past Director, Stedelijk Museum, Amsterdam, currently resides in Amsterdam, Netherlands.

Craig Hodgetts
Professor, University of Pennsylvania, architect, currently resides in Los Angeles, California.

Lucebert
Poet, currently resides in Amsterdam, Netherlands.

Count Giuseppe Panza di Biumo
Collector of contemporary art, currently resides in Varese, Italy.

Jim Simmerman
Poet, currently resides in Flagstaff, Arizona.

Theodore F. Wolff
Art critic, Christian Science Monitor, currently resides in New York.

Occluded Front James Turrell was designed by
Jack W. Stauffacher of the Greenwood Press,
San Francisco, California. Type is Kis-Janson,
set by Wilsted & Taylor, Oakland, California.
Printed on Centura Dull 100 # by Gardner/Fulmer,
Buena Park, California. 7500 copies printed.